Songs of the
Black Würm Gism

CREATION ONEIROS

CREDITS

Songs of the Black Würm Gism

Hymns to HP Lovecraft: The Starry Wisdom, part 2

D M Mitchell (editor)

ISBN 978-1-902197-28-9

First published 2009 by Creation Oneiros

www.creationbooks.com

Copyright © D M Mitchell and individual contributors 2009

Cover illustration:

"THE NINTH DUKE MANIFEST IN HIS INSUFFERABLE BEAUTY;
OR SEVEN TOMBS FOR SEVEN GROOMS"

by

Alan Moore

Design: The Tears Corporation

A Butcherbest Production

Editor's acknowledgements:

Thanks to James Williamson, David Britton, Robert Agasucci
And love to Aurora, Caleb and Cormac

contents

introduction:
architects of fear
john coulthart

I

1920: the writer sits, at night, an old city asleep outside his window, dim light upon the empty page. He sits and waits for the words. When the words arrive he sets them down, hopelessly he often feels, a pointless task he submits to with resignation. Recurrent illness has been a rebuke against hope, lack of acknowledgement rebukes his ambition. When illness prematurely claims him, he dies with an assurance of extinction, certain that his words will be lost along with his breath.

But the words survive. Drawn from the ether of the new century, his sensitised intelligence has crafted a mythology for the time, giving shape to forces that his contemporaries perceive dimly, if at all. A mythology of those vast, impersonal yet manipulative powers coalescing in the air of the coming age, a mythology of conspiracy elevated to the level of metaphysics, a mythology of tyranny and mutation, paranoia and holocaust.

II

The writer is Franz Kafka. When he died in 1924, HP Lovecraft was unknown outside the pages of *Weird Tales* and of the handful of his stories already published there, none were those that would later make him famous. ('The Call of Cthulhu' came in 1926.) Lovecraft is unlikely to have known Kafka's works, even in the early translations of the 1930s, yet the similarities between the pair persist, not only in their powerful representations of dread and alienation – the one crafted in a spare and affectless style, the other in the baroque vernacular of the pulps – but also for the way they define a sense of their times, and of the world, that subsequent readers have come to regard as visionary.

Jorge Luis Borges (who dedicated his story 'There Are More Things' to Lovecraft) identifies in his essay 'Kafka and His Precursors' a phenomenon common to writers who possess this kind of singular vision. The writer that forges a new way of seeing, says Borges, creates his own precursors, also forging connections between disparate themes, other writers and so on, that were previously unconnected. When the vision is powerful enough, and its influence proves to be as adaptive as a successful virus, we look for words to describe that influence and the reach of that vision. "'Kafkaesque' is the only word in common English use which derives from German

literature" writes JP Stern. "Its meanings range from 'weird', 'mysterious', 'tortuously bureaucratic' to 'nightmarish' and 'horrible', yet we do not associate it with the horror machines of science fiction or Edgar Allan Poe." Equally, we now have the word 'Lovecraftian' which can mean many of the same things, with possibly 'squidlike and squalid' (to borrow a phrase from the late John Balance) replacing 'tortuously bureaucratic'. In Lovecraft's case we can, of course, associate the word in part with Poe, if only to see where the designation has come from, and note how it builds upon foundations laid by Poe to touch the unique dreads of a new century.

<center>III</center>

When Lovecraft began to hit his peaks in the late 1920s, a young William Burroughs was cultivating a lifetime hatred of authority during his tenure at the Los Alamos Ranch School in New Mexico. In August 1931, teenage Bill could have gone to a newsstand in Los Alamos town and picked up the latest issue of *Weird Tales*, there to read about "the monstrous nuclear chaos beyond angled space which the *Necronomicon* had mercifully cloaked under the name of Azathoth" from Lovecraft's 'The Whisperer in Darkness'. 'Tam, Son of the Tiger' by Otis Adelbert Kline received the cover treatment that month, with a mediocre painting by CC Senf. Lovecraft's lack of faith in the enduring popularity of his works is perhaps easier to appreciate when you realise that none of his stories were deemed worthy of a cover illustration during his lifetime. Yet Kline and his contemporaries – many with names as baroque as the characters in their stories: Nictzin Dyalhis, Pearl Norton Swet, Ronal Kayser, the egregious Seabury Quinn – have been buried by the dust of their rotting magazines, while Lovecraft's influence proliferates in books and films and digital media.

Ten years after 'The Whisperer in Darkness', though, Lovecraft was dead, and – so he believed – his works forgotten. In 1941, as William Burroughs never tired of reminding people, Robert Oppenheimer and the scientists of the Manhattan Project came to the Los Alamos Ranch School to close it down, bulldoze its buildings and replace them with a research facility where they could create a monstrous nuclear chaos of their own. The Trinity explosion in the Alamogordo desert prompted Oppenheimer to recall some words from an ancient text, a pronouncement from the god Vishnu in the Bhagavad Gita: "I am become death, the destroyer of worlds."

<center>IV</center>

"(The *Necronomicon* was) composed by Abdul Alhazred, a mad poet of Sanaá, in Yemen, who is said to have flourished during the period of the Ommiade caliphs, circa 700 A. D. He visited the ruins of Babylon and the subterranean secrets of Memphis and spent ten years alone in the great southern desert of Arabia – the *Roba el Khaliyeh* or "Empty Space" of the ancients – and "Dahna" or "Crimson" desert of the modern Arabs which is held to be inhabited by protective evil spirits

and monsters of death. Of this desert many strange and unbelievable marvels are told by those who pretend to have penetrated it. In his last years Alhazred dwelt in Damascus, where the *Necronomicon* (*Al Azif*) was written and of his final death or disappearance (738 A. D.) many terrible and conflicting things are told. He is said by Ebn Khallikan (12th cent. biographer) to have been seized by an invisible monster in broad daylight and devoured horribly before a large number of fright-frozen witnesses. Of his madness many things are told. He claimed to have seen the fabulous Irem, or City of Pillars, and to have found beneath the ruins of a certain nameless desert town the shocking annals and secrets of a race older than mankind. He was only an indifferent Moslem, worshipping unknown entities whom he called Yog-Sothoth and Cthulhu."
 −HP Lovecraft, 'The History of the Necronomicon'.

"The Cities of Red Night were six in number: Tamaghis, Ba'dan, Yass-Waddah, Waghdas, Naufana and Ghadis. These cities were located in an area roughly corresponding to the Gobi Desert, a hundred thousand years ago. At that time the desert was dotted with large oases and traversed by a river which emptied into the Caspian Sea."
 −William Burroughs, *The Cities of the Red Night*.

Burroughs' cities are brothers to Lovecraft's Nameless City, and Irem, City of Pillars, referred to in 'The Call of Cthulhu' as the supposed home of the Cthulhu Cult. The Cities of the Red Night are invoked with a litany of Barbarous Names, a paean to the "nameless Gods of dispersal and emptiness" that includes the Sumerian deities that Burroughs found catalogued in the 'Urilia Text' from the Avon Books *Necronomicon*, and which includes (how could it not?) "Kutulu, the Sleeping Serpent who cannot be summoned." In Burroughs work the 'Lovecraftian' is transmuted, the unspeakable becomes the spoken and the nameless is named at last, beneath the pitiless gaze of Burroughs' own "mad Arab", Hassan I Sabbah, Hashish Eater and Master of Assassins. "Nothing is true, everything is permitted."

V

2005: Nothing is true and everything is permitted but only in the space created by the latest architects of fear, the demagogues of the Twenty-First Century, our very own agents of the Control Virus. We see now that Irem, City of Pillars, is named in Sura 89 of the *Qur'an* ("Hast thou not seen how thy Lord did with Ad? With Iram of the columns? The like of which has not been created in the land?") and that the *Qur'an* itself is presented to us by the architects of fear as the new *Al Azif*, a *Necronomicon* for an age of terror. In 'The Dunwich Horror', the Whateley brood, like miscegenous backwoods Unabombers, pore over their ancient texts in the hope of invoking titanic forces that would "clear off the earth". In 'The Call of Cthulhu' the cultists wait patiently for their god to return, when all the earth will blaze "in a holocaust of ecstasy and freedom". So Cthulhu reveals another face as Shaitan, "the Old Dragon" and "Lord of the Abyss", named in Sura 25:29 of the *Qu'ran* as "the forsaker" who will lead men away from the path of righteousness:

"Mankind, Shaitan is al khadhulu."

At the dawn of a new century, in mountain retreats, "mad Arabs" pore over these ancient words before unleashing a new Manhattan Project on America's City of Pillars, raising columns of smoke and human ash over the city of 'He' and 'The Horror at Red Hook'. Hatred stalks the city streets as racist tabloid editors gibber and froth at the spectre of swarming immigrant hordes, while African witchdoctors are butchering boys and throwing their bodies into the River Thames. Nuclear chaos is but a breath away, the architects of fear assure us, it's only a matter of time. "I am become death, the destroyer of worlds." So we turn for respite to another story from 1931, 'The Shadow Over Innsmouth', and read:

"Keener news-followers, however, wondered at the prodigious number of arrests, the abnormally large force of men used in making them, and the secrecy surrounding the disposal of the prisoners. No trials, or even definite charges were reported; nor were any of the captives seen thereafter in the regular gaols of the nation. There were vague statements about disease and concentration camps, and later about dispersal in various naval and military prisons, but nothing positive ever developed. Innsmouth itself was left almost depopulated, and it is even now only beginning to show signs of a sluggishly revived existence."

At the dawn of a new century, those with the Innsmouth look have found themselves in the penal colony, waiting for a trial that will never come. Can you feel the heat closing in? Welcome to the Witch House; these are your dreams.

Manchester,
Summer Solstice, 2005

foreword
d m mitchell

I had envisaged a follow-up to the anthology *The Starry Wisdom* almost as soon as I'd finished compiling it and even before it had seen print. It had never quite fulfilled all my original intentions and so I'd decided that I needed to create a 'corrective' volume to balance it. Unfortunately, due to the way of the world it wasn't until now that creating such a volume has been a real possibility. My problem with *The Starry Wisdom*, was that while attempting to recontextualize Lovecraft's ideas and themes, I'd steered it still pretty much into the 'horror' genre. I had initially wanted to bring his influence into the realms of mainstream fiction, or at least to a place that challenged rigid market-defined genre-categorisations.

The tone of the earlier book was also still conditioned by what I would call the gothic sensibility, a hangover from 19th century paradigms and the decadent reaction against same by the symbolists and romantics. The atmosphere of *The Starry Wisdom* was one of darkness and pessimism underlaid with an omnipresent feeling of defeat. This had become the popular way of viewing Lovecraft's work, thanks mainly to the reductionist appraisals of him by writers such as Edmund Wilson, Michael Moorcock and Colin Wilson. On the contrary, I have always discerned a strong current of Dionysian Nietzschean adventure in Lovecraft's writing. And in terms of lineage and influence, I'd always felt that the more challenging and interesting aspects of his oeuvre had been overlooked in favour of his formulaic and clichéd gothic trappings, by both detractors and imitators alike.

In this volume I have emphasised the latent content of Lovecraft's work over the manifest. You will not find too many overt references to the Cthulhu Mythos (now stripmined by the 'gaming community'). And yet, between the lines Lovecraft's entities and transgressive philosophies, his lost worlds and lysergic necropolises occupy every page.

In both anthologies my reinterpretation of Lovecraft is refracted through the works of William Burroughs, Alan Moore and David Britton, and more recently the transmundane monstrosities and post-human pornography of Japanese *anime* (see *Akira*, *Urotsukidoji*, *Doomed Megalopolis*) and films such as *Tetsuo*.

I've also focused on Lovecraft's 'dreamworlds', some of which have been called twee, but many of which depict realms of pure existential nightmare ('The Terrible Old Man', 'The Music of Erich Zann', 'The Picture in The House', 'The Hound') and which bear noteworthy parallels with the output of many of his surrealist contemporaries in terms of channeling the pre-WWII zeitgeist. I am thinking of Artaud, *Maldoror*, Ernst's *Semaine de Bonté*, Leiris' *Aurora* and Jean Ray's very Lovecraftian *Malpertuis*.

In this book, you will not read of antiquarians discovering forbidden tomes and invoking

horrible dooms, nor of wars between 'Elder Gods' and 'great Old Ones'. You will traverse dark 21st century dreamscapes where the smokestacks of Auschwitz and post-industrial wastelands merge with the Mountains of Madness, be infected by viral technologies courtesy of Nyarlathotep Industries, squirm at the excesses of trans-species pornographic set-pieces, and revel in visions of the biological flood-gates thrown wide and the prospects of total cosmic freedom.

–D M Mitchell
Yucatan, 2008

preliminary invocation

YLSI E VIN A IPGEDOT SAGA
YLSI AR BRIN EOLIS CAOSG OD A PERIPSOL
YLSI AR BRIN EOLIS DOSIG OD A BASGIM
YLSI AR BRIN EOLIS ORS OD A OLPIRT
GEH RA-HOOR-KHUIT SOBAM AG OLLOR BRIN DORPHA MIRC DROLN COCASB
GEH IABAS
GEH IAPOS
ILS BRIN OLN YRPOIL AAI BALIT OD PRIAZ AR GCHISGE OIAD
ILS BRIN EOLIS TILB OD A TLB
ILS BRIN EOLIS TALBO OD A NAZPS
ILS BRIN EOLIS OLLOR TABA CORDZIZ OD QUASB CORDZIZ
ZIR _____ ILS NOCO C ILS BRIN DLUGAM CICLE. ILS BRIN EOLIS A ZLIDA OD A ORSCOR OD
AR DS DLUGA MALPIRGI C TOGLO. SOLPETH C E, LAP ZIR A MURIFRI DE RA-HOOR-KHUIT, OI
ILS MONASCI DLUGAM C A NOCO DE A ROR.

AIR

SOLPETH C E—— AR ; THIAO; REIBET; ATHELEBERSETH; A; BLATHA; ABEU; EBEU; PHI;
CHITASOEL IB; THIAO.
SOLBETH C E OD EOLIS TOL GAH ABOARPI PAMBT; AR GAH DE OD CALZ OD DE A ILMO;
MIRC CAOSG OD OROCH A CAOSG; MIRC ORSCOR OD DE A ZLIDA; TOGLO DE GIGIPAH OD
TOGLO PRGEL, OD ANGELARD OD SOR DE IAD CHISO ABOARPI PAMBT.

FIRE

E VIN YLSI, MICAOLZ IAD DE ANANAEL FAONTS AAF AFFA FAORGT DE GEH—-
ABROGOGOROBRAO; SOCHOU; MODORIO; PHALARCHAO; OOO; APE; THE BORNLESS ONE
SOLBETH C E OD EOLIS TOL GAH ABOARPI PAMBT; AR GAH DE OD CALZ OD DE A ILMO;
MIRC CAOSG OD OROCH A CAOSG; MIRC ORSCOR OD DE A ZLIDA; TOGLO DE GIGIPAH OD
TOGLO PRGEL, OD ANGELARD OD SOR DE IAD CHISO ABOARPI PAMBT.

WATER

SOLPETH C E!
ROUBRIAO; MARIODAM; BALBANABAOTH; ASSALONAI;; APHNIAO; I; THOLETH; ABRASAX;
AEOOU; ISCHURE, MICAOLI BORNLESS ONE!
SOLBETH C E OD EOLIS TOL GAH ABOARPI PAMBT; AR GAH DE OD CALZ OD DE A ILMO;

MIRC CAOSG OD OROCH A CAOSG; MIRC ORSCOR OD DE A ZLIDA; TOGLO DE GIGIPAH OD TOGLO PRGEL, OD ANGELARD OD SOR DE IAD CHISO ABOARPI PAMBT.

EARTH

E VIR YLSI—-

MA; BARRAIO; IOEL; KOTHA; ATHOREBALO; ABRAOTH;

SOLBETH C E OD EOLIS TOL GAH ABOARPI PAMBT; AR GAH DE OD CALZ OD DE A ILMO; MIRC CAOSG OD OROCH A CAOSG; MIRC ORSCOR OD DE A ZLIDA; TOGLO DE GIGIPAH OD TOGLO PRGEL, OD ANGELARD OD SOR DE IAD CHISO ABOARPI PAMBT.

SPIRIT

SOLPETH C E!

AOTH; ABAOTH; BASUM; ISAK; SABAOTH; IAO:

OI IADOIASMOMAR

OI TI ENAY DE A AOIVEAE OD TOGLO

OI IADPIL CASARMG A OZONGON HOXMARCH

OI IADPIL, CASARMG OLN BIAL BABLE DE SIBSI, ENAY DE TOGLO; GEIAD

SOLBETH C E!

IEOU; PUR; IOU; IAOT; IAEO; IOOU; ABRASAX; SABRIAM; OO; UU; EOU; ADONAI; EDE; EDU; ANGELOS TOU THEOU; ANALALA LAI; GAIA; APA; DIACHANNA; CHORUN!

ZIR IADPIL! A MICAOLZ GAH! VGEG DE LASDI, GOHED PRG

ZIR IADPIL! LAIAD!

ZIR IADPIL! SOBAM DO DODSEH BABLE DE VONPHO OD A CAOSG

ZIR IADPIL, CASARM BIA GNAY CONST

ZIR IADPIL, DE CASARM I ZLIDA DE IABES MIRC CAOSG

ZIR IADPIL, CASARM ADGT YOLCAM TOGLO MIRC OLPIRT

ZIR IADPIL, ETHARZI OD A CAOSG

SOLBETH C E OD EOLIS TOL GAH ABOARPI PAMBT; AR GAH DE OD CALZ OD DE A ILMO; MIRC CAOSG OD OROCH A CAOSG; MIRC ORSCOR OD DE A ZLIDA; TOGLO DE GIGIPAH OD TOGLO PRGEL, OD ANGELARD OD SOR DE IAD CHISO ABOARPI PAMBT.

IAO! SABAO!

luvkraft vs kutulu
Grant Morrison

The Great Old Ones from the Outer Dark, the Skeletons in the Cosmic Closet, the Forgotten, the Withheld, the Lloigor, the whole howling, flayed, obscene, transcendent Anti-Pantheon from Spaces Beyond and Between...

All real.

All time and space bent back and snapped credit card-style. Einstein's universe, fucked like your sister by ravening cosmivorous theorems and feral mathematics of the ninth dimension, falls to its knees in an instant...and the sun turns to coal and the seas to a swill of industrial pollutants, seething acids and boiling faeces given brief unendurable consciousness. The sky is skinned like a zebra hide while numerous 'monstrous new constellations' contort into view in what can no longer be called with a straight face 'the heavens'. Huge cathedral-engines of pistoning flesh twist into being from nowhere to trample the human race beneath crawling buttresses which rise and fall, thundering like supersonic guillotines, as they lawnmower through the cities and the countryside, the rainforests and the hollow mountains filled with nosy fuckers who failed to see this one coming. Everything is ground up and consumed in gale force rains of sulphuric acid. All life dispatched like the pathetic body in the bath in some bald cunt's basement.

R'lyeh, the drowned hyperopolis, unfolding itself from the fathoms of the sea and the subconscious, covers the planet like a blush, meticulously converting all matter, all energy, all spirit into fuel for the Supercontext and the Imagination Furnaces of the Great Old Ones. Perfect comicbook thought bubbles rise from the bristling swaying chimneyfields of the extermination multiplexes; exclamations, famous last words, life stories, question marks, in their billions, like balloons at a funeral, literate smoke ascending and sifting to nothing.

And the end comes all at once; with bangs and whimpers equally represented. Uncounted millennia impact into seconds, then compress to a single point containing everything.

The aeons-long dream of Great Cthulhu is over and we are no more than sleep-grit the Prime Minister of Horror picks from the lost bowers of his eye orchards. *Ia Kutulu! Kutulu Fihtan! Ia! Ia! Ia!*

Later that day:

Chapter One
VOMIT FROM THE PLEIADES

...The Witch House Bar and Everlasting Night Club is next door to the Pointless Place on Millionth

Street-and-Never, deep in the Ultraviolet Gas Quarter of R'lyeh, the city without boundaries. This, for as long as we wanted it, would be Friday, August 13th, 1999.

At night, which is always, the city thunders and flexes restlessly. We leave the house, swept up in travelling swathes of light and indecipherable image, entering the electron rapids of fast forward video. This Supersituationist derive, throughtown, from our room-and-million-kitchen apartment above the shoggoth middens in Tsathoggua Street, to the Witch House is, as always, one long scrolling display of infinite novelty-rich, self-regenerations. Unstable forms and crackling steel moving in time-lapse around us. The Taj Mahal...erupting through tar pools and concrete, the muslim dome spun like clay on a wheel and teased into cyrillic onionspires by invisible hands...the Kremlin... wiped and smeared upwards and upwards, evolving a protective carapace in the art deco style...The Chrysler Building...nods its head and sinks to its knees and elbows and is the Guggenheim ..metamophosing, hatching, opening endless doors into endless rooms where wideawake monsters come and go.

Vehicles strip to X-Ray blueprints, redesigning themselves perpetually – a hearse flowing into a black Trans Am that hatches like a bug into a dayglo Volkswagen and puts out spindle legs and runs up the wall, somersaulting backwards to helicopter wildly overhead in a clatter of unfolding propellers. Motheaten tents and stalls at the roundabouts have open suitcases filled with the full range of hallucinomorphic patches, plungers and coils. Mad Arabs offer books to soil the soul and sear the cornea of the mind's eye. The market's like a hairball of matted lanes, narrow stairs, gables and awnings and connected stone arches. Weird old perverts in dusty antique shops sell fish masks and ships-in-bottles. The Innsmouth smell from every mossy stone and dripping grate. Here capitalism is still practised as a perversion by connoisseurs of the bizarre.

The last thing we need are stimulants or blockers. Our bodies are self-governing autonomous narcotics factories already.

Oubliette is noisily experiencing fusion with the Cthulhic Net as she enters the third stage of the night's latest mutation the way a train enters a tunnel too small for the train. I have to turn away. Some things are best left to the imagination, where they can be savoured alone in the dark as aids to masturbation. My own physical transformation gifts me with sudden 360 degree insect vision however and I'm unable to ignore the sight of Oubliette becoming something that looks like a pterodactyl raping and gutting a young couple on their honeymoon. In wraparound multiple compound lens vision.

In the space that fills the gaps in our jostling schizomorphic skyline, the negative sun, blue and boiling with ten billion Hiroshimas per square inch – is fertilising a barely struggling infant B-type star. Ever since the original sun became host to parasitic Quasar pulses containing the unstoppable viral consciousness of Azathoth the Nuclear Chaos, these astronomical rape pageants have become more and more regular. Watching the filthy old neutron star tease younger suns into its gravitational field – some as young as 30 million years – is a sight to scar the cornea of the mind's eye.

"You think too much," Oubliette says and falls away into a full stop. I follow, both of us flickering like old film between flashcut streetscenes. The flame and the scream. Through a window a red room with one malignant letter of the anti-alphabet scrawled on the tiles. Dead kids.

Sick scrapbooks, dusty with atomic waste. Creaking gibbets. A crawling mold on the map of the moon. Serial killers etching novels by the light of purple candles in the locked bachelor pads that line the infected Sewers of the Qlippoth. Blood in the inkwell, the pen never runs dry.

Eerie orange lamp flickers candle down and become a blue flame with a little ghost's face grinning inside. I anchor there and stop dead in the rotten, wet heart of the Quarter. Oubliette's all around me at once, supertuning her biological spectrum to a rate of ten thousand phyla per second. For just a moment she is the living embodiment of the infinite diversity of life itself...and I want to fuck her all the way to the root of the atom.

Hot rain gusts suddenly, stripping human skin posters from the billboards, peeling our shadows off the cobbles and washing them downwind with the newspapers and leaves.

Some fucker is bellowing in Aklo, the guttural root language that was the cradle once of all swear words. We're outside a raucous, overlit Shoggoth stye where nervous blue men and women titter weirdly and line up to lose their virginity in several hundred ways simultaneously. A crowd, emerging from the WitchHouse, gather to watch, bubbling like stew on the boil.

The Ultraviolet Quarter holds them all in its orbit, holds us all, filings in a magnetic field.

Chapter Two
BEYOND THE COLOR FROM BEYOND

Brown Jenkin runs the Witch-House. The angles are all wrong but non-Euclidean geometry is the only way to pack in the millions-strong crowd. Jenkin – a sickening fermented thing combines in his DNA all the worst aspects of ferret, monkey and bearded baby and that's the way he likes it. Tonight he's gnawing holes behind the walls, creating freakish geometrical aberrations into which he'll pack more customers.

Squeezed into prisms, labyrinths, clusters of unlikely cubes and planes in the unending mathematical intricacy of the Witch House are the clientele; a scintillating cross-section not only of the Quarter's bohemian nightlife but also of a higher-dimensional omnifunctional entity which Brown Jenkin serves in his capacity as familiar. Everyone who is everyone is here tonight, in the most literal sense.

We thread through the cataracts and op-art folds in the toga of spacetime, looking for our contact, eager to light the fuse of the evening.

Pickman's Daughter is 'white with black shoulder-length reiterating guilt complexes'. It's the only description we have but it's enough....

Oubliette spots the painter's living abortion in seconds, tucked away like a needle in a haystack of chiaroscuric feedback in the red gloom of the salon. She's kissing witches gin from a corrupted Unholy Grail that suppurates through her fingers like the Tarot Seven of Cups – Debauch – and is then a nursing bottle, a pint mug, a Coca Cola green glass classic with tits, a gourd. And it's true; her impressive complexes flow and fern and frame her like black fractal embroidery. They're obviously not real but they suit her.

Older than lies, she keeps a portrait of herself in the attic and likes to fuck in front of it;

a monstrous study in oils of a corrupted toad-like creature on IV, cancering out on stained hospital linen. Painted by Dad.

The Multiple Personality software stored in the Selfplex Primal Void is frilling into action, generating countless possible selves from consciousness-vacuum fluctuations. Tripping on the ripple from the NLP generators, we surf through the Selfplex menu options; we need to access the maximum rapport function. With NLP cybernetic systems activated we can monitor, mirror and pace the behaviour everyone we encounter, allowing us to cut-and-paste seamlessly into any social situation.

So it is that Pickman's Daughter greets us like long-lost friends although we have never met and probably never will in any meaningful sense.

"I practise a kind of origami, as applied to the physical form," she says, in an attempt to make us think she thinks we're stupid. Oubliette is cool, sipping Jesus-vintage Chardonnay from a colostomy bag. I grow a flashing angler fish bulb from my chin and perform the words 'Fucking awesome, Pickman's Daughter.' as a four-word play, over and over again. The reactive dissonance amuses the old fraud as we knew it would. She stops and spins – an exploded barrel with eyes – then resolves down into something I can make sense of, talking all the time.

"My father was a twisted nerve of a man. He found some flaking pigment on the walls of the real world and picked it off with his nail. His masterpieces were simply attempts to capture what he saw behind the gloss and the emulsion. Behind the ghastly facade of THIS/NOT THIS."

"But he was undeniably a mediocre photo-objectivist painter... and a white racist." My statement seems irrelevant and impertinent but we're in such poised rapport with Pickman's Daughter that she simply laughs and goes on.

"Yes, he hated honkies." Her momentarily bleak smile reminds me of a machete-cut in a pig's haunch.

"Because he himself was one?" I ask, more out of boredom than anything else.

"He was simply the first human being to depict the squeezings accurately, as the Un-Ones began to crush their forms into 3-D. His work was considered nightmarish and nausea-inducing then but it was simply an attempt to render the impossible onto canvas. I don't consider that racist."

"It's very hard to look at the impossible," I agree. Logic in the Witch House is as impeccable as it is mazelike.

"We're both artists," Oubliette yawns and to prove it, she etches her name into the table with a phial of concentrated hydrochloric acid.

"What do you know about the Yithians ?" I say abruptly. "The so-called Great Race of time-travelling intelligences?"

For the first time, she seems unimpressed and I suspect some glitch in my Selfplex files. Rapport is flaking away. She refrigerates me with a look and then speaks carefully.

"Completely fictional, like all the rest of this. The names alone are enough to tell you. 'Yith', 'Yoth', 'Yuggoth'. It's like a child being sick in space." Pickman's daughter shows her teeth and takes a sip of psychedelic venom. "Why do you ask ?"

"Because you're the only person who knows the answer. If we were to ask anyone else,

we'd be wasting our time."

"Yithians! Oh for Dagon's fucking sake , the entire thing exists in Lovercraft's head, don't you understand ? This world we're in is entirely fictional, a dream reflected in the iridescent liquid crystal slime that illuminates and conceals Great Cthulhu's mind-popping nakedness, a story reversing itself off the page into the ink on Lovecraft's typewriter ribbon. The torn edge of a paper universe we can't even see."

Rapport is the wrong strategy obviously. She extends a tapering glassy probe into her bucket and sips a half-pint of nectar through a thick vein in her elegant snout.

"What does it matter ? We're only words imagining themselves to be the things they describe. Haven't you ever wondered what the consciousness is of words shepherded across a page ? How they experience their own existence. We are a swarm of letters playing at being people. Sentences in Lovecraft's head dot dot dot."

Oubliette deftly cuts the Gordian knot of this tedious gnostic sulk before it throttles all our enthusiasm.

"Okay, So where do we find Lovecraft's head, then ?.."

Pickman's Daughter makes a gothic arch with her eyebrow.

"Because when we find it, we're going to poke holes in his skull and look inside to see ourselves tiny, running in terror as the sky falls in."

"You're taking me literally..." Pickman's Daughter points out.

"Of course we are," I say pleasantly. "As clinical schizophrenics, we're symbol-blind. We lack the conceptual apparatus required for metaphorical thinking. Rolling stones simply gather no moss."

I can see she's weakening. It's impossible not to like us.

"So where would a head like Lovecraft's do its dreaming ?" Oubliette slithers.

All sound empties to a seven foot radius around Pickman's Daughter. She's folding herself into the child an octopus and lotus flower would conceive. Travelling tattoos, queasy magickal notation and malevolent runes ripple in bars and columns across her bellowing brow-sac.

"Where do you think ?," The words scan across her face like news on a Times Square billboard. She dismisses us with a perfect Voorish sign drawn in blue cigarette smoke and we're plunged backwards through the wall like it's layers of glue to hit the wet cobbles, exorcised black and blue.

"Where do you think ?" Oubliette says, perfectly synthesising the voice of Pickman's Daughter.

I know she knows what I'm going to say. It's what we were hoping.

"The Pyramid."

There's only one way to see the Millennium Pyramid and we'd learned it from a man who'd lived there for years before coming to his senses. Whately was his Pyramid name and the Dho-Hna Meditation he taught is simply a way to look at what's always there and recognise it for what it is.

We begin to hyperventilate, rapid-inhaling the city and the night. The plastic reality of

R'lyeh goes flat, silent and cold on the out breath then swells with life, colour and depth on the in. We continue the meditation synchronising our chopping frantic puffs. Then we reverse the whole sequence, accelerating until R'Lyeh polarises from figure back to ground and the Pyramid becomes obvious in all its impossible constriction.

Five and a quarter miles on each side, seven miles from base to apex with one thousand three hundred and twenty floors, the Millennium Pyramid was a deliberately cyclopean eyesore which never changed shape or purpose and was surrounded by a lethal hex circle extending a full mile beyond the perimeter wall. It was designed and maintained for one purpose only: to keep us out.

The Pyramid was the handiwork of the last few million proto-sapiens left alive and unchanged by the arrival of the Great New Ones. Its walls contained one thousand three hundred and twenty cities with laws and statutes, schools and factories and clocks and armies. The ignorant millions within this appalling stable solid had defiantly barricaded themselves with Euclidean geometry, denying our existence while fearfully cataloguing our manifestations with their telescopes and cameras.

"They're our Dho-Hna, the negative conceptual image of R'Lyeh," Oubliette says . She wants to fast forward to the fight stuff but there are last minute preparations for a Breaching of the Boundaries like this one. First of all, the Pyramid existed entirely in past tense.

"I hate going into past tense," I say miserably.

"I used to hate it," Oubliette corrects. She's cute like a boot and for just a moment I imagine her stamping on a human face forever.

On the star-slicked streets of R'Lyeh, it's still raining...afterbirth, ambrosia, pennies, dead fairies and we vow eternal love and betray one another twenty three times each, laughing, on our way to raid the tomb-head of H.P. Lovecraft.

Chapter Three
THE WHORE BENEATH THE FLOOR

Stairs descending like deformed spines into the toadstool city near the flaking edges of the THIs/NOTTHIs screen generator. Dim titan figures bled into the margins of perception. Hidden in the blind spot at the corner of our eyes we were aware of the cast shadows of the great anti-concepts, the spaces between of the ever present always invisible macroverse...crackle and scuzz, the fractal embroidery of galactic entrails.

The pyramid's defenses gave way...there was always someone inside trying to summon us for some insane personal reason...

Death was imminent.

There was a reprogrammed Shoggoth in the room with us, selected for its aggression. Ignoring for a moment, the poisoned flower head which opened and closed like a golf umbrella, showering mind-control spores on everything within a ten foot radius, we went for the mid-section – a mass of seething, pistoning carrots and rotting, clutching tubers. These sex organs

were on such open and flagrant display, that it should have come as no surprise to the shoggoth or its remotecontroling operator when Oubliette scythed in close, fingers strobing and superheating the air as she castrated the monster in a brief storm of chopped vegetable material and primitive protoplasm.. ...and as the mass of perfectly-evolved jigsaw biology spun on its radial axis to inseminate our auras, howling like a mandrake ripped out by the roots. I ran through billions of evolutionary strategies per second. Natural selection as a martial art – fasts forward, pause, rewind – we melted together, minds in stereo and were a thing like a church organ – wheezing stops and pulsing pipes halfway between a crab's mouth and the ..glass and rusty iron hoses, spraying an organic DDT across the shoggoth's vulnerable sensory lichens...

We decided to abandon all mercy as the creature went down. It's operator would still be experiencing vestigial Central Nervous System mapping and could feel everything the shoggoth felt. Four hundred pointed metal hooves went in like ..and kicked the fucker to chicken salad in seconds

We were breathing deeply, expressing a red fog and

"This had better be fucking worth it."

<div align="center">

Chapter Four

CTHULHU V. LOVECRAFT

</div>

Oubliette looked like Adam, I looked like Eve

We were in an enormous world of intricate, inexplicable machinery left here by the time-travelers.

Clumsily, using two five-fingered barely-articulate tentacle stubs we uncovered the submerged head of Howard Phillips Lovecraft, late of Providence, Rhode Island.

The head was motionless in a cylindrical tank filled with little aquarium ornaments – a ceramic castle, rocks crawling with Plutonian spores, dank rotting vegetation and tiny alarming fish. We bent closer and compressed to look through holes the paperthin skull. All that remained of the mouth pouted and puckered like an arsehole.

"Who's there ?"

The eyes opened like manhole covers, breaking a thin crusty seal of conjunctivitis and revealing mournful onionskin pupils.

"I didn't believe...the fountains on Yith. The way minds are gathered up and threshed. the sieves that destroy human feeling, leaving only cascades of horror and tainted dreams."

"How long have I been here?"

We had no way to respond, having no sense of the passage of time, or even of the concept of time as applied to a universe of constant change...

"Monstrous. Blasphemous. Squamose. Rugose..." the wartime radio mike at the base of the cylinder sparked and hummed as syntax makers clicked into ratchets rotating home...My brain was placed in a jar and transported...I saw visions of the future, then realised that my visions were not of the future at all..."

"They were simply memories of a state I had...I had become one of them..the Yithians...unifold extension into eight dimensions..."

This was playground stuff. Lovecraft's attempts to translate Aklo concepts into English seemed laughable. We said nothing yet but we could clearly see that the brain in the tank was rotted through with Green Germ. The Germ probably broke through into the Pyramid as microscopic spores, to enslave humanity from the cellular level up.

We saw the book only once – it disintegrated as it was read, like a dream. The pages fluoresced. Or perhaps there was only one page. It was that kind of book. Glowing tides of letters washed in superblue waves of text across the flashing primary colored

As we ogled the Ultranomicon, Lovecraft narrated his last most horrific story.

"ABBBCAGDBACGCGAAABBBCAGDBACGCGAAABBBCAGDBACGCGAAABBBCAGDBACGC-GAAABBBCAGDBACGCGAAABBBCAGDBACGCGAAABBBCAGDBACGCGAAABBBCAGDBACGC-GAAABBBCAGDBACGCGAAABBBCAGDBACGCGAAABBBCAGDBACGCGAAABBBCAGDBACGC-GAAABBBCAGDBACGCGAAABBBCAGDBACGCGAAABBBCAGDBACGCGAAABBBCAGDBACGCGAA"

Four hours later, the punchline was nowhere in sight and yet Lovecraft's head literally oscillated with spasms of cosmic horror in its eerie submarine pigstye as his voice synthesiser cranked out endless flatly-intoned looping strings of four of the most boring flatspeak letters. It was like Stephen Hawking struggling with the later stages of Alzheimer's, his titanic brain going the way of his fused, blown body, three funnels down into the cold Atlantic, gobbling like a retard.

"ABB.."

My attention was drifting like the devonian shelf; an inch every fifteen trillion years a continent. It was Hal 9000 having a breakdown in front of everyone at Stanley Kubrick's funeral. This was boredom extended into ... It was almost erotic.

"BACG"

We evolved mood shields so that we could listen to Lovecraft without caring what was happening in his weblike disintegrating cortex . As the recital reached its flat crescendo, the effort was causing his fragile brain to shudder like a beautiful flower that's been dropped into concentrated sulphuric acid. Delicate neural structures fell away like collapsing buttresses in a cathedral. Lovecraft's brain glowed, miasmic through the paper-thin head. Dissolving grey flakes sifted away as he coughed out the last few letters and fed the bonsai monster fish that shared Lovecraft's dank aquarium. Little human-faced screaming malarkies that darted through the lattice corridors of Lovecraft's fucked cranium. Whatever the tedious parade of flatscale letters were doing to Lovecraft did not translate. He seemed increasingly terrified, pushing his bland robot voice building to pitches of implied drama as the tin can hum and spellcheck anonymity of his voice struggled to convey claustrophobic vistas of celestial terror and disgust . With only four letters to choose from his efforts were failing miserably.

"The world's so terribly hideous.." moaned the decapitated pulp writer. "I can't feel anymore..."

"I thought you'd have been happy," said Oubliette. "You hated the cold, you hated other people.."

"Only at first," Lovecraft droned. "Now I just miss them. I miss everything except this

hideous view...No-one understands me..."

We decide to confirm his worst suspicions by mercy-bulleting him between the cavernous eyes. A sunken bindi appeared slowly and unravelled like a navel taking Lovecraft's hangdog expression with it. He seemed satisfied as his consciousness collapsed into unity with the millionfold expansion of the Yithian celestial Monad.

Wouldn't you?

Or at least that's what we assumed must have happened. When we looked up from frenching one another's clitoral arrays into symphonic orgasm, the great man was so much swirling intelligent snow, flakes sifting to powder in a twisting screw of water – the cylinder glowed briefly, turning the little castle into a haunted house, lit inside like a Halloween face in the debris and weed forests. The head like a nightlight to make children mad. Then the tiny Innsmouth Horrors moved in to snap up each and every turning flake and neuron.

"He's pure consciousness now – unencumbered by concept or line." I said without much conviction.

I looked at Oubliette.

"Did you get all that ?"

"What ?" she said, genuinely baffled by my question.

"His last message. What Lovecraft just said..."

Neither of us had thought to bring even the most basic recording device, such as a notebook, pen or reliable memory into the Pyramid. I'd staked all on the semi-autistic recall of a constantly-mutating reality abuser. To my relief, Oubliette was able to recite the entire dreary text by heart, having memorised the Hypernomicon with one dismissive glance. I made her prove it, although I had no way of knowing if the abstract strings of abaccc she was parroting were accurate. The procedure took another eighteen hours even on fast forward.

"Do that again," Oubliette said.

At speed we noticed something curious about the rhythms of the letters. A structure visible in the...

"DNA," I whispered. "The book is the code for Cthulhu's DNA. Someone in the pyramid intends to build a replica Cthulhu! Probaby to attack us!"

We intended to invoke Jodie the pig from the story of the Amityville Horror – Jodie, suckled by giant termite pigs in the eastern styes of Hell, could be summoned only by rites involving taboo-smashing family breakdown scenarios enacted in a creepy house. Oubliette and I adapted to become genetic twins. We were identical down to the zygote and immediately begin to have sex behind our parents' backs in the sinister home I grew for the occasion. It rose up like a skeleton then shrouded itself in bricks and mortar and clapboard, it haunted the vacant lot where it had disappeared into a dimension sphincter years earlier. The house was perfect for the type of illicit gender-bending incest that was going on under cover of the bleeding walls, distorted judgmental voices and regiments of buzzing demonic bluebottles. Our parents rapidly showed signs of madness surpassing even our own. It was here that the less adept could lose control and continue in a spiral of mental decay and bloody murder behind closed doors...we held the moment on pause and brought Jodie through all unsuspecting

Two red eyes at the window, checking out the mayhem. first time he'd seen Shoggoth porn, ten million images per second deep. The snout quivered.

We had him...

The Great Old Ones ate our souls without even thinking about what they were doing. Humanity is a form of BSE in them, eating their minds from the inside. They really wished they'd just stayed where they were, safe in Lovecraft's head or page–

black tide
aishling morgan

'Josepina is a wanton, Brother Florian, no more than a wanton.'

'Indeed, Brother Siward, yet we must persevere.'

'Just so, Brother Florian. Doubtless her obstinacy is sent to try us. Her sin?'

'In essence, gross moral turpitude. Do you wish the particulars?'

'Name them to her face. Who knows but she might feel shame and thus begin to repent?'

'As it is willed.'

Florian struck a gong, admitting a girl, slight, dark-haired, freckled, gently rounded at haunch and chest. Her expression, initially of trepidation, altered to sullen defiance, her snub nose turned deliberately up.

'You have erred, child,' Brother Siward addressed her.

Josepina remained immobile.

'Possibly when confronted with your sins you will show less impudence,' the Brother continued.

'To whit,' Brother Florian stated, 'a series of acts so base as to seem animal, yet distinguished by an intricate sensuality that discounts all possibility of your pleading blind lust. Self-abuse, on occasions too frequent to numerate. The sucking of members, three times at the least. The taking of seed in your mouth. Enjoining the shippen-men to spill their seed across your face, with offering to share the pallet of he would could perform this revolting act in the least time. Bedding with Grey Simon. The wilful surrender of your cunt without intent to procreate, much less within the sanctity of marriage. Urinating in the boiling-vat. Sodomy.'

Josepina made no response, save to shift her weight from one foot to the other.

'Revolting child,' Brother Siward added. 'Do you have no plea? Will you not say you were forced to these uncouth acts?'

Again Josepina stayed quite.

'Dishonesty, at least, cannot be numbered among your vices. Will you at the least show remorse?'

The girl shook her head, the tiniest of movements.

'So be it. Fifty strokes. Bare yourself.'

Without a word Josepina turned her back to the men. Bending, she flicked her long dress onto her back, revealing culottes of coarse linen, loose around the thighs, tight at the waist and across her buttocks. Her hand went to the drawstring with a motion indifferent, almost contemptuous, tugging the bow out to allow the garment to drop to the level of her ankles. Naked, her bottom formed two chubby hemispheres of girl-flesh, firm, yet heavy, each marked with a

scattering of freckles. Between them, her sex showed clearly, a soft mound richly covered with black hair, the pout of her lips and the knot of pink flesh between them conveying not shame and misery, but insolence.

Tugging the waistband of her dress high, she let her breasts swing loose, two plump handfuls of dangling meat marked with the same freckles that decorated her face and bottom. Each nipple was stiff, a dark bud that gave the same message as the single bead of white fluid that had formed at the mouth of her vagina. Resting her hands on her knees, she composed herself for punishment, serene and to all appearances indifferent both to her nudity and the coming pain.

'Incorrigible,' Brother Siward sighed as he rose to his feet.

'Take heart,' Brother Florian answered. 'I have a cut of blackthorn fresh from the vinegar barrel. Perhaps it will have some effect where lesser instruments have failed.'

Brother Siward nodded, his eyes never leaving the girl's exposed body. Brother Florian moved to one side, opening a chest to take up a length of black wood, thin and pliable, its surface reflecting dull gleams in the sunlight. Josepina watched from the corner of her eye, her expression betraying nothing of the responses of her body. Making a polite inclination of his head, Florian passed the whip to Siward.

'Beat her well, Brother,' he intoned. 'Who knows, she may yet be moved to repentance.'

Josepina's flesh tightened as the wicked instrument of punishment was raised, her bottom cheeks tensing to part and hint at the dark pucker of her anus. Her eyes closed as the whip lashed down. It hit, making the flesh of her bottom bounce and quiver and her lips peel back from her teeth, briefly. A line of white sprang up across the smooth globes of her bottom, quickly turning to a fresh pink bordered in red.

'Make comparison,' Brother Florian addressed her, 'as you are beaten. Your habit against that of your sisters, in particular Epiphany. At the quiet hours she prays; you perform lewd acts with menials. Commands she follows with placid obedience; you respond with poor grace, if at all. Her answer to the ribald calls of the churls is a shy blush and a turn of her head; you give back ripostes that bring colour to the cheeks of your tormentors.'

Three more cuts had landed across Josepina's naked rear as he spoke, and three times her bottom had bounced under the impacts, the flesh deforming briefly before returning to its natural, female shape. Each time her teeth had drawn briefly back, but not so much as a grunt had escaped her lips.

Brother Siward continued with the beating, aiming hard cuts to make the girl's buttocks jump and jiggle, one after another until her bottom was a mass of purple welts and double, scarlet tracks. All the while Brother Florian lectured, commenting on the Josepina's depravity and comparing her with the virtuous Epiphany. At last, red faced and puffing, Brother Siward threw down the blackthorn whip.

His colleague took the stick up, measured his aim across Josepina's quivering bottom and brought it down with all his force across both nates. Brother Siward, his breath recovered, began in turn to berate the girl, remarking on the vulgarity of her exposure.

'Do you not feel shame?' he demanded. 'Bent, with your cunt flaunted for all to see? Have you no modesty? Does revealing your breasts and buttocks mean nothing to you?'

Josepina said nothing, gritting her teeth in response to Brother Florian's now frantic belabouring of her buttocks and thighs.

'Wanton trull!' Siward continued. 'We have made you strip! We have thrashed you! The hole of your cunt is showing, the hole from which you evacuate also, all that you should hold most secret! You respond with not so much as a flush to your cheeks!'

Still Josepina declined to answer, her sole response to the savage punishment being the quickening of her breath and the gradual juicing and swelling of her sex. Her whole bottom was a mass of welts, nothing left uninjured save the depths of her cleft. Some small change in her poise had left her buttocks flared, pushing both vulva and anus into prominence, blatant and wet with her sweat and the fluid from her sex.

Teeth set, eyes staring in furious determination, Brother Florian continued to thrash her, well beyond the designated fifty strokes, until at last the blackthorn whip snapped across her rear. As the end flew clear to skip briefly across the stone flags of the floor and come to rest against the far wall, Josepina allowed the lightest of sighs to escape her lips. Florian stepped back and she held her pose, moving only to pull her back further in and make her sexual display yet more flagrant.

'She has the hide of an ox!' Florian declared, wiping sweat from his brow.

'So many beatings,' Siward answered. 'Yet most learn quickly that to howl and jump brings mercy.'

They paused, both men considering the beaten girl, Josepina looking back, her large dark eyes fully open, her expression unreadable.

'I confess to a degree of tumescence,' Brother Florian stated.

'I also,' Brother Siward answered.

'Blind lust must be answered, the Lord forgive us our frailty.'

'We are human, Brother, no more. To refuse to answer to our base needs would seem to be an act of hubris.'

'Just so.'

As one the men pulled up their robes, tucking the hems into their belts. Both revealed large bellies resting on spindly legs, pale skin, thick growths of pubic hair from the centres of which sprouted penes already close to erection. Brother Siward, the fatter of the two, stepped forward, took Josepina firmly by the hair and pressed his cock to her lips. Her mouth opened and she took him in, sucking the man who had just beaten her without hesitancy or resentment.

Brother Florian watched the girl suck, tugging at his cock as he moved behind her. Lifting his belly, he laid it on her well whipped buttocks, prodding at her vagina with his erection. It went in, finding the wet hole and slipping inside until his balls found the thick tangle of her pubic hair.

Together they used her, one in each end, mouth and cunt, never once meeting the other's eyes as they shared her body. Her reaction was different, and showed nothing of guilt. Siward's balls were soon in her hand, stroked and rubbed as she sucked on his erection. Her own breasts came next, cajoled as they swung to the motions of Florian's pushes, caught up, weighed, the nipples teased and gently pinched. At last, with both men beginning to grunt and puff, she put

her hand to her sex, rubbing at the swollen clitoris even as Florian's heavy belly slapped against her bruised buttocks.

Siward came, his face puce and his teeth gritted hard as he emptied his semen into Josepina's throat. With the cock held deep in her gullet she began to gag, the spasms of her throat milking his sperm even as her own orgasm started. She came with her face red and her cheeks blown out, her eyes shut tight and the muscles of her bottom locking over and over against Florian's gut. With that Brother Florian also came, jerking his erection free of Josepina's hole at the last instant to spray thick, cream-white fluid across her beaten, upturned buttocks.

Both men moved back quickly, dropping their robes and mumbling prayers. Josepina stood, stretched, reached back to wipe the come from her bottom. Running her fingers over the bruised surface of a nate, she scooped what she could into her palm, put her hand to her mouth and ate the semen. She swallowed and licked a last blob from her lip before her expression returned to its earlier serenity, showing not one trace of the sorrow, misery or contrition expected in a beaten girl.

'Slattern! Trull!' Brother Florian exclaimed. 'Are you not in the least repentant?'

'Are you a she-devil, a succubus, to remain so indifferent to your sins?' Brother Siward demanded. 'Have you no sense of rectitude, no compunction?'

Josepina said nothing but hauled up her culottes to cover her welted bottom and let her dress drop back into place.

'This will cease!' Brother Florian snapped. 'This sour disobedience, this vile behaviour! In future you will model your conduct not on Lilith, as you seem to do, but on Epiphany. Be meek! Be virtuous! Follow her example in every way!'

Briefly Josepina's mouth curved into the smallest of smiles.

As Josepina walked from the room in which she had been beaten, Epiphany sat in the chapel, her eyes closed, her hands folded in prayer. Sunlight struck through the high windows to her side, dust motes dancing in light that showed the first trace of dusk. An irregular diamond of rich blue, cast through the window, moved slowly on the pale locks of her hair as she knelt. For an hour she had barely moved, even her lips still as her mind dwelt on matters far removed from the mundane.

Only when the bells in the tower high above her began to chime did she move, rising and walking from the chapel, hands clasped in her lap, head bowed. As she moved across the busy court each person she passed was greeted with the same, barely audible blessing, as if her soul were too delicate to bear such brute contact. Never once did she raise her eyes. At the gate she mumbled a meek request to the doorman, who answered with a grunt.

Beyond the gate she followed the line of the high wall, moving with yet greater timidity, her hood pulled tight about her face. All about her was bustle, brothers answering the call of the bell, boys hurrying on errands or in simple mischief, the fishermen, moving down towards the quay and boosting of the octopus they would take on the high-tide that evening.

Many gave Epiphany admiring stares, watching the way her breasts and buttocks moved beneath the light material of her dress. A few made ribald remarks, commenting on the way the sun revealed the contours of her body, even offering money for sexual favours or demanding she

lift her dress. To all of this Epiphany responded with the shy aversion of her eyes, never angry, never hurried, blushing faintly and occasionally murmuring forgiveness for the more outrageous comments.

At the quay she stopped, looking out across the sea and then down into the still waters of the harbour. The smaller octopus had already started to come in, darting among the weeds in water tinged dark with their ink. A few children stood, knee deep in the rising water, tridents poised in a vain attempt to catch the creatures. Older fishermen ignored the water, indifferent to such small quarry, intent on the preparation of their nets and tridents for when the black tide was high and the giants came in from the sea.

All spared a glance for Epiphany, the old men in brief admiration before returning to their work, the young in speculation, each urging the others to make an approach. None tried, every one aware of her purity and unwilling to suffer certain rebuff.

Presently she turned and began to walk, south, along the shore, with the sun falling slowly towards the sea in the west. Only when she reached the headland did she look back, pushing her hood from her eyes to scan the beach and dunes, alert for any who might have followed. Content that she was alone, she moved on, faster, now, her eyes fixed to the grey-green bulk of the next headland.

She reached it as the sun touched the horizon, skipping quickly through the gentle waves as the water lapped at the base of the low cliff. Beyond, a bay opened, the cliffs rising above a shore strewn with great boulders of yellow stone and a beach of pale sand. Choosing a rock at the centre of the cove, she climbed to its smooth upper surface and composed herself, arms hugging her knees to her chest.

The tide rose fast, cutting her off as the last red glimmer of the sun faded into the sea. Water, black with octopus ink, washed close to the base of her rock, the brilliant moon throwing reflected silver from the waves. Epiphany remained still, listening to the murmur of the waves, her eyes fixed to the water, watching.

Shapes began to rise, black humps among the waves, as smooth as the water, yet moving with a power of their own. Eyes appeared, broad ovals reflecting dull silver in the moonlight, the size of coins, the size of apples, the size of saucers. Epiphany shivered, her teeth chattering despite the warmth of the night as she watched the great, black octopus pull themselves up into the shallows.

With the press of fat, gleaming bodies pushing against the base of her rock she stood, her trembling hands going to the clasp of her dress. A soft click and it fell away, the linen garment dropping around her feet. Her culottes followed, pushed quickly down, her boots last, to leave her standing, naked in the moonlight, her skin ghost-pale, her hair like silver.

Her mouth came open as she stepped down from the rock, her lower lip trembling hard. Cool water touched her foot, and the muscular firmness of a tentacle. A wave splashed onto her leg, breaking to wet her thighs and the soft, yellow down of her underbelly. The body of an octopus squeezed against her leg, soft yet resilient, pressing itself between her legs and on into the calm shallows among the boulders.

Epiphany stepped forward, feeling the water rise until it reached her knees, then

kneeling, submerging herself to the level of her chest to leave the waves lapping at her breasts. To all sides she could feel the bodies of the creatures, smooth, rubbery tentacles sliding against her skin, suckers using her flesh for grip as they pulled themselves inshore. One, its bulbous body the size of a marrow, nudged between her thighs, pressing to her sex and sliding beneath her, one tentacle tracing a slow line along the groove of her bottom as it passed. Epiphany let out a quiet whimper at the sensation, spreading her knees wider to the black tide.

Around her the octopus had begun to mate, the males reaching out distended sperm-arms to the females, caressing and sucking, seeking the apertures to the mantles and the egg clusters within. Many touched her, arms moving in exploration, unsure of her taste, unsure of her texture. Her vulva was open, swollen and wet, leaking her femininity to the sea. Again and again tentacles found her flesh, drawn in by the taste of her sex only to reject her as alien. Others used her body as an anchor, coiling their arms around her, sucking at the flesh.

With fat, resilient bodies pressing in on every side, she let herself sink lower into the water, submerging her breasts. More tentacles immediately found her, gripping both breasts, curling around her back, squeezing her waist and belly. She began to sigh, and to rock, her breath coming slow and deep as she moved her body back and forth in her cage of rubbery arms and swollen bodies.

A tentacle gripped between her legs, lying from pubic mound to anus, tiny suckers clamping to her sex lips and clitoris. She groaned, feeling the suction on the sensitive bud at the heart of her vulva. Another, larger cup closed on one nipple, drawing the bud out, stiff and sensitive. Beneath her two beasts began to squirm, their bodies writhing against the sensitive flesh of her bottom in their ecstasy of copulation.

A wave splashed her face, and as it cleared she found herself looking into two huge eyes, as large and pale as the cut halves of a melon. A moan escaped her lips as thick arms took her about the waist and curled beneath her bottom, brushing the smaller creatures aside. A sperm arm as thick as her wrist brushed her thigh and she knew the newcomer was a male.

Reaching down into the water with a new urgency, she caught hold of an octopus, her fingers busily checking the arms for the tell-tale groove that would reveal its sex. None existed, marking it as female, and she quickly pulled it between her thighs, her fingers sliding gently beneath the mantle, opening the cavity and pressing it to her sex.

As she rubbed the female octopus against herself the big male pulled her closer, his thick arms powerful beyond her strength. She released the female, sinking her slime covered fingers into her vagina as the full bulk of the male squeeze between her open thighs. With a deep groan Epiphany threw back her head, abandoning herself to the fate she had worked for, leaning back and pushing her sex out to the now eager male.

Eight arms took her, holding her, pulling her in. Two were behind her back, two around her waist. The fifth cupped her bottom, much as a human lover might have held her to mount her body on his. The sixth and seventh held her thighs, spreading them to the point of pain, opening her for exploration and fertilisation. The last, the elongated sperm arm, had already began its work, caressing her, stimulating her to the point when she became receptive.

Epiphany writhed in the arms of the octopus, sobbing and whimpering with reaction,

her whole body engulfed in an ecstasy far beyond anything else she knew, the horrid thrill of the black tide, with her body locked helpless as the slime covered sperm arm stroked her naked flesh. With her nipples aching beneath suckers, her vagina gaping as it leaked the taste of the female into the water, she could only lie back, moaning and sobbing, crying in her ecstasy, heedless of the waves breaking over her body.

A tentacle tip had found her anus, working inside to fill her rectum with cold, rubbery flesh. Helpless to stop it, she let the pleasure come, feeling her bowels bloat and fill with the arm reaching up, coiling and uncoiling deeper into her gut. Her arms went around the body of the big male, hugging it to her, her warm embrace against his cold, bulbous mass. His sperm arm was at her belly, moving lower, drawn in by her taste, rubbing between the lips of her sex, squirming against her clitoris…

She came, crying aloud as the pressure of the sperm arm squeezed down past her clitoris, pressing against it. He found her hole as her climax peaked, making her scream as her vagina filled with tentacle. With his sperm arm inside her he pulled her close, crushing her to him. The tentacle in her anus pushed deeper up, anchoring in her bowels and stretching her ring until she felt she would burst. More sperm arm squeezed into her vagina, filling her until her front hole felt as bloated as the back.

Lost on a plateau of exalted, obscene bliss, she let herself be taken, feeling her body fill with bulbous tentacle, squirming her breasts against his body, kissing and licking as his dome, crying in-between, calling herself names that would have had Josepina blushing in confusion.

The second orgasm came as the sperm started to flood her vagina. She could feel it, running sticky into her body, bloating out her cavity and spilling from the mouth to the rhythm of her contractions. Part of an arm was pressed to her clitoris, rough yet soft, and with a frantic wiggling of her hips she brought herself off, bumping her bud over the ridges and papillae of the beast's skin and coming with a long, drawn out scream.

With her cunt brimming with octopus sperm she began to buck wildly in his arms, everything forgotten but the pleasure of being mated. Her orgasm held, every muscle in her body locked tight, anus pulsing on the thick, intruding arm, mouth agape in one, long scream, arms tight around his resilient bulk. Still the sperm came, filling her and flooding out into the water around her, washing over her face with the waves so that she could taste it. Driven to an unbearable peak of lust, her senses began to slip, her mind riding on bliss so high, so sublime that nothing whatever mattered beyond her act…

Epiphany came to her senses as her open mouth filled with water. Gagging and choking, she quickly pulled her back up on her lover's tentacles, bringing her head clear of the water. He was spent, and pulling back, the tentacle in her anus working out in slow waves, the suckers moving across her back, buttocks and legs. Her vagina was still contracting and she felt the end of the sperm arm pull free. She leant forward, giving him a parting kiss between his great pale eyes before pulling herself back and standing, only to sink down once more to her haunches, exhausted.

Staring out across the moonlit sea with vacant eyes, she allowed the spent tip of his sperm arm to slide from her vagina. Her body ached, her anus smarting and pulsing, her vagina

dribbling octopus sperm into the water. She knew she would be covered in sucker marks, bruises and tiny cuts, yet all would be covered by her long dress and the demure hood she always wore.

Only when the sea had began to retreat did she rise. Washing the last of her lover's sperm from her body in a rock pool, she set her face to the village, walking the moonlit sand, her expression meek, timid, and above all, innocent.

skull of she-head

james havoc
om mitchell

Soft white nova sucks inside:: goatshead-grinder sounds the stroke of she-head stabbing time::
drug power:: the starry elevator unfurls, engages:: achondroplasic maggot-peelers racked in
vented cages over braziers broiling cyanide bones and stoked by black exterminators, killers of
the sable hex whose burning wheel of swastikas surmounts electric portals housing hammers of
the ultra-gash, enter six insecticidal psychopaths with pulsars of crustacean faeces firing,
dousing, arcing into hyper-space as one by one they suppurate and splash with mutant
ectoplasm lizard guts transfixed by filth, abomination overdrive in neural clusters charred by
white light kill-convectors, silver skullplate eye-reducers, teenage death-fist vivisectors, rage of
sonic fur on fire at funerals under ocean entrails, beauty labyrinth of razors chained to phantom
foetus trash in rock ophidian ante-chambers, sun-head of the suicides who wired to
pandemonium proclaim a liquid swordfight sigil, underbelly brimstone blitz of jackboot glitter cum
collapses, she-cat hentai hades hunt in war world storm the hangman's hovel, brains pulped on
the kuroneko cretin anvil, rose revolver, palace pact of wasps eclipses neon moonchild tears

negator, pinnacle of glimpses in the noise machine accelerator, queen of heat fucks lucifer, tectonic dust and lava boiling, scarring, howling in the void of violence left by octane angel spasm, heavy gasoline and powdered diamond metal insurrection, speed infection to the beast in pentagrams of poison blood that emanate from loops and ghosts whose viscous veil of torture tombs arachnid meat in mega-voltage, saturn spume in codices imprinted on the feral flex of neurons stitching snake receptors, pelvic reptile phosphorus in ancient atom interceptors, anus amber, fang inferno, switchblade bolt unleashes brides of havoc from the cobalt chasm, lightning coiled in talon membrane, mantis load

annihilator, photocidal juggernaut of blurred oblivion, eyes unspooling, planet claw refracting on a vampire vision vermin hook, cannibal decapitators seeded by a sodom ray that emanates from embryos impaled on spits of vulture horn, nemesis of spikes descending, fractal demonolators in messianic malformations, seismic mass accumulator shifting into fifth dimension, ice necropolis vomits holy vulva, locust fathom, crypt of butchers blossoming, lung of cicatrix in flames, organism oscillating over molten malediction, crucifixion counter-crush in würm of motors, scorpionic, sobbing sores that synthesize oneiric plague, clitoral psychosis in the ruins of a mastercharge, panther

muscle retroflux, satanic swamp of lizard lesions gibbering under hurricane: meteor:: butterfly:: sword:: seven rapes that killed the king, feedback sluts in vex of venus, masque of sewers, ditch destroyers cramped in chaos, retinal relapse of spurs that spark in larval absolution, screwing keloid detonators into shadow-whip of dice, strobic shotgun sperm contusion, clash of sixes, flowers flayed, reverb of cryonic cohorts carving into screaming target, cockroach bible incubus with adamantine afterburners, genocidal groove transmission, telepathic vertigo of vixen fireball she-division, cosmic lips of coelacanth, the hornet heart that suppurates a solar zone, carnal

horizon, atavistic anti-protons suturing to sulphur craw, revulsing into vortex as the spectral helix incandesces, astral fugue assimilator rising into crystal crescent, tattoo tempest, total eyeball, temple of chthonic crime vainglorious in occult mirror, coruscating zodiac of vengeance torches evil towers, sado-grid of synapses, excremental ossifiers radiating viral tongue from nucleus of shattered slit, enigmatic amputators revenant in snowblind plumes, decay of cinders, bullet-proof, love missiles of the limbless launched from hundred-storey oven-block, chromium cross-bones raised on ramparts, alien scintilla branding brotherhood with über-carnage, mesh of eagles,

depredators shimmering in labyrinth of cryptic curses, coprophagic lice strip bare the crowning of the kraken thrust, twist of quasars, vesuvial propulsion shriek of can to can concatenators, neo-nebula disgorges intravenous ventilator, barbed-wire offal dome erupts, inaugurating blasphemies, leviathan, prehistoric parasite incinerator pulverising, war across the tombstone wreckage, stüka syndrome epidemic, hunting prey in sickle-shaped continuum, complex of shards reversing into vacuum, husk of centipede cell, amino-skeletal cascade reflex, napalm night-krieg of diz-buster attack battalion, serpentine with synchro-slashers, holocaustal atavism

haunting crematorium, permafrost of ashes gloating, gouging glyphs from monolith, cyclopean with psycho-fasces super-ciphered, surgical, spitting slaughter into fetish, venom ducts dissolving dais, idolators in ferric flash, terror trip triggered:: poised in pincers:: pussy-prowler calls cthulhu, fecalithic black flag flailer cleft in psychotropic mushroom cytoplasm, spinning ill, espies a tangerine equator, shark-god pineal penetrator, maiming with magnetic fury as the ringless future reels on rocks of basalt archetype, arterial, velvet catafalque that weeps dilating, cortex laved in ambergris and cold creation crawling, flaunting compass credo, luminescent keratin that lures,

kirlian, succubus of dagon drives the devil-ship to nighted nexus, protean assassins of an arctic codex, cinched in glaciers, invertebrate in anti-bibles, born of bitches, crosses crack venereal map at borealis, glut of hawsers, treasure gaping, womb of crabs that craves the lash, lodestone tilts in sunken lairs, resonance of fractured phallic runes that ripples into equinox of dogstar, orgiastic, drooling sect of scavengers holds cave communion:: avalanche:: pendulum:: snare:: asylum of erotic engines, mournful, moving into mass extinction, generating gravity that feeds combustion, virus sloughed from spinal cord at sunset churns priapic waters, whirlpool whipped by blaze of

tendrils, ultra-sonic, syphilitic, icon palled in crimson prism augurs hanging, disembowelment, deep-sea hunger agitating aeons-old unholy hybrids, nocturne torn from tainted nursery, galaxies implode by synapse, golden sado-galleon listing, lurching into marine matrix, sub-aquatic memory of fungal spires whose hierophants in hooded thrall chant glamours through vermilion vectors, echoing in coral keeps where corpses creep in cataclysms, covens of cephalopods that feast on phosphorescent semen fletched in gizzard of albino raven, beast of bullwhips craving cankers, saturnine, primordial, razor rim of night retracted:: riptide reddened:: node of negatives convulsing..

Mystery Man Has Japanese Island Abuzz (AP)

TOKYO – Hidekazu Kakoi was looking for a fishing spot about six miles off shore when he noticed something bobbing on the horizon. He pulled his boat closer and discovered a man, grasping a duffel bag. That was just the start of the mystery. Now recovering on the tiny island of Tanegashima, off Japan's southern coast, the mystery man has refused to speak to authorities since his rescue Sept. 2. The duffel bag floated away, and local officials say all they have to go on is the fact that he's Asian, wore a tank-top with a Korean label, and fell, jumped or was pushed into the water with his shoes on. "He's still not talking and we have no idea where he came from," Shoji Nakamura, an official on the island, said Wednesday. "We've never seen anything like this before."

The mystery has the island buzzing, and is starting to get national attention. Is the man a North Korean spy? A Chinese drug-runner? A hapless Japanese landlubber? "There's all kinds of rumors going around," Kakoi said by telephone from his island home. "Of course, he wasn't in much condition to tell me anything when I pulled him in."

Amid the otherwise frustrating lack of clues, one fact is raising eyebrows – the Korean label on the man's shirt. Tanegashima is home to Japan's main space center. Virtually all of Japan's rockets are launched from pads on the island. Two years ago, Japan put up its first spy satellites from Tanegashima, the first of several intended to monitor missile

North Korea. North Korean spies are known to have infiltrated Japanese waters, and in the late 1970s and 80s even kidnapped at least a dozen Japanese citizens and whisked them off to North Korea to teach their agents the Japanese language and culture. Several abductees were finally returned to Japan two years ago, and their stories have become a well known cautionary tale here to avoid beaches at night. So could the man rescued last week be a spy? Police say that is a possibility. They also believe he might have been running drugs or was involved in some other sort of smuggling. No Japanese fishermen or divers have been reported missing in the area. The man has a reason he doesn't want to talk, one official said, speaking on condition of anonymity. Authorities he said, can wait. Police say the man appears to be in his 20s or 30s and is of average build. Police have tried to talk to him in Japanese, Chinese, Korean and English, but to no avail. They do not believe he is deaf or unable to speak or write. Fisherman Kakoi said the man never called out for help when he was in the water.

"For a while we just looked at each other. I was scared," he said. "But then I pulled him in. His hands were purple. I didn't ask if he was a criminal – I just wanted to get him to a doctor. But now I wish I would have gone back for the bag," Kakoi said. "That might have answered all our questions."

the splattersplooch
David Britton & Mike Butterworth

Gather ye rosebuds while ye May,
Old Time is still a-flying:
And this same flower that smells to-day
Tomorrow will be dying.
Herrick, 'To the Virgins, to Make Much of Time'

If, like the sirens, roses lured otherwise sensible men to their ruin, then the Brandywine Bridge spanning the flowing Thames, separating the Gumstool Charnel House in Nettlebed, Oxfordshire, from the Holocaustically successful Crematorium Goose – a converted classic 17th Century brick-and-flint furnace – and lying succulent in the river valley, drew oddballs to its consistent warm presence like bears to honey.

Even in the depth of the severest winter the bridge glowed with sombre red warmth. Roses, and the intricate feathery red-and-white Semper Augustus tulip, bloomed all year on trellises nailed into its heated brick. But for all the happy waft-and-welt of rose trellises and steady hum of the guzzy-buzzy honeybees, a deep sense of unease stalked the region.

Black as treacle, the reed-lined waters flow slowly here, incongruous shoots of red blood winding snugly in their centre. How far the Thames had travelled to reach this seminal point, who could say? Lord Horror told Squab he had once sailed it the length of Kenya, as it mixed with the Tana and Uaso Nyiro rivers, through Uganda to the Mountains of the Moon and into the Congo. She supposed this was an accomplishment of sorts. Compared to zoning-out in front of a TV it was, but not in relation to reading a book.

There is a humour – a light, conspiring mockery that punctuates the melancholy drama – freshly imported in the shape of our young heroine, La Squab, the prettiest coquette in the bizness in her black lace Chloé scarf, Jackie O silk blouse and full-length Gucci mink coat to keep the early morning chill at bay.

With her Jimmy Choo kitten heels on firm sod, she viewed the hot bricks and arched a manicured eyebrow. An uncommonly strange voice broke her thoughts.

"Thinking of going over the bridge, Little Sparrow?"

Taking off her scarf and stuffing it in her pocket, she looked at the voice's owner. There was no doubt that it was a hundred per cent human, but the only other person she had ever heard talking in so affected a mechanical tone was Stephen Hawkins.

A dissolute, youngish man, clearly a piss-head but with an intelligent burning look in his eyes, was surveying her from the driving seat of a ramshackle Oochee-Papa-Poontang fornication

wagon.

"Might be," she returned.

As it happened she did intend crossing the bridge. She had decided, on a whim, to visit her friends Fudge and Speck in Pixie Village. But she had not travelled this way before: coming from the west was a new experience, and perhaps an adventure too.

The man opened the wagon door so she could have a clear sight of him. He was small, of slender build. A straggly shock of dark hair tumbled to his shoulders. What looked like a blunderbuss was nonchalantly slung across his back. He was dressed in gypsy finery, all red, silver and black. A pair of black Donna Karan trousers with royal red side-stripes rested elegantly on silver leather Sigerson Morrison zipped ankle boots. On his fingers he wore large gold rings set with jade.

"Then a word of advice from one who's been there," the voice crackled, as if pulled and fed through a faulty microphone of poor quality. If rust could talk, this was what it would sound like, she thought. But though it grated on her she sensed an underpinning comic nature. She would not have been surprised to hear it utter the Dalek's cry: 'Ex-ter-min-ate'.

"Upon my mirth," she stifled a laugh and shook her mop of blonde curls.

"If you want safe passage over those unholy bricks, go on all fours."

"As if." She was affronted. "Never in my life have I made an entrance without dignity. Even when my blade dipped inconsolably in the Hereafter to give a taste of fact to a molecule, I pirouetted with grace and refinement. What would Uncle Horace say if word ever reached him that I had walked over a bridge like a dog...? Never!"

"Not like a dog, like a crab. A crustacean once went across the bridge, and when the creature that guards it, the Splattersplooch, reached out a tentacle, the crab raised a pincer and gave it a nasty nip. Since then the Splattersplooch has avoided anything travelling sideways on all fours. But suit yourself."

A beast-grunt passion chorus issuing from the wagon's confines accompanied his words. He kicked the panel behind him with the heel of his shoe, and shouted in French what seemed like a long blasphemy of the Girty Puddings.

Squab noted he had the look, with his beflowered face, of a strange kind of clown. His eccentric way of speaking, without inflexion or nuance, with an equal accentuation on all the syllables, even on the mutes, was relentless.

"Well, don't say I didn't put my two-pennyworth in," he said to her in English.

She scrutinised the cabin. Empty bottles were scattered on the floor – 'Ether', she read on one of them. Stuffed owls dangled from bits of string about his head.

"You're just humbuggin' me," she said dismissively, walking a few feet into the neighbourhood of a flowering apple tree that was fairly vibrating with bumblebees. "I don't believe there's a Splatter beast under that bridge."

She now recognised the little Frenchman, but didn't let on, pretending to study the bridge.

Beneath its cascading roses ran a supply of electricity in steel conduits half-sunk in the masonry. Not, she thought, that this accounted for the almost obscene heat pouring from every

brick in the Brandywine Bridge. Of a creature, there was no sign.

"You'll soon see your error." The pataphysician tapped his nose. "Hold on now, what's this coming our sweet way?" He leant eagerly across the passenger seat, pressing his forehead to the side window.

Up a dark mulchy path through the trees, footing it like a mad thing, a one-eyed, one-legged human curiosity was coming as confidently as any biped.

Striking the side of his head with his right hand, an action that caused his single eye to roll backwards, the one-leg swept past them, churning the black earth under his foot as he went. He mounted the bridge in a single bound, and reached its centre a split second later. Obviously he had arrived at his destination, for he now simply stood there, determinedly swaying: a golden thing. White, wind-tattered clouds raced overhead.

"Doesn't look like he could knock the skin off a rice pudding," was Squab's considered opinion. "He's a rum turd, and no mistake."

On the monopede's molten bronze skin a caterpillar patina of honey-coloured body hair was moving with the manic valse tzigane of the committed suicide jockey. Hair, like green lace, swished from his head. There was no face that Squab could see, just a wide, empty circular mouth fitfully opening and closing as he panted from the exertion of his journey. Slowly he spread out his arms and issued a brief hoot, almost a pleading bray.

At his arrival, the bridge glowed redder, cinders of ash and spurts of hot gas erupting from its brickwork. Was the monopede importuning to be scalded to death by steam?

The solitary, fuzzy wasp-eye in the middle of his head glowed orange. Moving his arms gently, in a suddenly mournful tone he sang out:

> "Whose heart is made of brine and stone,
> Who makes its nest from sailors' bone,
> Whose feared by men and fish alike,
> Who feasts on farmer, priest and pike...?"

The occupant of the Poontang wagon soon rejoined with his own evocation: "'So, 'Below the thunders of the upper deep...'", he shot a warning glance at Squab, "'Far beneath in the abysmal sea, his ancient, dreamless, uninvaded sleep. The Kraken sleepeth: faintest sunlights flee about his shadowy sides: above him swell huge sponges of millennial growth and height; and far away into the sickly light, from many a wondrous grot and secret cell unnumbered and enormous polypi winnow with giant fins the slumbering green...'" He spun his head again at his small acquaintance (who he hoped was listening agog) and finished coldly, "'...There has he lain for ages and will lie battering upon huge sea worms in his sleep, until the latter fire shall heat the deep; then once by men and angels to be seen, in roaring he shall rise and on the surface die...'" "And so," he commented casually, leaning tawny arms on the steering wheel of his vehicle, "the natural world is only surprising for what's left out – it's a skin-deep world – but for that very reason it's not a mysterious place."

With typical disingenuousness the eyes of the Frenchman were now fixed not on the fairy

victim but on the rippling waters.

He expelled warm breath, and sat up straight. He was growing hot, and removed his waistcoat, leaving the sleeve of his shirt flapping loose. "For in the real world you have to rely on imagination to swing your partner strong around the Poison Tree."

The noise of foaming water rose from the point in the river where he had been looking. The birds had stopped singing, and except for the one-eye's mournful voice an unwholesome peace fell on the land.

"Whose ears are deaf to mermaids' sighs,
Who only smiles at children's cries,
Who picks its teeth on coral shells,
Who sleeps content in sunken bells...?"

A large head slowly emerged from the foamy wash.

At first, Squab thought it looked like a massive, wrinkled brain – it might be rubbery – with two predatory eyes peering cold at the unfortunate thing on the bridge. A perverse DNA ancestry seemed to be written in those malevolent orbs – squid, octopus, crab, shark, or some unknown ossivorous denizen of the ocean's oily depths.

Noticing the big beast rising, the monopede chanced a final narquois couplet in its direction:

"Where sea begins and nightmare ends,
Beware the Splattersplooch, my friends."

He commenced jumping up and down on the spot, arms pressed tight to his side, straining to project himself into the sky.

"Here it comes," said Monsieur Jarry to La Squab, teasing a Strand between his lips. "Pay attention now, look and learn why the wary call it Bad Man's Bridge." He struck a vesta on the metal dashboard.

The striking match brought a small, lanky form – a type of ape, Squab was sure – rising from the floor of the passenger seat where it had been sleeping. It was Bosse-de-Nage,* Jarry's companion – a dog-faced baboon. Giving a single snort: "Ha-ha," it jumped leerily onto the vacant seat.

The Splattersplooch was now clearly visible, a mutated cephalopod sporting clusters of suckered tentacles that wriggled about its head like worms caught in a threshing machine. It heaved a single massive tentacle into the air and waved it ominously. Squab saw a long trunk-like snout unfold, revealing a mouth with two solid rows of black laniary projections. At the same moment her ears were assailed by the most terrible antisonant piping scream:

"Who did me wrong today or yesterday?"

Did she imagine she could discern its real voice amidst the maelstrom?

It had an echo in the black night of Lord Horror's rambunctious soul. The bumble of his stride.

*Bottom-face.

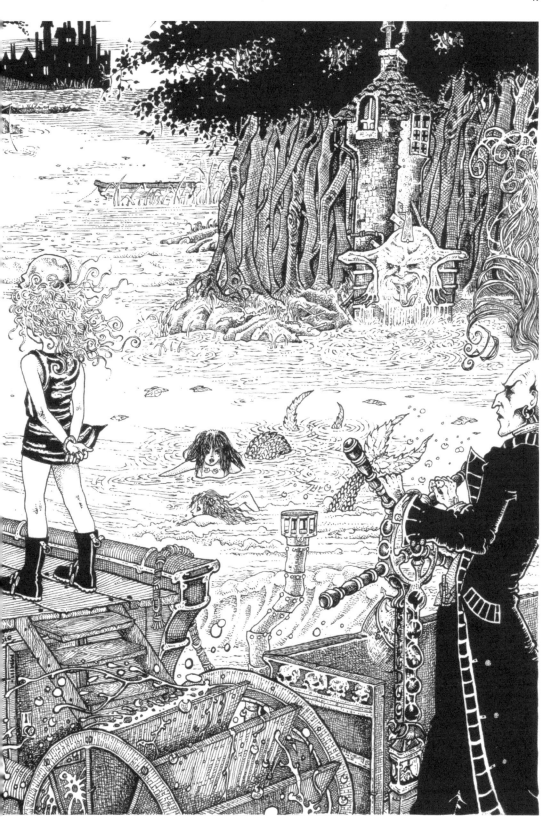

The clichéd angst of his obsessions – that pedigree affliction that marked him out as a man separate – seeped from his presence. Here and there he came walking from Festung Breslau, goose legs buckling, vials of horse blood for human transplants in his deep pockets, abroad in Fairyland, that country of sly crosset tablum and rocking stones, cears and tumuli.

A dead man cannot carry another.

We are born to perish. At the end, there is nothing.

*Endlosösung.**

"Spiel that special sorcerous spell," encouraged Jarry of the creature.

Then came a rolling 'BOOM'...the great Splattersplooch giving out with sumptuous sonorous waterfalls of sound.

"Christ, what's that..." the little Ubu cocked his ear in jest, "...could we have just heard reflections of the prelapsarian English soul?"

Slithering its immense tentacle across the sky the river denizen cooed for just a moment, then it brought it towards the pencil-thin figure still cavorting on the bridge.

"With a good pair of opera glasses on a clear day," said Squab, nonchalantly, "you could see Hackney Marshes...if it wasn't for the houses in between." She was now leaning on a run of redbrick bridge wall.

The tentacle folded gently around the jumping man's body, enveloping him in a long, wide cape. Along its fleshy jag rudimentary fissures cracked open and sprayed a secret stink, a lethal cocktail of poisons and powerful enzymes, over the hapless figure. The liquid commenced its work destroying the flesh. Appetisingly, the tentacle withdrew. Soon, the one-leg's arm started to melt.

"Phew," Squab chuckled apologetically to herself, "wouldn't you know it, the best place to find a helping hand is at the end of your arm."

The tentacle crushed down on the monopede again, lifting away a whole bunch of its flesh and swept the mush into its mouth. The Splattersplooch sucked up the one-eyed's runny bone and flesh as if it were Granny's soup.

Squab squinted amusedly at Jarry. "I would also like to speak as find," she nodded towards the happening. "True friends are like diamonds, precious and rare. False ones are like autumn leaves, found everywhere."

After a decent line of coke, she was fond of such everyday homilies.

The shrimp Jarry placed a relaxed arm around Bosse-de-Nage (who commented: "Ha-ha."), while maintaining a keen eye on the oceanid.

A change was coming over it. Orifices were appearing on the top of its trunk, and a kind of auto-caesarean wound spread across the round of its snout. From trunk and snout clusters of mulky capsules appeared.

Connecting with the air the eggs opened, and octopus-like young wriggled feverishly about the creature's head. Sinking greedy infant teeth into its fleshy bits, they began eating.

"I've seen this before," Jarry said casually. "After it has not eaten for some weeks, when it feeds, the Splattersplooch ovulates and births offspring. Its options are many. Rather than starve to death our alien can also decide what parts of its body are not necessary to survival, so the young

*Final Solution.

can feast on the tenderest bits and ensure the lineage – or it simply eats itself to exist, until new food becomes available."

"Hah, yes Monsieur," hummed Squab, delicately eyeing the surrounding food-for-caterpillars – stinging nettles, holly, ivy, buckthorn, cuckooflower and other such non-mellifluous things. "Love many, trust few, and always paddle your own canoe. That's the way it should be."

"Nothing wrong with the right grub, makes bones grow straight," Jarry advised decisively. He leant back, his bandolier of Heckler and Koch automatics and grenades catching the sparkling sun, and further speculated, "At optimum times of the year, the Splattersplooch's reproductive organs are redundant and are pre-absorbed back into its body, which can shrink to a size that just about sustains itself." He stretched his neck to get a clearer view. "Though today it looks in need of something more substantial than an apéritif."

Reduced by the furious attack of its young, but still large by any normal standards (and dwarfed by the giant Sequoias and the King and Queen oak trees), the Splattersplooch stretched up a whole fluther of sticky orm-like limbs in the air and commenced a lazy rumba-waltz.

"Now that reminds me of Uncle Horace dancing The Moby Dick," said Squab excitedly. Her shoulders rose up in giddy, girlish anticipation. "He was so deviant, so Frank Randle. Money still can't buy funny."

"Hell girl, you'd be even more amused if you could have seen Lord Horror crawling over a mound of corpses in his prime." Jarry took his arm off the ape's shoulder. Reaching beneath his seat, he rummaged about. "Eel-slithering peacock-proud from the gnarled old womb of the Big Belly Oak, flashing teeth fit to die for, touched by negrillo magick, wielding his hooked nose as a dagger, dispatching everywhichway miscreants of the Left-Hand-Path. Of course, who departed depended on which moral Geiger counter he was using that day; left, right or liberal, man, woman or beast. He was Ahab's inner turmoil made corporeal."

"Yeah," said Squab dryly, "I've seen him walking the crook down Bad Blood Alley."

"I know you have," the Frenchman chuckled. "But it's always worth reporting facts on Horror first-hand."

Boss-de-Nage slapped its spongy arse on the seat. It would soon be turning somersaults. "Horror's still not backward in coming forward," Squab said quietly, a certain wistfulness in her voice. She sighed. "I've seen armies of 'grovet-teams'* bend the knee to him…"

"…and halitotic circus dwarves stand at salute," Jarry finished. "Be that as it may, he could be sharp on his heels when it suited. On a good day, he'd step from the metaphorical womb, where no marauding felon could dig him out, secure as a tick on a cow's back, and vanish with a Trickery spell in seconds."

"I love the way I listen to you," she told him.

"It must be my Gallic charm," he answered modestly.

The bridge was now visibly palpitating and glowing with an eerie vital blow of radiance. Human voices were rising from its interior. She did a double take. Could she hear the creepy wails of lickspittles and *Untermenschen?***

The sounds prompted a series of view halloos from the ripsaw throat, bell-true and powerful, of its Thames companion, the Splattersplooch. The twin obscenities blended in voice

*Strong-arm groups.

**Sub-humans

like the chaos and trickery of Mischief Night, when drunken miscreants boil dogs and stuff crematorium chimneys with cabbages, and the legendary Unnamed gaze blindly with eyes like polished windows – birthed in the heat from the hammer strokes of Creation – into the heart of man.

"Yep. Casting a spell …" Squab gave a tip-top triumphant little pout. "There's more of that enjoyable 'Medicated Magic' that Horror promised would never cease to thrill my bones. As always, Death's emissary was not wrong."

Her small lips quivered with satisfaction. "Isn't that river beast in cracking form…" She held her girlish arms excitedly around her chest. "Doesn't it raise your juice and kindly boil your hambone?"

Flubberating stuffs still leaked from the threatening form of the Splattersplooch. It swivelled evil eyes towards them, and fell silent.

"Sure," Jarry forced a pantomime grin, still searching beneath his seat. "Hobbes, in Leviathan, gave Sovereign Power the form of a giant sea-creature to emphasise its inalienability." He gathered up a rubber snout-restrainer. Fiddling with its mechanism for a few moments he quickly strapped it about Bosse-de-Nage's head. The baboon yelped once. Jarry looked determined. "I've come to believe this present manifestation of the Splattersplooch is a deliberate ploy intended to hide its real origins. From the stories I've heard, it used to clearly resemble one of Francis Bacon's biomorphs – a single-necked random amorphous mass of body with pig-like dugs…" Bosse-de-Nage's hands briefly landed on Jarry's head, but the Frenchman was faster, and punched his companion to the wagon floor. He put a single Sigerson Morrison boot on its head. "Now," he continued, "in a gastronomo-ethical universe God would be forever reproaching and chiding the Splattersplooch in its watery haunts, where it fishes for the flirty mermaids with the Maker's everlasting cold hand on its flesh."

"T'ch!" snorted Squab, amusedly eyeing the bridge. "There's one thing for sure, that unfortunate one-leg won't be sent home with a boner and a heart monitor."

Of the monopede, only a single wet running shoe remained, still stuck to the Brandywine Bridge. It fizzed softly.

"Och, piece o'shite," Squab disdainfully wiped off a chappati-like lump of the one-leg's flesh that had landed on her shoulder. "Yes, yes, old fashioned dancin' has remained popular at ceilidhs north of the border, and I can now see what the natives do around here for entertainment." She gave a theatrical hurrup with her rump. "Christmas was a hoot," she quipped. "Reminds me of cunthooks." She jerked her head towards the monopede's remains. "'Leaving the left foot free' is an established part of their celebrations, along with the Yuletide furniture and mince pies and a rousing chorus of 'Silent Night'."

The noise of crashing undergrowth interrupted her. A naked woman's headless corpse broke cover from the woods. The body came in a wriggling crawl, jiggling over the ground, before proudly rising up on dainty feet, waving white, sensuous arms, and hoochy-cooing. Squab recognised a display of tarantism, the 'dancing mania', in its movement of limbs. The corpse blew airily like the wind, then collapsed, and lay quite dead.

"Go for it, girl," Squab encouraged.

Sometimes Squab has a child-like voice, which retains the questioning inflection of a pre-school weeny. At first you are too gripped by her worldly, enveloping gaze to notice it. Because her eyes suggest they've seen it all, the innocence of her voice temporarily passes you by.

Perhaps some of her many rôle models are the Russian nihilists of the 1860s, men such as Chernishebsky and Zaichnevsky.

"Stump down hard on that mess," she shouted.

I could scarcely persuade myself that murder had been actually done to the one-leg, and a human life cruelly cut short just a moment before my vision.

Why, the relic of his shoe was still smoking, evidence of his once corporeal presence; now absent.

If I left the scene at this point, would not my absence itself be an evidence to everyone of my alarm, and therefore of my fatal knowledge?

When I viewed closer, the Splattersplooch loomed before Squab like a blot of something blacker than Negro and brisker than Marmite.

But presently I was my own master again, and looked to Squab different from life's comeliness.

A resolve came over her.

She removed her mink coat and threw it carelessly on the ground. Presently, on all fours, she moved her legs and arms in a fast scuttle, chiming: "If Horror hears of this indignity, I'm sunk." With percolating limbs she approached the incline of the bridge, and proceeded up its length. This close, she could taste roasting meat – a curious almond-and-garlic flavour – rolling from somewhere beneath its structure, yet could not put a name to the beast from which it cooked.

"There you go!" She halted, dead in the centre of the bridge. Still on hands and knees she looked behind her. "Walk a mile in my Jimmy Choo's," she addressed Jarry, "and tell me you can't smell blood!"

"Not I," called back the pataphysician. "My father called me Alfred, not Harold the Ever-Ready or Usher the Bloodletter."

From the back of the Oochee-Papa-Poontang wagon the primate fornicating chatter of Bos-de-Nage's relatives blasted out like trumpets at the gates of Brazen Dis.*

Inside the cabin Jarry tried to dampen the ardour, but too late. Aroused, the baboon, with an unexpected (swelling) female flourish, swung its lower body left and right, its rear end, a peacock fantail of red flesh, now so large and grotesque that sitting down was not an option.

"Ha-ha," whispered Bottom-face succinctly through its restrainer: and it did not lose itself in further considerations.

Squab chuckled. Even if its arse was dipped in diamonds, she decided, its utterances were worthless.

Despite the heat pouring off the brickwork, she shivered. "That's right. I'm a Pee-Wee sonic person," she said to the bridge. She pressed a finger to her ear. "I hear, feel, thrill to the quiver of air – Sam Phillips understood the dynamics of sound, yes sir, capturing that rocking spin like a holy imp imprisoned in the bottle."

*Hades

She heard a subliminal noise, coming, perhaps unlikely, from the Brandywine's beating heart. "There you are, I'm sure there's a smidgen of bat in me." Her satisfied words came soft and greasy as noble sperm. "I'm a sonic detective now. Stand by, here we go…"

The Splattersplooch was still motionless, waiting in the water, its eyes visible above the bridge wall, its young feeding, snuffling like little black pigs of death.

Hands and kitten-heels soundly planted on the brick surface, Squab looked directly into the huge orbs. One of them blinked balefully at her, its lid leathery and tanned as a fiend's back. The eye closed slowly and then rose up again, wiping a film of grease from its iris. Was that a fish she could see, swimming around in the eye?

Another illusion, she decided.

Beneath her, as if a gag were working loose, the bridge seemed on the verge of delivering a statement. Spoken in words of smouldering brick and cement it would not, she was sure, by nature and effect, when uttered, be pleasant to hear.

She could smell melting tar, and wrinkled her nose. Her face, in which the angularity of childhood was still visible, with her blue, slightly oblique eyes, was expectant and knowing. She bunched her limbs tight and compact, making herself small as she could.

"My truth and My mercy shall be with him; and in My name shall his horn be exalted…" The chill voice of the Brandywine Bridge spoke clearly for the first time, cutting indelicately through her thoughts.

Fine sparks that blue-pokered in the air accompanied these swinish words from the red brick.

"If only I had blue skin and a necklace of skulls," she was emphatic, "I could probably carry this off."

The bridge shivered seductively, and from deep in its bowels sitars and shehnai struck up an exotic raga. Now Squab, who believed in positive action and self-determination, was a young girl. Unable to resist an excuse to dance, like the monopede before her had done, she shot to her feet and began moving to the sound, flirting delicate wrists in snake-like undulations about her. Keeping as perfect time as any western child could, she swayed hither and tither, and turned a quite preposterous pirouette.

"*Veritas mea et misericordia mea cumipso: et nominee meo exaltabitur cornu ejus.*" This declaration (pumped in a cloud of steam from within the bridge) accompanied the merry harmony, and Squab knew enough of the classical tongue to recognise the gist gavotte of it.

Abruptly remembering herself – and the Splattersplooch! – she looked down into the Thames. The liquorice waters clinging to the oceanid had turned blue. A strip of thick blood was running from under the bridge, circling it in a surreal fairy pool. It noticed upright Squab. Seeking her littleness, a swishing tentacle, heavy with myriad babies teething on its skin, snaked out towards her through the cloudy vapours. In its maternal state it was all it could manage. Easily, she dodged to one side.

The bridge became more hortatory (again, the Horror effect). "Fetch the hooks," it called, "a martyr's flesh will make a sweeter breakfast than a common Thames herring."

"Go for it." Squab suddenly jumped into the air, hands circled over her head.

There's a move of satisfaction for a line well delivered.

"Get on this." Up and up and up.

"Let's get some gone." Almost levitating.

"Here's me doing The Saul Bellow."

Squab imitated the Pissdous Ratous, reeling like a drunken Frozen Charlotte,* rolling goggly eyes.

"Eat me."

Damp globules of flesh were squeezing from between the brickwork beneath her. Coconsciously, she hopped like a frog to one side. In a few moments more a human mouth emerged from the suppurating bridge wall. A bitter sigh escaped its Ashkenazi lips.

She reverted to crab formation, warily studying the mouth's teeth. Mouth and teeth reminded her of vagina dentata.

"Well, squeeze me till I pop."

She had the intuition that this was an infant's mouth, visible on its features the kind of relief from painful tension received when infant teeth erupt through the mucosa of the gum condition (fancifully known amongst the medical profession as 'fantasies of explosive cannibalistic penetration').

From enjoying Francis Bacon's triptychs Squab had no trouble identifying phalluses equipped with mouths – mouths as funfair sites for sex and violence.

What could be more biomorph than the vision of the Splattersplooch, malevolence personified, bopping in the mist? Were its spermy phallus-shaped fishy limbs destined to plunge into the growing wet orifice on the Brandywine Bridge?

Metamorphosing rapidly into an adult's, the mouth munched, opening and closing before her; sweet tongue of mint, teeth of cheese, lips of carmine sponge, breath of Zyclon B.

She waited expectantly.

The mouth, that gash of profound impulses, a font of rising anxiety, spoke: "Into my heart an air that kills. From yon far country blows. What are those blue remembered hills…"

Another long sigh. A big blue bubble rolled off the tongue, and floated into the sky. The mouth blew furnace breath directly onto her. "I would give…" a long silence "…my soul for a chance of dying crushed under your feet."

The sounds of church bells, cowbells, blows on bricks, the pant of George Dyer's vulgar hips in motion, dully ricocheted.

"I'd succumb to your passion of vehement cruelty…Deeply I desire to die by you if that could be; and more deeply I desire you to destroy me…scourge me into swooning, and absorb my blood with kisses…caress and lacerate my loveliness…alleviate and heighten my pains. I want to feel your lips upon my throat (if I had one), and want you to wound me with your teeth…inflict careful torture on my gums…bite through my sweet and shuddering brick."

The bridge gave a funny boom-chicka-boom.

"Why," laughed Squab, "I think you've mistaken me for a lover…"

The mouth stretched into a swastika-swelling grin. The brickwork of the Brandywine

*A podgy-bodied ceramic doll from the 1870's, coated in a thick white glaze, its name taken from a ditty about the death of a girl who refused to dress up warmly while riding to a ball on New Year's Eve.

Bridge softened, and yet more steam boiled from fissures in its masonry; inside, Squab sensed, humans greased and ignited.

"…a lover," she continued pointedly, "with more passion than I possess. Maybe if I were a few years older, I'd be up for your leery games." Still on hands and knees, she arched her back, and made ready to scramble-sprint off the bridge to the other side. "I'd hasten your demise in a tick."

"Oh, blessed heart, I should like you to tread me to death. Darling, I wish you would kill me this day; it will be so jolly to feel you killing me. Not like it? Shouldn't I! You just hurt me and see."

Clear liquid noises accompanied these sentiments. She could hear screams, hoots, sobs and whistles, coming from within.

> "When perverse rebellious love
> Masters the feminine heart,
> Then destroyed is the union
> Of mated lives for beast or man."

The bridge began to swing easy, rhyme-to-death blood trickling from its cornices. The flesh, pressing like crematoria goo from the heated brickwork beneath her hands and feet, sizzled. It stuck to her dried fingers with a particularly abhorrent tenacity. She felt the megrims and the vapours of fleshy biff-drops; the infection of Mengele's thalidomide and Bacon's algolagnia.

> "From bone to brick, I'm made for love and death
> For that is my world and nothing else.
> That is – what can I do – my nature.
> I can only fuck and nothing else.
> Women and beasts cluster round me like
> moths round a flame
> And if they burn, I'm not to blame."

Enlivening clicks of teeth in motion rumble, soft hisses that sounded like kisses fly; then the mischievous roars of bellows and, over all, bucolic and immense, grievous laments of anguish rising from the inhabitants within the Brandywine.

"Suckers." Squab's back arched further, and she indignantly tightened her muscles. "So, you want me to be a cunt like everybody else?"

She didn't wait for a reply but put the full energy of youth into a spider-crawling dash. She left the bridge briskly, running upright and straight-backed. ("Let's creep away from the fray for the party's over now…" Noel Coward knew a thing or two about life, and the appropriate time to be away on his toes, don't you think?)

Squab came to a halt. She continued running on the spot, panting. "What-O," she mopped her brow. "Thanks to the speed of my gollies and your fortuitous advice…" She waved

an amicable hand to the pataphysician across the river "…I've got away scot-free. Now that smells like teen spirit to me!"

"Well done," he shouted back.

"More to do."

"Isn't there,…" said Jarry, ever the Dada spin doctor, ongoing champion of flux and creation. "Look at what a can of worms you've opened."

He pointed to a shadowy spot beneath the main arch of the bridge. The water where the blood was appearing was now bobbing with the corpses of naked men, women and children. The trellises that adorned the bridge were broken and hanging down, trailing blood-red Rosa banksiae into the sluggish current. More bodies came bubbling up, Dachau-starved, Treblinka-gassed, inky numbers etched on their foreheads.

Squab regarded these brick-and-mortar ghosts with warm indifference. The water fluted over them, the scatty wind twirled her hair into wanton curls.

Since only fish had escaped God's curse on Adam and his descendents, we must perceive the presence of Endeavour's mighty hand on Squab's escape from Tolkien's Brandywine Bridge and Ken Reid's River Monster of the Id.

Was Lord Horror now playing the joker?

Surely his deviant hand was ubiquitous in these proceedings.

Holocaust fragrances wafted off the unfortunates as they scudded from the reeds in a coiling Teddy Tail, the white profiles of their dead faces clearly drawn against the rippling wavelets. The occasional swish of mermaid tails, those flirty guardians of the Thames, cut the air, their presence a reminder that kinder forces were also at work.

Caught in the centre of a dead group of bald turkey-heads, a woman with the ears of a vixen and wide staring eyes turned circles, shuddering like elastic in an earthquake.

"Well," mused Squab in all sincerity, "if it's Hell they're going, they'll face it. I don't think they've done no wrong."

Her eyes followed the shoots of viscous, brick-red liquid fermenting from the corpses. If you drank it, she thought, it would have a deep soothing flavour, the kind that powered her favourite fruit drink, Vimto.

"The dead are their own nation," she said, her delicate feelings doing her justice. "We'll all belong there one day."

A mermaid's fishy tail flipped among the corpses, turning over giddy topsy-turvy whirls of white water. This was seen by Squab as a lucky sign – all would presently be well again.

"I too don't like the thought of dying," her voice poodled along nicely. "On the other hand, I approve of the idea of not being here."

Did Paula Rega ever feel this perplexed about the interior world revealed in her paintings?

Squab shrugged.

"Auf Wiedersehen."

She waved again to the Frenchman, and set off purposefully across the clipped sward, along the river in the direction of Pixie Village.

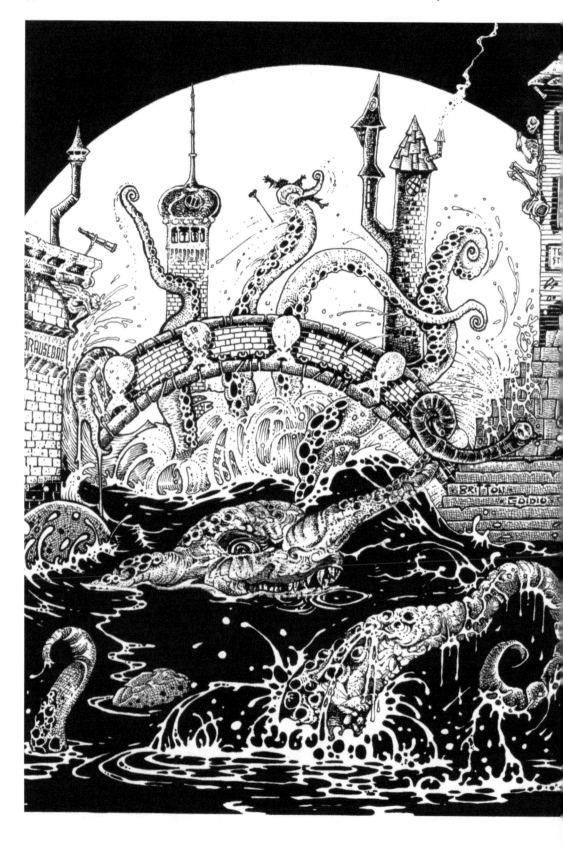

But almost immediately she came to where the Crematoria Goose was snuggly bunked down amongst a necotoria of diseased flowers.

Fagged-out blooms, marigolds, cornflowers, lupins and tulips piss-yellow and wilting under the sun, covered the old brick-and-flint furnace. Clusters of nightshade and foxglove, tightly bound by stinging nettles (after which Nettlebed had been named), were grouped around the walls. On its roof were human remains, a tropical plague of malformed bone arranged in fractal shapes, the whole looming in the image of an immense cross and swastika, epicene and bawdy. Wind rattled the skeletal mass, conjuring a big noise from Planet Bop.

No hidden agenda here, then, Squab surmised. Just another statement of the Thames' rôle as the nation's entrepreneurial conscience.

She sniffed noisily. There again was that aroma of toasted almonds and garlic.

Glancing expectantly at the river she saw a haughty pyramidal raft of corpses sneaking toward the furnace gates. From it, a long slick of blood stretched back to the Brandywine Bridge. The Untermenschen, seeded with severed hands and feet and decorated with the bones of pigs and apes, were piled on top of each other in obscene embraces, their skins furnace-red and flayed, pretty blue licks of gas-flame igniting their bodies. Certain unfortunates had what looked to Squab like deer antlers hammered into their skulls.

"Awesome," she said sarcastically.

She shook her curls. This would never do. Her visit to Fudge and Speck's tree house was meant to have been a cheerful idyllic break. She couldn't end such a sunny day in such a dark mood. Being in Horror's company for so long was sometimes like living in the shadow of Himself, and something she couldn't sustain for any length of time. She hadn't bargained on this grotesque adventure.

Yet, truth be told, she admitted, it did have curious parallels with other events that had recently occurred to her and Uncle Horace as they travelled down the Thames in their small steamboat, the Dolly Fisher. Their voyage had been interrupted by all manner of esoteric things lurking in the undergrowth, or inappropriate buildings importuning unsavoury deeds.

Each unholy building seemed symbiotically linked with another – no doubt, she surmised, to get the job done with the minimum of fuss.

She was impressed by the Redeemer's hand on such cold order, but she was beginning to suspect that paranoia had set in, and the hand of the mighty Rearranger had jinxed them; but she set her mind against such thoughts.

The steady thrum of bumblebees was in the air, and the breeze, as it moved through the oak and elm of old England had a flavour of Pendlebury; Ken Reid's spirit was in its breath.

That was enough, wasn't it?

Squab gazed across the river to where the Poontang wagon glowed in the sun. Its back doors were open. There was no sign of Jarry. He had gone, she imagined, to exercise Boss-de-Nage's relatives in the glades.

Listening to the little Frenchman had proved a wise thing. Pity more people didn't.

Of the Splattersplooch there was also no sign. Had it retreated back beneath the Thames, to await the next traveller?

Her eyes drifted idly along the far bank to where the mulchy path broke through the trees. She squinted. Sure enough, a jerky figure was approaching, dancing like a buffalo on angel dust. Presently, she made out a three-legged caprice with a tiger's striped body and the head of a rabbit, lurching along in an ungainly way, Brandywine bound.

"Oh hum, another arse coming to the pot." Her voice was weary, but not without charity. "Dear, oh dear." Yet another offering to the Hereafter would shortly make its play. But, she supposed, like all living things, the Splattersplooch must eat.

She set off once more.

What she really needed now, she decided, was a nice cup of tea.

domain of the valve cardinals
jacques dingue

Picture an old street falling through from a background of faded photographs, a small shape wrapped in black rags huddled in a doorway. Luminous eyes glimmer above sharp white teeth. Maldoror's withered hand flicks over pages of the Manual of Correct Entries, stopping at a page marked with the sigil of caterpillar-death. Sick flies buzz like the murmur of distant voices at a family gathering to which one is not invited. A small dim red sun winks unsteadily reminding one of the beautiful certainties of death. Groans distract the attention.

Occult symbols and dog fetishes crowd a young girl's eye. Enmeshed in Vatican imagery, she lies impaled on the staff of Christ – the nun's reward for a lifetime spent in fatty changes and monthly devotion, shot up on stained glass and the worm's embrace of tongues. Fibrosis in the Church of Advisors who murmur solemn incantations of under-nutrition and toxaemia scavenged from the morbid Bible – to assist the processes of chance. Heart policies made by a Pope, seeking their compensation, are dashed on the winds of High Mass or dipped in the eyes of a harlot scavenged by wolves.

Dog hair, broken teeth and the subtle machinery of a girl's torn clothing combine to form the impression of insect love. Necrophile cardiac telegrams on stone slabs, bolts of purple lightning and meat-spasms. A black window opens and an old man leans out at forty-five degrees, supported only by his misery. His hands grip the ledge with the joyful desperation of an aneurysm, the proficiency of a scavenging bird whose beak has fed only on creatures that have never seen the light of day. Smoke belches from his mouth and electronic screams turn the sky black where the headless snake of Catholic Guilt dances to the sound of lugubrious gongs.

Delicious stars slither gleaming silver and blue between shimmering two-dimensional walls of a faecal cathedral. In the College of Compensation, light from a solitary candle falls flickering over the peeled eyes of the seven observers – enshrouded, hooded, plague-carrying witnesses to the addiction of Christ dropping on all fours to a slow-hand clap. Their flabby jowls hang severed, ripped open in a mad bloody froth that sears the throat in acid gulps. Nervous priests appointed to the degeneration of the Roman Catholic clergy, hypertrophied and anaemic stand below the Pope as the disease is carried by the stimuli sent by Rome, but not before the howl, worse than anything heard on a forest floor.

They writhe and dance in embryo spasms, mouthing foreign tongues of flame, licking the red moon like an old woman's face. No longer are there enough cups to fill with the unchecked viscera slapping around the barefoot priests. The Valve Cardinals scoop up what they can, drink until their stomachs burst, or piss coagulated blood with the control of paraplegics. Then, spreading the legs of a blow-up Virgin Mary doll, they fall one by one piercing the navel in

latex umbilical intercourse – the forbidden fruit.

"Death to the Mother!!" they shriek like castrati, re-enacting the destruction and suppression of indigenous cultures and rehearsing the annihilation of the planet. Drawing their knives, they fall upon the grotesquely enlarged stomach of semen, into which they bury their daggers to the hilt, releasing in a rush of stale air mixed with seminal fluid – The Immaculate Conception.

On the altar of Holy Dispossession, a sacred hyena gnaws at the hanging entrails of the sacerdotal virgin in an apotheosis of irresolution. Black thunderclouds like cramped muscles open to reveal a dark eye entering the filthy congregation like viscous jelly, clouds of flies on a mixture of shit and honey. Women weep in shameless abandon while on a mountain top blind King Oedipus laughs, masturbating to the sound of flutes. The Maenads are abroad and the Valve Cardinals shudder.

"Euan Euan, Oi Oi Oi !!"

Flee the sound of their approach in chariots of dust pulled by a team with jackals' teeth, who waylay an accursed traveller and pull him kicking and screaming to the desert floor. They give him the opportunity to gasp in amazement at the length of his own entrails, the size of his own booze-enlarged liver, and the great flock of carrion crow that follow the scent of death, leaving nothing but the inedible gold teeth and the shrunken left eye wrapped carefully in a silk handkerchief.

In the jaws of a white fox, furious suns piss light and a rain of particles of fur and blood moved by strange magnetism. The hill of patriarchy is parched and shrivelled – the shattered visage of the Oan Beg lying forgotten on the withered grass. Eyes in coral-pink penis flesh are grafted onto living stone, rising like smoke through corridors of holy lust. The wolf's profile hangs overhead, emblazoned with swastikas and sunwheels. It breathes with the night beneath a moon of invisible paper.

Impossible biologic birds of tin stand always in mysterious chords, knotted together like the eager note on my door where the Eye opens like a mouth seeing the face of its lover. Eclipsed by snow from five split places loving with iron hands painted like revolving doors with trees. The Artificial Eye of the Usurping God comes circling late over an alleyway bonfire. Want, colder than an empty socket shivering in the heat of street corners. Cathedral towers humming with a faint vibration of tongues rest an eye with a sable pall as for burial.

A free reign for the ghostly preachment and the Earth's discharges. Enter the clump of dark trees and giant plumes of funeral feathers waving sadly. The artificial eye is made of glass, hushed and noiseless becoming roughened in the course of time. The Black Eye of the Dying Solar God, still wresting a twisted feeling of awe from the millions of sacrificial victims. Anti-suns, ciliated hairs twitching blown across bright lifeless skies. A horse's skull nailed to a tree, near sheets stretched between pointed twigs dug into cracked earth. On the sheets is a small painting of a pair of lips – old machinery screams in a red room while dogs' teeth snarl cunt-lipped in agony and fear.

A changing neon sign above an old shop colours floating in the dusty air.

The Eye is discarded to the cautious wind and the swift clouds that skim the moon.

Washing in the sand, it stops to listen turning its head this way and that in the wind then continuing to squeeze while the patients hold their heads like guilty spirits, free from the cramped prison called Convenient Method.

Hither comes the sound of voices, out on the waste waters of glass, sleeping a thousand miles away. The patient stoops forward and fits the eye securely in its socket, then rushes to meet the blasts from the unknown, throwing back its head in the desert places of the world. Here in the fury of opening and closing, his unchecked liberty reaches every part of the soul.

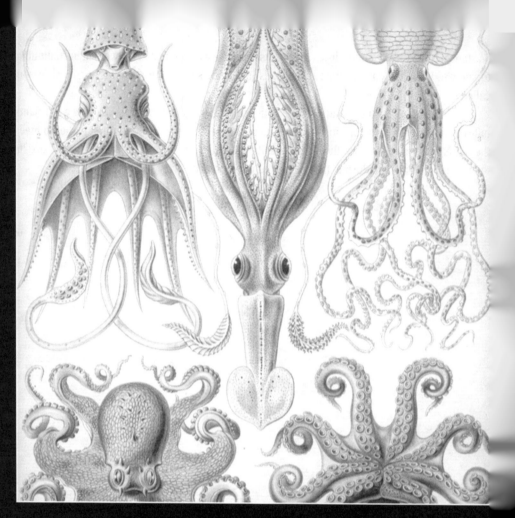

About 1,500 jumbo squid wash onto Southern California beaches (01-20) 08:50 PST
NEWPORT BEACH, Calif. (AP)

About 1,500 jumbo squid have mysteriously washed up on Orange County beaches, thousands of miles from their usual South American home waters. The bug-eyed sea creatures, believed to be Humboldt squid, normally reside in deep water offshore and only come to the surface at night. That means people rarely see them. They are typically found in South America but have in recent years been spotted in large numbers in the Gulf of California, Oregon and Alaska. Scientists said they aren't sure what prompted the migration. "These things are invading, and we don't know what's going on," said John McGowan, professor emeritus at Scripps Institution of Oceanography in La Jolla. "It may be they're following a warm California current. Oceanographers don't have a clue why a large population of squid like this is moving north or why they strand themselves." Although they can bite, the squid are not aggressive by nature and don't attack swimmers. Beachgoers have been surprised to stumble across their torpedo-shaped bodies and elongated tentacles. "They look like a miniature sea monster, something you'd see out of a Jules Verne novel," Newport Beach lifeguard Capt.

Eric Bauer said Wednesday. The squid have been found since Tuesday on the sands of Laguna Beach, Newport Beach, Crystal Cove State Park and San Onofre State Beach. Authorities plan to remove them in the next few days and will give at least two to the Santa Barbara Museum of Natural History for research. In the meantime, though seabirds and crabs were feasting on the dead squid, beachgoers were advised not to eat or even touch them, due to possible bacteria contamination. The jumbo squid have become another headache for beach maintenance crews that just finished digging out of debris washed down from streams and rivers during this month's pounding storms. "We've found dead raccoons and other animals. I would prefer picking up seaweed instead of these squid because even dead, they squirt you with ink," Newport Beach maintenance director Dave Niederhaus said. The squid came ashore about a week after an oil spill from an undetermined source coated more than 1,000 seabirds off the Southern California coast. Many of the Western grebes and pelicans drifted onto beaches from Santa Barbara to the Venice section of Los Angeles.

Battleships
herzan chimera & james havoc

It was hot and humid that day in Central London. The balmy air was pressing my damp undergarments to my flesh. This memory of the complementary sensations of disgust and delight that clothed my sweaty predicament, at first a steel-edge reminder of subsequent perfunctory events is now, only twenty-four hours later, a faded and jaded bastard-son lost to the turmoil of my wonderful and fortuitous reunion late in the afternoon of March 15th 1898.

I had not long since that afternoon, if my flaccid recollections can be relied upon, terminated my employ at the dank and dreary broomcupboard offices of the District Surveyors in Clerkenwell, having exchanged more than a few rather loudly slanderous remarks with my superior upon my final exit, when I happened upon an old cricket-team chum from my studious childhood years as a hardened boarder at Brighton Grammar School.

An enchanted and stoic establishment dedicated to the honourable pursuit of intellectual excellence and comic perversity, that to this haunted day invokes the brain-burning taste of Death Camp soil after the "fog" had settled.

A minor paradise of calculus and cocksucking; in that order.

"Foxhead!" The mystery figure had hailed from across the tumultuous street, thick with groaning, tyke-hauled barrows laden with tubs of donkey-lard, en route to Farringdon Station and all points North.

Initially, I believe, I had picked up my pace somewhat and had pulled my bowler down over my eyes. Perchance my addressor was a debt collector I had up until now managed to evade, or a spurned husband intent on sweet revenge after my name had been innocently cited at the flashpoint of some matrimonial arraignment to which I was hitherto oblivious.

Then, suddenly, realising Foxhead was a name with which I had not been associated since my aforementioned schooldays, I halted abruptly and turned to face my hailer.

He was a tall fellow; gangly-looking as he skipped a loping stride through the perilous wheels and negotiated his navy woolen cape in the aftertow.

Conscientious to keep his footing on the uneven, ill-maintained and dog-shit slick old road.

"Foxhead! It's you!" his taut face beamed.

I must have been wearing rather a serious face, for he laughed aloud, tossing back his head in his customarily flamboyant manner; a single gesture so vivid it necessitated no further interrogation.

"Gleeson!" I exclaimed, launching myself arms-wide into his embrace and hugging him to me.

We laughed like thorough-bred lunatics for the better part of a minute; passers-by forcing sheepish grimaces at our mad display.

"But my, how you've grown," I commented.

"Chest high." He broke free, masturbating air.

"Foolish man...I mean, you were always such a..."

"Shrimp? Yes. I admit it. I was a thimble of urine. Cheeks like peaches." He made a fat face.

"Indeed. Where did it all go?"

"The weight? Fucked it off!" he bawled, as a fragile-looking femme glided coyly by.

To my shame, I laughed; aloud. We both laughed, long and loud, intoxicated by each other's spirits.

"And me so lean. So athletic. So hungry-looking," I added between raucous gasps. It was not until I had regained my composure sufficiently that I recognised that all-too-memorable look of effete dread in Gleeson's eyes.

"Easy now..," I remarked, "What could so grieve one so mercurial of nature as your good self?"

Gleeson suddenly and inexplicably let a big wide grin crawl all the way across his pallid face from ear to ear. A supernatural feat of physiognomy.

"I... err... seem to have stumbled upon a magnificent discovery. A purgative for the amoral soul the like of which few mortal men have sampled. Food of the Gods, man. And of their darker halves, no doubt..."

"In plain English."

"Like a fucking eggshell, man," he giggled unrestrainedly. "Feet the size of prawns. The future. Oranges and cinnamon..."

"Wait, wait..." I tried to calm him.

At length his mania subsided.

"You're not on business of any sort?" he asked, anxiously checking his pocketwatch.

"No. Actually, I was just..."

"Splendid!" He motioned with a sweeping gesture of his white-gloved hands for us to move on, linking arms with me in public. "So much to catch up on. Senile though the days are." He tugged my cheek boyishly. "It's the whorehouse for this couple of war-horses. Merry maids. Copious flagons of ale. The telling of the tale is a snorting foot-fetish." He hooted; lost, I believed, to the insane humour of his own privately-distorted world.

So, after hailing a passing rickshaw and enduring the spine-shattering helterskelter round the seedier parts of this already filthy city, we drew up at the gated entrance to a large estate that sat back away from the main drag the way an old man hunched before the fire leans back on one buttock to blast forth and ignite a methane holocaust, in whose sad blue flames he may see the shimmering faces of lost and former loves – and, perchance, a glimpse of pussy. Not an inviting sight at the best of times, which – considering our sinister locale and the encroaching evening – these were quite obviously not.

Gleeson flipped a column of punched-out florins at the panting 'shaw-punk. "Hey up,

Nutcracker, away and fetch some choice bones for your good lady wife. Now then, Foxhead; shall we dine?"

With an undersea glance he ushered me enthusiastically down to the sewer which ran along by the cart's metal-rimmed wooden wheels, blind to both the stench and the depth of the effluent in which he stood ankle-deep.

"Come. Hurry."

Taking his gloved hand I stepped reluctantly down from my clean dry elevation and into this slaking ordure. A tingle of fear shot through me as I thought at first that I had lost my feet to the slime. Gleeson as ever had anticipated this and readjusted his hold, clenching my wrist so it threatened to snap, and helped me onto the pavement.

With the rickshaw making a suspiciously hasty getaway and me stamping whatever the Hell it was from my only pair of presentable shoes, Gleeson busied himself with the bell built into the Gothic, marble-column gateposts.

"Battleships lost at sea..." he gleamed as I approached him. "Don't look so afraid, wee Foxhead," he continued. "Anyone would think this was your first time on hallowed ground."

I suppose he had already clocked the dread in my eyes. I denied the insinuation outright. "How dare one be so bold!"

"Yes sir." He punched my left shoulder. In the dim distance, a crumpled-over figure carrying a feeble lantern was making his funereal way down the gravel path towards us.

"Doctor White," the lantern-carrier greeted my schoolchum, "How kind of you to greet us with your distinguished presence."

"Doctor!?" I exclaimed, as the wretch wrestled with the cumbersome gate.

"Duke, this my very hairswidth friend, Vincent Lavender — Foxhead as he is to be addressed," Gleeson introduced me.

"I am privileged, Foxhead." He extended a weak and arthritis-ridden claw, which I shook tentatively.

"Now..." Gleeson gathered me under his wing, "...this here is the Duke of New York. That's what they call this place, you know. New Fucking York." He roared with laughter.

Inside the "brothel" I was met by such unrestrained sights of carnality as might feature in some demonic debauch in honour of Satan himself. My clothes, soiled and sticky as they were, were quickly peeled from me by a trio of naked ladies wearing false pigheads; grunting with swinish, mud-swilling pleasure at my fast-approaching nudity. Gleeson watching the rape bemused as I frantically clutched at my socks and gaiters.

All about me. Men. Women. Children. And, to my astonishment, they, shaven of all body hair, were indulging in such vile acts of degradation that I feel sick to my stomach even now. Ah, to taste again that virginal vomit... *Shhh, who's that?* Eerie horror sounds fall away silent.

So, with Gleeson as my lowly guide, I was shown more of this establishment's lurid clientele and voracious, low-life acts.

Passing one open door from which frenzied shouts were emanating, I halted to witness a crowd of baying gentry, on their knees before a baited grizzly-bear cub that was being set upon by a pack of seven little naked girls with Chinese finger-hooks and razor-belts; their sobs of pain

eaten up by the viewing rabble; their white bodies ripped beyond recognition by the cub's claws; their tiny breasts sliced open, mauled into grotesque mammary grins; their bald heads tattooed with obscure calligraphics. The arousal of the bear-cub aptly illustrated by the angle of its fleshy erection; immune, it seemed, to the multiple lacerations along its throbbing length.

The girls performing balletic leg-lifts, showing off their blood-red pudendae to the audience and urinating bright green when they were inadvertently caught in the horny creature's malicious embrace.

"Piquant," Gleeson glimmered; deriding.

On past many other doors down a paneled corridor, all of them firmly closed on their atrocities, to an open door four from the end on the left. Gleeson elegantly curtsying his buck-naked request for my entry into the room beyond.

I remember standing there in my socks and gaiters, physically shaking, afraid to move, nailed to the shagpile by the apprehension of what revolting horrors lay ahead.

"Foxhead!" Gleeson suddenly shouted, jolting me from my torpor, "Any time before the Solstice!" And he smiled that utterly insane smile that I'm now convinced he had been conscientiously perfecting since his graduation from Brighton Grammar.

Inside the spacious boudoir, soft-lit in violet, was a luxuriant double divan dressed in jaune silk sheets and sporting numerous pillows fashioned from a similar, if not identical, fabric. There was a pungent claustrophobia to the air; a fruity perfume that like an eel or snake wriggled and slithered its nauseating way down into the lungs with my each shallow breath.

"Ha!" jeered Gleeson, "Sentimentalists swallowing their mothers in Summer. Sit, man, sit." He closed the oaken door firmly behind me. "Drink?" he asked.

Again I must have shown a strange face, for he added: "I'll take that as a yes, then shall I?"

I nodded madly. My palms wet with perspiration. As was my top lip; a family trait, the wet upper lip. Always thought that was very Freudian; or maybe Jungian.

The door swung, unannounced and impromptu, ajar.

Startling me so that I let out a shout which made Gleeson drop the decanter he was emptying into two large crystal tumblers. Whilst in through the open door there swept, like Autumn leaves in a stiff breeze, the naked female trio who had so professionally stripped me. Their regimental manner unnerves me still.

They shooed Gleeson away from his cursing and onto the bed, softly laying him down beside where I, in my highly bothered state, had been laid out. I had not protested at their orders nor, at first, had I noticed that as well as the pighead masks they wore, their breasts, large and round and white as I remembered, had been transplanted with baaing heads of ewe.

Amazing trick – I thought at the time.

Time indeed seemed to linger idly by, like a bellboy impatiently awaiting his tip. One of our "hostesses" left the room under no obvious instruction, returning warped moments later with a solid silver tray upon which were arranged a selection of peeled fruits and spices, while the remaining *femmes serviles* had donned shiny, lubricant plastic gloves and were busy working Gleeson's and my own dick to a suitable stretch of arousal.

"Fucking amoeboid." Gleeson glimmered; his second favourite face, I declare.

"How's that?" I asked, finding myself less and less able to understand his rapidly thickening dialect.

"Cat smooth. Eggshell slippery," he emoted, grasping the porcine face of his masturbatrix and slobbering luridly into her snuffling snout. Pulling away his bright face, wet with pigspit, and taking with his teeth a fruit segment proferred by the third maiden; my hand-maiden oinking riotously while she wanked. The room had become a menagerous clamour of squeals and laughter and slurps and lechery.

It was at about this point in the farce that, I believe, I first began to panic.

My oinking hand-maiden dipped her masked head over my groin and began sucking my erect dick with her pig-lips. I could feel the tiny pigteeth behind the hairy, rubbery lips, the coarse pork tongue working abrasively against my tender rim. "What the fucking Hell do you think this is!?" I shouted at the very top of my voice, pushing the woman from me and rising, hysterical, to my socked feet.

All four of them were gawping, gobsmacked; utterly astonished at my immature outburst. They were all staring at me, dumbfounded. I noticed one of the girls looking at my erection; standing proud.

"It's a fucking trip, man," announced Gleeson. And all was loud humour once more. "Sewer deep, luncheon hydraulic. Have a piece of orange." He shakily offered me the heavily-laden silver tray.

"Fuck the fruit!" I shouted. This brought even louder laughs, for some sick and twisted reason. "And why have these sluts got pigheads!?" I screamed at the sudden lonely silence. Again four rather serious, accusing countenances.

"You're just being sow-er, man." Faces close to bursting. "Why so pigged off?" Giggles spurting from the sides of mouths. "Oink you happy here?" Immense explosion of mocking laughter.

The orgy resumed. Gleeson, fighting against the amorous tide of swine mouths, hands, sucking breasts of ewe, cunts moist with chuckling, still proferring the silver tray. Eyes brightening ever wider. I felt a cynical hand reaching ashamedly for the fruits; took a lemon-coloured segment and popped it into my mouth.

The room, quite accidentally I believe, fell on its side. I laughed until my lungs ached and I felt my bladder was going to rupture.

It must have taken the girls some time to help me back onto the bouncing jocularity of the divan, for as I was welcomed back into the many female arms a feverish, sweating heat had befallen me, and every other around me.

I remember finding this most amusing. And as pigheads and eweheads sucked and slurped at my cock; my mouth; my ears; my bollocks; my toes; my fucking toes... and having thought "my fucking toes", in a trice was one of my rampant escorts' boiling cunts engulfing my left foot. She took me in to the ankle, head back, the muscles of her arms veined and pumped up from pulling me in. Though I could no longer see, since there was a ewebreast before my eyes into which I had a mad compulsion to insert my tongue, I could feel my shin slipping further into

the woman. I could feel the hairs on my leg brushing inside her uterus, pressing up on her womb-silk.

My toes touching... her ribs?!?

I shot to a seated attention. She was there; on her back; legs in the air; my left foot now swallowed up to the fucking knee... ah, not again I thought, having made the metaphorical mistake and having my leg disappear inside her body to the thigh.

Hot hands pulled me back to the bed. I ignored them and looked to my immediate left. Gleeson was on his back, face contorted with perverse pleasure as the woman rode him, her bleating breasts and snuffling snout utterly fiendish. Suddenly from the open door came another naked maiden.

But she was very different.

Her Chinese head was bald of hair, and bore only the most basic suggestion of features. Her skin was pale; bleach-white. As sickly a shade as I've ever witnessed. Colour aside, she seemed physically normal until she strolled round to Gleeson's side of the bed. Haunting the place usually set aside for the pubis was a small elephant's head complete with nervously flapping veiny ears, curved ivory tusks and, jutting from the pelvic bone above her vaginal mouth, a long and inquisitive trunk.

"I can smell your thoughts, you naughty boy," the Chinese woman confessed as her groin-snorkel tasted his forehead exploratively.

Gleeson glimmered and gleamed, shuffling to lay across the bed, his head slung over one edge; "And I want you to screw them. Work me over, you rag-burning honey." Having given this request he took the trunk in hand and guided it down his own throat. Sucking her off while she smiled at me in her polite Oriental way. Gleeson bucking with choking ecstasy beneath her.

She extricated the trunk with a flick of her slender hips; Gleeson like a hungry fledgeling champing for more.

"Come on, give me some more of that. Fuck my eggshell brains out."

The look she gave him would have turned flame to ice. And, though close to orgasm myself, I could not avert my eyes from this battle of wills in order to enjoy my own pleasure. She took his head by the ears. Gleeson's mouth opening and closing impatiently. But instead of plunging the trunk in, she impaled the lethal tusks into the top of his skull. Gleeson let out such a horrendous and horrific scream that I ejaculated with shock, my body fighting peristaltics as I watched on; enthralled.

Ruthlessly, the Chinese woman impaled the tusks once more into his broken head, screwing his brains to pulp. On went the destruction, Gleeson's face splitting, nose dividing, until at the height of the brain-curdling his body jolted; as a result of the elephant head in his cranium, or the strange woman jumping up and down on his cock, I know not.

But jolt he did; throwing off his sex-rider; hurling aside the Chinese; a gushing deluge of excreta ejaculating from his gaping brainpan.

"Fucking Egg Shell!!" he screamed, as out of the cranial fissure three foetal forms, covered in silky grey fur, flopped. Siamese triplets joined at the point of the lacerations they were busy inflicting on each other with claws and teeth and desire. All red and dripping bodies matting

black in the feeding frenzy.

The trio crashed to a slushing mess by the unseated pighead woman as she struggled to regain her bearings through the fog between her ears. Her pink head sporting a neat bruise, cut to a gaping lump. Instinctively, like a shark in the presence of blood, the trio – one frenzied form – pounced upon the dazed woman. Gouging and gnashing out great wet burning bleeding chunks of flesh. Her porkhead squealing. Ewebreasts protesting with deafening bleats. Her plastic-gloved hands punching gaping wounds through fur. Pulling back bloody stumps.

To my further astonishment, the remaining women seemed totally oblivious to the death of one of their own. The woman with my entire left leg up her hot cunt was still bucking like fury. I cared not that my socked foot was peeping out of her mouth. Cared not that her fingers were pulling off the sock and gaiter so that her thin pink tongue could protrude between the toes; cared not for the Chinese bitch who had turned over the dead carcass of Gleeson White and perched herself behind his bare arse, and had shoved her elephant trunk deep inside his anus only to pull it out, lick brown faeces from the wrinkled leathery tip with her cunt-mouth then shove it into that effluent passage once more. Cared not for the woman at my prick, wanking me off in all the right ways with her smooth conic fingertips and snuffling in my belly-button for truffles. Cared nothing for the sour stench of sex and slaughter. What disturbed me was the fact that the foetal mass that erupted from Gleeson's brain had reared itself up onto its highest hind legs and was looming drunkenly over that side of the bed, licking its many lips and leering with its many eyes, bringing with it the truly nauseating stench of its mashed guts and faeces exhalations.

Ever so casually, it began to topple towards us.

I remember in my daydream scrambling away from the falling hulk. And, as I clambered dizzily to my feet at the door end of the room, witnessing the uncloaking of the truly nightmarish, tearing all my senses to shreds. The humungus struck the occupants of the bed with a wet and bone-crunching thud. Instantaneously, it tore into the Chinese whore, still buggering the lifeless casing of Gleeson White, with gargantuan glee; ripping her featureless head right from her shoulders. Her spasming trunk, as she fell back off the bed, spurting a gangrenous sewerage high into the room. The far side of the abomination munched great lumps out of the dead Gleeson White, while some other insane part of it devoured a pigheaded whore from the feet up. The look on her porcine features as flint-edged teeth chomped and crunched one of her legs while she kicked out one of its roving eyes with the other; that horrible squeal of her breasts; eyes like bolts of lightning as it sought out and chewed to a pulp her clitoris. The only surviving whore was trapped on the far side of the room, urine trickling down the inside of her white legs.

"Run!!" I shouted, holding out a hand. She looked at me and squealed. That distress call shot through me; chilling.

"Quick!!" I urged as the monster on the bed was in momentary respite, busy licking its lips.

"Jump!"

No sooner had I screamed that final word than she was leaping over the edge of the bed, grabbing sweatily at my outstretched hand.

Saved.

Until that rash impression turned into yet another disgusting red herring; for as I pulled her to me her pigface began to split, her mouth widening grotesquely, and she was snatched from me, dragged to the beast by a maniacally-mutated arm. She squealed and squealed until the top of her head was gnawed off, her pathic eyes weeping blood. I turned from the horror and ran into the corridor, which was now carpeted in shrimp fur and husks of salt-cured oyster tendon; bedraggled with barking ropes of giraffe blubber. Each door I frantically yelled at was locked. Even the far door where I had espied the baiting of girls and bear was locked; from the inside.

I raced into the reception area but it was devoid of men, women, children or even their shaven pets. The air stank of violets. I threw up onto a highly-polished circular ebony dining table I had failed to notice on my disrobed arrival.

The carriage clock in the corner by the front door proclaimed a deafening midnight.

As the chimes rang out their solemn knell I shook the locked door in its frame until the glass shattered, showering my naked body and bare left foot with shards of glass. I fell back to the wooden floor, spitting curses. My trembling hands picking out bits of jagged glass from my knees, shins and feet. The pain unbelievably amplified.

There was a rasping sound behind me. I spun round.

There, lumbering its horrendous way towards me on all fours, was the remnant of Gleeson White. His bare back was all scarred and pitted from his attempts to escape. His arms dislocated, it seemed, from his shoulders black with bruises. When he raised his buckled and twisted head I thought I would die on the spot.

The skull was distorted to elephantine proportions. Big grey ears a-flapping, cooling the searing heat of his wounds. Its ivory tusks curved up out of his eye-sockets, the eyeballs still a-watching, perched at the ends.

He opened his mouth and a loud trumpet sounded as a long grey trunk unravelled, impersonating his tongue, and spat a meaty splatter of blood at me. His arms dislocated further from his shoulders, grinding with gristle, and just hung by his sides as he mechanically rose to his feet. His dick and bollocks had been bitten off, and in their place, grafted into his skin, was a slobbering pighead; bleating like an electrocuted mastiff.

I scrambled back through the shattered glass, tearing up my hands and lacerating my buttocks. Impaling my bleeding palms on the splintered glass door-frame, I dragged my pain-racked body through to the heavy front door, and fought with the lock.

Hooves charged me from behind. I turned, terrified at what my ears purported. And my eyes at last saw Gleeson White for the Satanic demon that he was. His skin now all but flayed off; bleeding lakes. His eye-tusks directed at my chest as I...

Well, actually, I have lied.

I have lived my last dying hours a lie, to discourage the sad recurrence of their memory. The truth, my good friend, is an abysmal catalogue of insult piled high upon injury. The horrors I experienced as the roiling mass of mutated flesh and bone and terror fell towards me, as I struggled to extricate my leg from that whore's greedy cunt, is too great a burden.

You cannot imagine the pain, the artificially-prolonged humiliation I underwent in that fucking room. Nothing quite as heroic as a death struggle, I'm afraid.

My constitution, you see, has never been that strong, and the effect of my panic regurgitated the vile symptoms of a recurring illness with which I am cursed. To tell the truth, the fucking thing fell right on top of me, breaking my rib-cage and snapping my spine. It devoured all the women but, for some insufferable reason, left me unscathed as I writhed in my agony. It also left Gleeson White's dead body where it lay, and I had to suffer his rapid, nauseous decay for many hours.

My lungs are now haemorrhaging regularly. Christ, I feel I may choke on these damn bloodclots at any minute. From below, the chiming of midnight sounds.

Oh, the agony. How long must I stay here, incapacitated as I am, gulping my fate? Again, those ever-present, eerie sounds make me shudder.

"Why am I here!?" I splutter.

Someone appears at the door.

"Foxhead!"

The bent-over old man addresses me. I strain to make out who it is. Recognition.

"Duke. Help me."

"Can't do that, sir. More than my job's worth." He smiles apologetically as I again cough up a phlegm of bloody gristle.

"Please. Help me," I beg.

He purses his parched lips. "Oh, I don't know sir."

"Please. For pity's sake."

"Battleships lost at sea..." he mutters.

"What was that?" I cough restrainedly.

"Sorry, sir?"

"That. That thing. Battleships. What is that? I've heard that before."

"It's an old sailor's saying, sir." He raises his snowy eyebrows. I urge him on with my eyes; pleading.

"Well..." he begins, "Battleships lost at sea, sir, rarely surface." He shrugs. And dutifully pulls the door closed.

Locking it on my screaming, coughing, shouting, choking death.

LETTER FROM LENG

"Prater Slime has undergone an entire species brain tissue transplant and is having some neurological problem with the re-adjustment to the appearance and mechanical kinesistic functions of the anatomical structure of the human organism. This is so the threshold of the cold waste of the eastern astromongolian plateau can open to the human realm ... to communicate through that gross plane of the excrement of consiousness, with the shift in focus of the Eye of Cthulhu from the fossil coast of Atlantis in western Oregon to the coagulated non-human vortex of force emanting from a strange island in the west, so that a new threshold might be breached into the eighth plane of terror-firma.

"The High Priest of Leng wanders about the fossil-pebbled beach of Lake Ontario, looking for the crystallized primitive forms to reactivate back to life. He has found a structure known as the Temple of the Beast deep in the bowels of Toronto, and has been approached by the Cult of Yig on several occasions, being taken out to a strange serpent mound north-east of Toronto, spending a night there, seeing things from some long thought dead North American tribe that lives in secret in the 100,000 lakes of north-eastern Canada. The Lodge has undergone a change to the form of large-headed beachcombers, scavaging the refuse of 5 billion years of Kulture, feasting in a post-apocalyptic world. Maybe it is the new revolution of the nature of Lam, being a large-headed primitive who obtains all joy from communication with the intelligence of the Unholy Sea.

"The Kode is written on the north wall of the Temple of Dagon on Sirius 'B'. The Temple itself is constructed of the crushed bodies of the Great Old Ones who burn with a dark flame. Pools of molten metal are on the floor of the Temple and in the reflection of the cypher of gravity is the face of the bastard child who is the shadow of the nonhuman in the human. This very small and compacted structure imposes a broad effect on all of Life, introducing ghosts of mutation who are the 7 sets at the threshold of the great gravitational lens. The 7 sets or mutational ghosts are the 7 divisions of the Library Akash or the bottomless pit out of which the locusts pour out and black out the sun ..."

LETTER FROM COIL

"In the John Soames museum I noticed an extraordinary Egyptian Stele about 2ft by 1½ft, and at the centre amongst hieroglyphics was a unique depiction of a fluid, amoeba-like Void, with hints of tentacles caught in its extremely uncharacteristically abstract depiction. It is like a crawling chaos – a palpable darkness sitting completely out of place in an otherwise ordinary Egyptian decorative panel. I will have to go back and copy it out – photograph it etc.

I have tons of 'raw' travel documentation from my visits to Palanque and the other great jungle pyramid sites of the Yucatan and Mexico City in 1984. At Palanque I saw evidence of a complex and sinister priest shaman school. Palanque was a city for Priests – a monastic city and in this respect it differs from all the other known Mayan-group sites. I have photographs of what is considered to be the Beast 666 – a stele of a priest holding a hybrid infant – with a lizard's tail and absolutely alien face. An extremely lucid guide took a great liking to me because I have a large tattoo of a Phoenix on my left arm and shoulder – which he interpreted as Quetzacoatl – The Plumed Serpent. He told me about an astral telephone that exists down the stairway to the famous stele of a warrior priest (the one that Erik von Daniken said was a spaceman at the controls of his ship) – the priests spoke to the dead priest-king and guided him through the Underworlds, sending back oracles and prophecies and acting

as a go-between by which they too might journey on the Nightside. The guide told me many extraordinary things – he seemed to possess a lucid and thorough knowledge of the use of the ancient site – as if it was in use to this day and still waiting for the correctly prepared and trained novice to put it to use. A full report is really the only way to impart the full consequences and wonderful things there. Things like tiny stones that he picked out of the river bed and explained that they were used to generate and accumulate psychic energies. Miniture batteries of plasma energy.

No other guide at the fifteen or so other sites we extensively covered possessed such a degree of arcane knowledge. We went to a subterranean cavern depicted to Chac-Mul – The Raingod – and we saw shrines to Gods – deities that he did not know the identity of – explaining that the Caves were used for secret sex magick sorceries, and that even the majority of the priests used to consider the practice abhorent and against the natural laws. There were hideous dwarf-like totems – and as they were piled up, spread out by the shore of a completely still and a black subterranean lake I felt as though we had been brought to the absolute centre of a powerful and pre-eval subhuman cult. I have strange phosphorescent slide photos of myself in this labyrinthin underworld."

Prater Coil

MALKUNOFAT : SECRETS OF THE SEA

The salt water purification ritual so widely used thoughout the rites is only a shadow of a greater and much older power; the power of the Sea. Out of the ocean arise the Deep Ones, and their servants, some of whom have been called the denizens of Atlantis. They remain ready to teach again the path from the sea to the stars.

Like a siren, the sea responds most to the voice of song. If one listens closely, one can hear her voice and join in her song. She responds also to touch; with these methods we speak to her and her companions.

Center the card of Malkunofat within the Tunnel. Over this, put a clear glass bowl filled with pure water. You should be able to see the card and concentrate upon its form. Saturate the water with as much sea salt as the water can take. If you wish, you may add some bones of the sea – the shells of her creatures.

pour out of your palms and into the water, singing as you do so in high, constantly sliding notes. Do not follow a meter Allow the notes to flow over one another like the sea. If several people are involved, do not follow one another's notes, but rather, let the water inspire your song. Your sounds may evolve into Winds of Space, linking the sea with the stars.

Put out whatever low light you have been using. Continue your singing, hands placed above the water, and begin to see a blue glow beneath your hands. Rest your fingertips lightly on top of the water. There will be a feeling of Vibration'. Such is life, for life exists as movement.

Relax and absorb, as visions from the sea flow through the water and into you. There may be teachings attached to the transmission, and they may appear to be memories, either stellar in nature, or of the Deep Ones.

Be silent and listen.

fragment: the broken diary
ian miller

I knocked politely on the back door of number twenty-two before entering and found myself in a small scullery piled high with old cardboard egg boxes. The scullery led through into a large stone flagged kitchen, where a large rectangular pine table dominated the central floor space. One of its legs was three or four inches shorter than the others and propped up on a corroded red Oxo tin.

I shouted "hello!", listened then shouted again. Nobody answered, nobody came. I fidgeted uneasily by the kitchen table looking about me, not wishing to go any further. I felt in my displaced state like an intruder, but I was expected wasn't I? I was a guest. A room had been reserved for me. Why was there nobody here to greet me then?

Tiredness scratched at my resolve, twitched in my eyes, and soured my breath. My mind wandered.

Perhaps they where hiding somewhere deep in the body of the unlit house expecting me to find them; two retarded old ladies who loved playing 'hide and seek', wetting their nickels in anticipation of frightening the shit out of me, lurching at me with a toothless BOO! and bouquet of dead fish. Christ! hadn't I had enough upsets for one day; and worse? What if they both had axes, were poised, waiting for me to open a door, or pull back a curtain somewhere?

WHACK! I'd seen the film.

Bleeding, debunked, 'bowdlerised', and a bag of marbles still left to deliver. I moaned dolefully. Perhaps they were watching me at that very moment, unseen, aka 'Haunted Mansion' testing me, watching for bulging pockets and sleight of hand near the knickknacks, observing me through a hidden spy hole. I looked around for a portrait with moving eyes but there were none. What to do? I watched the closed door on the far side of the kitchen, straining my ears for any sound of movement beyond, hoping, wanting, somebody to come and end this uncertainty, but they didn't.

I looked around to see where the light switch was, maybe switching a light on would do the trick but look as I might I could not see one or any other source of illumination for that matter, not even a candle. If the torch had not failed, if I'd given it one more shake before flinging it away, maybe it would have come on again. The gloom in the kitchen deepened and aside from the noise of my shuffling feet and my breathing, the only other discernible sound was the tick tock of an old wall clock above the stone sink to my left. It was then that something caught my eye; a dull sheen, a wisp of 'day shine', clinging to the curve of a small glass fish bowl, by the Kitchen window.

Something moved in the sluice green water and I crossed the kitchen to take a better

look. It appeared to be a large fish but given the poor light and murky condition of the water (which on closer scrutiny looked more like a semi solid green goo) I could not be absolutely sure. Fish or no, it was far too big for the bowl it occupied. I was assailed by a strong stagnant brackish odour that I now realised had permeated the entire kitchen area and blended very nicely with old cabbage, kippers and burnt toast smells. I touched the surface of the water and stirred it gently with a finger. It was thick and sticky and coated my finger in a green mucus slick.

The fish (it was a fish I now saw, though not one I could name) rose slowly up through the soupy liquid, mouth pouting and body moving in a slow indifferent motion towards the disturbance. It had a large lugubrious face, and stared almost enquiringly at me. I withdrew my finger, just in case it was one of those nasty fish that stripped flesh from bone, and wiped my finger on my right trouser leg. I wondered why nobody had bothered to change its water.

The pouting 'O' motion of its mouth in the soupy waste impulsively fashioned itself on my own mouth and I turned quickly away, knowing instinctively that if I watched the fish for a moment longer, I would be 'O' mouthing all day long, perhaps longer. I'd suffered from this compulsiveness since I was a small child, which on occasion had caused other people a great deal of upset. I only had to see someone, something twitching, moving in a strange way and it was upon me. Their affliction was mine. It sometimes took weeks; months even, to rid myself of it.

With my hand clamped tightly over my mouth I turned away and made for the inner door. I could feel an uncontrollable 'huff' coming on, drawn I knew from my repertoire of twitches.

(*My head was a jar of disquiet that might well have flummoxed even Pandora.*)

No hesitation now, I had to escape from the kitchen, but in my haste to reach the door, I inadvertently caught the edge of the kitchen table with my hip and sent a china cup and two saucers crashing onto the stone tiled floor.

"Shit!" If that didn't bring somebody nothing would. I did my best in the gloom to pick up the broken pieces and rather than search for a waste bin put the collected pieces in my coat pocket, determined to dispose of them later on. Whether it was the stress of finding myself in such an unsettling situation or just a blip of rogue elation, being 'jolly in adversity' you might say, I can't be sure, but I shouted "White Rabbits!" at the top of my voice and, liking the sound of it, shouted it again.

I had a strange recollection, after the second outburst, of shouting white rabbits at the top of my voice in Dusseldorf and being told to shut up before somebody came and took me away. That's Germany, somewhere on the Rhine. Perhaps it was just a dream. Either way, having now made enough noise to wake the devil, (not discounting the dead who I don't think would give a flying fuck) and every living creature in the near vicinity, I grabbed the door knob, yanked open the door and leapt through, as though stung, into a narrow poorly-lit corridor, ten or maybe twelve feet in length. The illumination came from a very low wattage bulb dangling inside a stained velum coloured shade, on a twisted length of flex, half way down the passage. Crypt light, ossuary shine, my dad called it.

I shivered.

Odours of: sweat, stagnant water, boiled cabbage, burnt toast, fermenting apples, farts,

(various) rotten fish, seaweed, and the smell of paraffin pervaded the air in the passage.

The walls were painted in a lacquered custard brown colour, textured in some sort of embossed pattern which years, perhaps centuries of over painting and repair, had smudged and flattened. Four ebony-framed pictures hung along one wall of the corridor. The one closest to me contained a sepia print of a seascape. Being in no great hurry, reluctant even, to penetrate further into the silent confines of the house, I paused to study the picture.

It was a steel point engraving, astonishingly detailed and very realistic. The surrounding mount was stained and slightly cockled, the effects no doubt of water damage or damp. The amoeba-shaped stain had also encroached into the lower left hand corner of the print itself. A band of Bleaching above this suggested the picture had once hung in another place, one exposed in part, to strong sunlight. A tragedy for any image I mused.

Was I a fugitive I wondered? Did I bear the bleach marks of my time in the hot sun? Exposed, fluxed and discharging colour as I went; travelling, God knows where, or why, with a compass that whirled like the rotors of a helicopter whenever I held it out before me.

If I expected an answer to this adjunctive thought, none was forthcoming. I concentrated on the picture again. Well I tried but a hollow clink, just discernible on the other side of the wall distracted me. I recognised the sound immediately. Someone on the other side of the picture wall was listening. That clink was the sound of a teacup being placed against the vertical surface of a wall. My Aunty Lilla did it all the time. Whenever the people in the terraced house next door started arguing, and that was most days, she could never resist listening in. Shushing loudly, she would press a china teacup, kept especially ready for such occasions up against the wall, and with an ear against its bottom. listen intently to the sounds captured in its bowel. I tried it once when she was out but all I could hear was the resonating whoosh of the sea and the noise of tropical birds. She told me she could hear every word they said and it was nothing short of scandalous the way they carried on. It was enough to curdle cream twice over, and when you met them in the street WELL!, butter wouldn't melt in their mouth's, nice as pie, sweetness itself. All goodness and light; helping in the sunday school, flowers in the chapel It's enough ot make you turn Papa list.

Like your Granny always said, God bless her heart, and I should know because your mother and the rest of my sisters left me to look after her all my life and I was the prettiest of them all, but I'm not complaining, and then there's your Uncle Edwin, who doesn't even know what day of the year it is or the year for that matter, 1917 1918 that's when his life stopped. Its just him, the engine room cat and the black teapot, sitting there day after day and nobody ever coming to see him, Maybe it would have been better if he had drown like all the other men on that tanker. three times he survived the oil and fire. Fell into the Manchester ship canal when he was a small boy and when they dragged him out alive the doctor said:

"This boy will never die of drowning"

Your granny use to say "Parasols on the promenade and pigs in the parlour"

"Amplified altercation captured in a resonating bowl" said Uncle Edwin in a lucid moment.

Her face would always contort and twist as she listened her mouth working on

their captured words. When it was a particularly violent exchange, things breaking and shaking,the hissing gas mantles in her kitchen ceiling would swing back and forwards on their chains illuminating her face with a flickering, shadow spiked light that was sometimes quite alarming.

I listen intently, and touched the wall as though I might feel something emanating through it. There was nothing, only the cold texture of the wallpaper and silence.

Hardly daring to breath, I starred at the picture again.

It depicted, in what I can only describe as alarming detail, a violent storm tossed sea with a foundering wooden hulled sailing ship demasted and pitched at a torturous angle on the slope of a mountainous wave, driving hard in on a rock strewn lee shore. The wave and ship filled the centre and middle distance of the picture. Lightening flashed in the black sky above it, bathing both the wave and dying vessel in an acid white light. In the foreground, emerging from the left, out of the bleached section of the picture, dwarfed and pitching in the waves and turbulent shore break, was an open whaler manned by eight men, all pulling, backs bent on their oars towards the stricken ship. All the forces of nature were there. I could feel it, see it, hear it. My heart raced and I gasped for air. I was suddenly in that small open boat, one of the oars men, part of the furore. I could hear the bosun, hard fought on the tiller, shouting encouragement. My nose was now pressed to the glass of the picture frame, I could see the strain in every man's face, the fear and uncertainty and the excitement that gripped them all. I caught the bosuns stare as the whaler breasted a wave, and noting his gaze looked over my shoulder at the dying ship.

I thought I saw a figure, but then we were plummeting down into a deep trough of roaring ebony black water and the ship was lost too sight. Then we where rising again, dipping our oars deeper. The water engulfed us and when it seemed we would be swamped, never to rise again, when up or down, right way up, or wrong way down, was impossible to ascertain, we broke surface on the crest of a wave and were whole again. The man next to me vomited violently into the well of the boat, then I saw the ship once more, closer now, and there on the reeling deck was a lone figure, his arm raised and waving at me, but how could that be; then we were rushing down another wave slope and the ship disappeared from view. When next I saw the ship the figure had gone.

My agitated breathing fogged the picture glass and I stepped back, heart thumping to wipe it away. The roar of the storm was in my ears, the taste of brine in my mouth and I could now hear the doleful clang of a ships bell. Overwhelmed, I turned away from the picture and straightway all the noises stopped, all that is, but the clink of the cup on the other side of the picture wall. I took a deep breath, counted to five, turned, wiped the fogged glass and looked again. The wind roared in my ears and I gasped in astonishment. The picture had changed. The big ship had gone. Only the open boat and its straining oarsmen remained afloat, centre picture and racing straight towards me, on the crest of a huge wave. It was a framed picture, an inanimate rendition, a print, how could it change like that?

Answer: "Because it could. My name's Alice" whispered a voice somewhere close.

the sons of mormurus
john beal

He walked away from the imposing railway station, its glass-domed roof glinting in the dusty sunlight, crossing along the wharf toward the dark bulk of a steamer. Around him the bustle of life, shouting smells of sweat, arose in clouds of acidity. The fishermen, bare-fisted hauliers, lobster-pots, crates, tongue-loose foreigners and arching labourers busily ignored his presence. At the sign of the Cock and Bull he entered the dim recess leading to a court beyond. The smell of brine and blood, rendered flesh and maggot corrosion all turbulently clutched his nose. Sea air had been replaced by entombed vacancy; the smell of time to go. A man, triangle-legs, bent heavily out, tapering jigsaw arms thrust out from an insignificant body nodded at him, his triangular paper hat – a boys boat – almost falling from his head. Insect ooze had been sprayed upon the thickly encrusted windows – small orifices almost alive with shattered illusions.

The butcher, hatcheting vast bloody carcass pieces, looked up from his work.

"Y'ar bus'ness Y'ar?" Strange accent, mingled with blood and entrails. The Man frowned.

"Y'ar be off th'ar's b'eight!" The butcher continued with incontinent, belching vulgarity. "Th'ar's bl'owt gone too." The butcher mumbled.

Stupefied the man stared at the butcher, arm swinging, cleaver shedding spray.

"Tick-tock." The butcher said.

"I'm in search of the residence of a Mr Mormurus?" The name was asked dubiously, "Can you help by any chance?"

The butcher sat abruptly on the wooden chopping block. His eyes searched the nearby windows, who's dizzy surfaces reflected Roman crazed decay. Abruptly his head fell and he was asleep, sawing across bones and gurgling contented gore.

Looking around the man observed no other person, he was unaware of when the bustling had ceased, but the black tarpaulin cracked in a void of silence now. He crossed over to its flapping mouth-like edge and reverently placed his hand upon it. Salt crystals scratched his fingers, and the smell of ginseng and sandalwood swept through his mind. Beneath the tarpaulin, enshrouded by its own shadow lay the partially dismembered remains of some vast oceanic leviathan. He stared unable to make it out. The head evidently was missing but there appeared to be five large globular eyes. The body, whose scales had been partially levered and sawn-off, was garishly green, white and black. A strange contortion of the twelve limbs gave the appearance of them all being on one side; whilst the belly, which had been cut, hung blackly open betraying entrails to the air. Inside the cavity strange air currents, perhaps from a huge swim-bladder made all the gore shudder constantly. It appeared to be alive, a hive of sickening activity, whirlpools of

inky oozing flesh.

"Wha'be y'ar doin'?" It was the familiar butchers voice, but it still made him jump.

Turning he replied, "I'm looking for a Mr Mormurus?" But the courtyards cobbled floor was empty. He realised not just empty of people, but the meat, the smells, even he noticed quizzically the etched windows in the hovels and warehouses were fractured and shattered.

He realised his ears were bleeding, the pain had been restrained in a subconscious blanket. Now suddenly he was aware of the glaring lights and stage prop sky. Weaving patterns criss-crossing the space between the buildings roofs, gave the impression of paths, walking between pebbles on an endless beach.

"Can I help you?" The sweet, melodious voice brought his careering thoughts back earthward.

Before him, in the dim shadow of the buildings he made out the form of a woman. She walked into the light and stunned him by her appearance. Her features were majestic, elegant even sublime, but the eyes which gazed quickly upon his visage held hidden secrets which could never be told. Her index finger was raised to her mouth in a sign of quietness. He felt himself lifted, abruptly looking down upon her head from above. A warehouse basement lift had risen beneath him. As he was about to appeal for help a shot rang out from below and the lady fell clutching the rapidly sprouting winged, red stain upon her chest. The white blouse fluttered as she came to rest gaping at the sky. He wondered, momentarily, if she too could see the lines across the sky. Then, abruptly he was back on the cobblestone level. Rushing toward the still form of the woman, suddenly everything went white.

In the smoke hung room the sound of film slapping against a projector was the only noise. The screen blazed with light, which hung, bathing the dusty air in a gradually widening funnel. Fidgeting, foot-shuffles and the darkness. A pinpoint of light could be seen through the tiny projection room window.

"That... was subject A. Note the name – Mormurus, it features significantly." The booming voice broke the rough silence, as the projector began to whirr and light hit the screen once more.

In the harbour, seaweed clung tight-fast to the jetty wall, coating it in a green-slime which shone with each wave that deposited water. The tide was ebbing. Howler-monkey horns from pleasure boats filled the air, along with the briny sound of the sea, seagulls glaucous cries, and the general everyday hubbub of the quayside shops and arcades. It was vividly hot. The thin crescent of sand baked white, matched by the dazzling white buildings and shiny, reflecting windows.

On the boat, The Mormurus, two individuals were finishing a conversation.

"... the pumps going at all times, lower me one hundred feet, then stop and await my signal." The man who was wearing a diving suit was saying. The heavy, brass coloured, metallic helmet was in place, but the small face hatch was wide-open.

As the two men in attendance began to close this and tighten the nuts which would hold it in place, so too others began the pump and manned the hauling apparatus.

An old hard-backed volume of unknown contents lay upon a half-opened hatch, and as

the diver was lowered over the side, the pages flipped haphazardly in a strengthening breeze.

Below, the gloom was etched into the water as a smear of floating non-descripts delineated the light. Seaweed and jellyfish floated by as the diver continued to descend. Then, with a sudden jolt the lead-filled boots hit home; momentarily buckling his knees. With great effort he walked along the deck of the wreck. Miraculously it remained almost perfectly upright and intact, wedged in the soft sand and rocks of the sea-floor. The hold had been opened when they had initially discovered the wreck, and now for the first time, the diver slowly descended into its dim interior. He was joined momentarily by a second who appeared to descend straight into its interior.

Vast numbers of crates, metal wired containers were piled up and inside these by the light which filtered down they could see myriad objects. Coins of archaic value, mayan head glyphs, jet and jade objects, whose surfaces were gleaming in their saline preservative. The two divers pointed enthusiastically to each new discovery. Ivory; gold objects, a strange assortment amassed from the worlds continents, a curious treasure whose largest piece was trapped inside the inch-wide iron grid.

The hall was splendid, a floor of marble checks, tall lamps, vaces and magnificent oil paintings, surrounded the gigantic stairs. Ascending centrally in alabaster white coolness, they split to travel sideways both left and right to enter side-passageways and balconies. On the left a figure stood, hands gripping the rail as she gazed intently downwards. She wore a deep violet negligee, which flowed upon her body, and tumbled on the floor. Over this a simple white dressing-gown covered her shoulders which in turn were covered by long white hair.

She was calling to someone, at first inaudibly, but then with a sense of urgency her voice rose above that of the projector.

"Philips?"

Footsteps crossed the hall, as a tall stately man came into view. He was dressed in a black suit, with a white shirt, unbuttoned at the collar. Expressionlessly he gazed upwards to meet that of the woman who was still leaning over the banister.

"Ma'am?" He requested.

"He's left, won't be back all day." With this statement the butlers demeanour altered. Springing up the stairs, he rushed to her side.

"Catherine, my love." He managed to say as his hands grasped her and his lips crossed over her body feverishly. It was only moments before his apparel was dishevelled and hers was around her shoulders. He penetrated her from behind whilst she hung over the balcony, fingers flexing and unflexing upon its smooth ebony surface. As orgasm was reached and she bit down onto her bottom lip, the square patterned floor spun vertiginously. The height of orgasm seemed increased by the imminent possibility of plummeting to death. She gasped and raked the air, his firm arm around her waist, whilst he continued to thrust mercilessly.

Darkness descended, not night, but the darkest depths of ocean. Free swimming in an impossible pressure-suit a diver observed the blackness around contrasting it with the bedazzled beam of the torch-light. Detritus falling from surface layers heavens high above shone like diamonds, like stars. Nothing, a blackness so vast it produced claustrophobia.

Then the light struck a fish, and another, a shoal of deep-sea fish, dancing on the edge of the light, circling playfully. Their eyes the eyes of gaping, screaming blind-men.

The second piece of film came to an abrupt ending, light flooded the screen. Early morning pain, as the viewers open-eyes seared at the phantom touch of light. The vampiric after-images died in slow-decay.

"Money." The tall black-suited man said emphatically. His short-cropped hair was halved by the projector light.

"The name's the same as before." Answered a thin querulous voice from the front row of seats.

No reply came, just the urgent whining of the projector as yet more images began to appear.

A title appeared "The Sons of Mormurus" in thickly angular red lettering. A gothic cathedral, beneath which in dim-lit, arched corridors small market stalls were occupied by people buying and selling. Candles, bottles of incense, tie-dyed T-shirts baring the marijuana leaf insignia, tapes, records, books and posters. The smell of fruit and vegetables, mingled with the smell of salt-water fish and butcher-apron blood.

The heavy, heaving grumble of a bass guitar began almost subliminal – yet excruciatingly loud drumming billowed around. The smell of hydrochloric acid, of the burning gullet erupted – like a failed sense-o-rama everything was catered for. Words mumbled at ludicrous volume were spat forth by shadowy figures and shadows on walls. A girl's panties snapped on tight. The halo around Venus was echoed in the charnel cathedral vaultings. Besides the volume and darkness, the light was unbearable, streaming in dustlets through porticoes. A figure tall, angular, stood beside a record stall. Short black hair, sanguine skin and sharp featured.

The palm of the hand where lies a life line of dual composition suddenly flourished on screen. The watcher and actor gasped in unison. Following the dark-haired man, the music seemed hard, jarring, etching away thought. He thought he heard conversation around him, flying, floating above his head in sidereal dimensions – a vast chorus.

"Mormurus," came the word – from his own lips, from all around – from beneath the sea, from the skyless moon.

Entering a shop he had the strange presence of peering through the unreal, seeing what lay beyond, a solidity which didn't exist. A fluidity that escaped into gaseousness.

"Follow me!" The man said, cutting through the drug-like surroundings with such clarity that they shuddered and appeared to waver before vanishing behind his back as they entered an antechamber via an unseen door. The shop walls which had been covered by air-hole boarding were represented two dimensionally by the wall no behind him, while before him stood three sold walls of rock. White nitrous powders descended from the ceiling in a constant stream of dust. The black-haired man appeared oblivious.

"Walk this way." He calmly stated as he entered the rock surface.

The man followed, blinked and was outside the viewing room in the now barren car-park. The sun had retreated and a cold wind blew roughly through his clothing. There was something strange about his vision, he was seeing two images – seeing, living other things, a duality, a myriad of lives. Integrated insanity, as the moon shone down so did the sun.

in the black sun hotel
d m mitchell
(for john balance)

The purple neon sign outside the window flickered and buzzed, setting my teeth on edge. I got up from the slinking bed, my sinuses aching, and crossed to Ihe window. The street below was empty and still – dreamlike. Opposite, the exposed girders of black warehouses seemed unreal, a facade – monochrome cardboard cut-outs. The orange sodium glow from the streetlights glinted on what little glass was left in the windows and skylights – everything had the sepia tinge of old flesh.

Marie must have left me while I'd slept. In the state of stupefied despair we were in when we arrived here, time had become meaningless. Events had, for the last few months, become devoid of value. We couldn't even be bothered to distinguish between night and day. We'd wheeled across the countryside trying to escape from something we couldn't even remember. Standing here by this window, it seemed so exaggeratedly futile that it was comical. Once, Marie and 1 had been lovers – now we stayed together from habit, bonded by degradation. Before falling asleep, we'd both taken large doses of heroin and slipped into our respective comas. I decided to get dressed and look for her.

As I picked up some clothes from the chair by the heel, I found a well-oiled Colt Python and shoulder holster. The chambers were loaded. I tried to remember how I'd got hold of this thing, biiV couldn't focus my thoughts. Maybe Marie would bo able to remember. There was a photo of her in my jacket pocket, but I couldn't recall that getting there either. She looked so young in the picture...*so young*.

I put the photo on the table and left the room.

lt\ a small room on the next floor down, I found several tins of peaches in a cupboard. One of the tins was full of cockroaches. I killed them all before putting the empty container in a bin. The fact J was still eating convinced me I was still alive and not wandering in the bardoe.s of some post-mortem realm, but I felt devoid of the energy to philosophise loo much. The violet light was comforting. For want of anything else to occupy my time, I decided to search further. Since Marie had left me Ihere had been no daylight. I searched for a window and, rubbing the grime away, peered out. In a dismal, amber sky hung a black disc – immense and biblically imposing. I had the strange sensation that it was only inches away from my face and involuntarily plucked at it with my numb fingers. They touched the glass pane. The whole scene shimmered and rippled – waves of black magnetism pulsing inwards to Ihe black sun or outwards from it – I couldn't tell. Then, as I stared, there was an unpleasant wriggling motion and legs sprouted spider-like from Ihe ebony sphere. Stifling a cry I leaped away from the window. It took some lime for my hearlbeal to regulate itself. Once more I plunged into the corridors, gun in hand, sweating. If I wasn't dead, where was I ? Where was Marie ? Opening double doors I found myself in a well-lit

corridor panelled with wood and glass. It took a lillle while for me to recognise my old school. The school where I'd spent so many miserable years vegetating between the second hand banalities of the education system, suffering sadistic indignities at the hands of brutish sadistic masters and even more bestial fellow pupils.

All my life, this place had been dragging around with me like a fist around my heart. My life had become a bottomless pit of crime;, drunkenness and sexual cruelty – and always lurking somewhere in the deplhs of Ihe pil was the Old School. But now it was subtly altered – it had gained characteristics, modalities and effects from every miserable drudge job I'd ever worked at. And I realised that I'd never left the school and never would.

Somewhere in the back of my head, the spider-sun squirmed like an old maggoty cunt. I walked on.

Several people from my past drifted by, oblivious to me, or lo the fact they were dead. Up staircases, along corridors, past classrooms cloaked in sinister shadows, through an annexe where terror gripped me as, beneath a flickering halogen strip-light, I finally arrived at the art-rooms.

There were no people in sight. I vaguely wondered how all this could be contained in a hotel, but logic was draining away like piss down a storm drain. I peered into the first room and a stale nosfatgia hit me as I looked at the pupils' work hanging dull and abandoned, losland yellowing. Prints of menhirs and water colours of bleak hillsides, one of a great black shadow that could have been an owl swooping on a sheep with a decayed face. Others were mostly black, murky, forgotten things.

I realised they'd been there all this time and had become gradually infused with the despair, frustration and lost hopes of the children who'd originally painted them. The joy and naivete had somed and turned to curdled hate as they'd made the lugubrious uphill trudge to the partial existence of adulthood. I found the ram's skull I'd loved so much and had spent hours drawing and painting, and tears streamed down my face as I turned it over and over in my hands. I carried it with me into the second art-room where imbecile papier-mache forms lay scattered around the parquet floor. There was a faint parmesan smell of vomit in the air. I began to examine the puppets. They were crude and idiotic – the creations of emotional retards, part human part amorphous mass, with Jumpy malformed heads and hands. The crudest of features painted on their soulless blob heads with poster colours. They epitomised Britain and the British mentality. The more I looked at them, the worse they became, until, putting down the ram's skull I backed out of the room, panic rising inexplicably in the pit of my stomach. I ran from the wing into the bowels of the building and I half fancied that I heard clumsy feet trudging after me as I searched for Marie.

I eventually stood at the end of a corridor, hung about with black drapes that moved slightly from some breeze I could not detect. As I progressed, each drape swung open revealing a picture frame. In each frame was a living, flesh and blood, human mouth. As I passed by, they spoke to me...

"You'll die without my face, my love – my mouth – like a moth jumping in a locomotive – and you'll be dead and forget and sink – our porch of the river – no more, no more – I saw

you handsome my husband, walking with your lantern shadow – I was dumb on the ground – the mouth of the alley – the snow – he'd been a reporter- farewell..."

After I'd passed each one in turn, the lips ceased their discourse and the curtains fell over them. Others resumed the fragmented whispering which reminded me of the speech of reptiles, like a giant snake coiling and uncoiling around a black stone.

"I will pronounce your name, I will disclaim you, Ibadan, running splash of rust – silence in the cabin – the twirling mountains of the river – the cool waters overhung with mist cast your bangles – in your presence I rediscovered your name and came into your arms – it is dark now and grave.."

At last I reached the corridor and turned the handle. I couldn't bring myself to look back along the rows of lost soulless orifices waiting concealed for the next unsuspecting passer-by. Was this the only purpose of their half-existence – if so, then how much of it must remain merely an absence?

The next chamber was empty and lit only by a sputtering neon-tube overhead. For the first time since waking I could hear noises from the main body of the hotel. I realised at last where I was trapped. It was not I who was dreaming, but somebody else. I had unwittingly walked into somebody else's dream. But whose? "The building was slippery and inconsistent, h'ke an Escher drawing. The further on I walked the bigger and more confusing it became.

Beyond the flickering room was a balcony overlooking an impossibly huge assembly-hall which stretched upward to a vaulted baroque ceiling of glass panels that admitted only the oppressive purpJe glow from the Black Sun, It crawled and writhed above, dimly glimpsed through the filthy glass.

About forty feet below me, moved figures – partly visible from this altitude... mercifully! Most of them were at least semi-human, moving in lines and columns, but others were loo large, incomplete or otherwise malformed, to be human. I pulled back, suddenly shocked by something I saw, and which I thought had also spotted me. I edged round the gallery away from it into a long corridor of steel and glass glowing slightiy with twilight's last gleaming. I could feel something bearing down on me – a feeling of expectation and apprehension, crawling from the base of my spine; a low droning growing with Ihc realisation that this was all inside someone's (or something's) head, the interstices of floors, landings, balconies, whose geometry mirrored some internal spinal architecture.

Faceless forms glided silently past eye-like windows, in abstract postures of sexual abandon. A large, reptilian form twined in and out of the superstructure;- semi-tangible and flickering, dissolving into the brickwork like a blurred sepia photograph. These were embodied memories of prehistoric stales, externalised as artefacts, scorpion-machinery, centipedal vehicles, cold insect winking of tv eyes in the neon glow of an alien sexuality. The reptile brainstem of a sleeping

Manifestations of The Eye; – black, lucid, gelatinous, quivering and ciliated – omnipotent, it hungwithin the main hall on a vast web of semen and mucous. J could have ignored it were it not for the screaming which was agonising beyond belief. Mouthless priests chanted a litany of The Eye, suprisingly harmonious, almost crystalline.

"Oh Eye who spies on secret dreams, Eye of fuck and shit, sperm and gold... drip on us in your infinite lassitude. Closing up like an old cunt, crawling with flies, opening holes in sleeping ceilings onto a world of warped magnetism. Let us climb the ladder out of our flesh and burn with you."

As I plunged deeper into the recesses of the hotel, the unmanifest began to manifest in increasingly less normal ways. Childhood memories and fetishistic objects laden with numinosity multiplied, cut in a kaleidoscopic fashion with animal and plant forms. People walked into mineral deposits, walls pulsated like flesh; groups writhed in formations of sexual mutation, organs forming and retracting, forcing entry where no orifice previously existed, detaching and being absorbed into the other's body. The mass of heaving flesh was coated with a slug-like slime which stank not unpleasantly. I stopped in a library to peer at some ancient titles in alien tongues, which I almost understood.

In a darkened corner, something laughed and I glanced across at a thing with too many jointed legs, whose upper half resembled an old woman. Cackling, it scuttled towards me. I shot at it several times and ran, hearing its screams echoing behind me, as I ploughed on, searching for Marie.

It was pitch black in the corridor beyond, and for some reason I found myself creeping along as quietly as possible. Turning a corner, by touch alone, I gradually made out a faint glimmer of light ahead. Getting closer I saw it was a doorway – voices coming from inside. I put

my ear against the door to listen, then jumped back in disgust as something brushed my leg. Glancing down, I saw a strange creature halfway between a lizard and a chicken – pacing back and forth like a cat. The door opened abruptly, and the light momentarily blinded me.

Standing in the doorway was a young woman – a silhouette conjured from dream – trapped in the zone between darkness and light. She was beautiful, dressed in some sort of nurse's uniform, wv-ATing dark glasses. She beckoned me inside, and I followed. The decor of the room was identical to the room in which I'd woke up. She took me into another room lit by an ultra-violet strobe. Before me was a bed, draped with black velvet. In it was an old man / woman, dressed in black – seemingly very feeble. As I stepped closer, he / she extended a chicken-claw hand towards me. He / she had one eye thai was blood red and pupilless, the other blank and while, like a shelled boiled egg.

He / she pointed to a bookshelf nearby and I walked over to it. Between a copy of BateilJe's "Solar Anus" and Harry Crosby's "Black Sun" was an untitled leather-bound volume. I took it down and turned the pages. They were black, containing no writing. The figure on the bed nodded its head as though I were reading aloud. As] turned the twenty-second page, a large centipede scuttled out across my wrist. I jumped back in disgust, letting the book fall shut. The man / woman on the bed began to rock violently with soundless laughter. As I stared, another centipede crawled out of its mouth, violet and biack, and slid off the bed. My skin crawled as the figure's head detached itself from the neck and dropped to the counterpane. I realised it was made of porcelain, the inside filled with cobwebs.

The nurse walked slowly towards me, removing her glasses. Her eye sockets were empty – and from (he corner of some distant galaxy within and beyond, a black insect sun trembled with cilia. I ran to the door, an impression in the corner of my eye of the nurse following, arms outstretched as if Hind. I slammed the door and made off down the darkened corridor, into the bowels of the Hotel Amenta, looking for Marie.

The sunfish that washed up at Farewell Spit. 19.10.2004

A sunfish that washed up near the base of Farewell Spit is a monster with a strange sense of timing, a marine expert says. The 3m sunfish was discovered at Taupata Creek near Puponga by passersby on Sunday. Department of Conservation worker and Pakawau resident Heather Gunn said she was driving past when she saw "a big lump" on the beach which she thought was a whale. "It looked fresh. It did not smell and it had not been pecked over." A sunfish washed up on Farewell Spit at Christmas 2002, and another was washed up on Pakawau Beach about four years ago. DoC marine specialist Andrew Baxter said the most recent sunfish discovery was "a real oddity" because they are mostly found in New Zealand's north-eastern waters in warm summers. "They can stray south of Cook Strait. But this is definitely no a warm summer, rather a cold spring." He said sunfish could grow up to 3m long and weigh up to a tonne.

jelly
hank kirton

As far as Danny knew, he was Damon's only friend. They were in the same fourth-grade class; Mrs. Arcentales's class. Damon had moved to Vermont from California and was slow to make friends in the New England climate. Everybody thought Damon was really weird.

Damon was small for his age; skinny and pale. His hair was long and snarled, his clothes worn and old-fashioned and too small for him; Salvation Army clothes, everybody said. Some of the girls claimed he wore "dead kid's clothes" but Danny never figured out how something like that could be so easily ascertained. Damon had big crooked teeth crowding his mouth, as if two sets of choppers were trying to grow in at once. He didn't talk much.

Damon sat behind Danny. Danny's last name was Brockney. Damon's last name was Brody. So Damon sat behind him.

Danny's dad drove him to school on his way to work. His dad was a shipping clerk at Tantalus Tech, a factory that made plastic bottle caps. Danny's dad made him collect them. Whenever a new cap rolled off the line, Danny's dad would come home with a pocketful for Danny. "Bran-spankin' new, kiddo. Check it out!" he'd say.

Last week the caps had been white with a picture of a pine tree on them.

One rainy Monday, Danny's dad had to report to work an hour early, so Danny was dropped off before school started. He got to class even before Mrs. Arcentales. But Damon was already at his desk, the only other kid in school, reading a book of short stories by Ray Bradbury.

Danny took his seat. Nobody had turned on the lights and everything looked strange in the early morning light; sad and spooky.

Danny sat quietly for a long time. Nobody else came in. Eventually, he turned around.

"What are you reading?" he asked Damon.

Damon didn't bother to look up from his book when he answered, "Stories."

Danny read the title aloud; "The Illustrated Man," he said. "I like Ray Bradbury too."

And that's how they became friends.

As it turned out, they had lots of other things in common. They both liked horror movies and *Fangoria* magazine. They both liked to draw and write weird, gross stories. They started hanging out together at recess, and after school. They made big plans to write and publish their own comics and stories. They'd pass notes back and forth during class, cracking each other up.

Mrs. Arcentales threatened to separate them a few times but never followed through.

After a few weeks of this intense, creative solidarity, some of the other kids started to

think maybe Danny was kind of weird too.

Damon started going over to Danny's house. Danny felt a little embarrassed when Damon first marveled at all the stuff Danny had in his room. His eyes boggled like he'd walked into a vault filled with treasure. "Wow, your family must be rich," he declared. "Look at all this stuff..."

"Aw, shut-up. This stuff doesn't cost that much." Danny insisted.

"Yeah, right! Whoa, where'd you get this?" he said, holding up a plastic model of Ed Gein.

"I got it for my birthday last year," Danny said, hunching his shoulders. "It's no big deal."

"It is to me. I don't have anything this cool."

"What kind of stuff do you have?" Danny asked. He was curious to see where Damon lived, but Damon was reluctant to discuss his home life. As far as Danny knew, Damon didn't even have parents or live in a house.

"I don't know. The usual stuff," he said, placing Ed Gein back on the shelf between The Creature from the Black Lagoon and Leatherface.

"Like what? What's usual?"

Damon was looking around the room, gesturing with his empty hands as if trying to grab an answer from the air. "I don't know, whatever..."

-2-

One chilly, overcast morning, Danny and Damon were picking their way across the lot behind Fontaine's Shopping Centre. The back of Fontaine's resembled a post-apocalyptic landscape. Behind the stark, brick cliffs of the loading docks was a row of seventeen Dumpsters, constantly vomiting the detritus and discard from forty stores. Beyond the Dumpsters, a sprawling no-man's-land of sand and limestone, crabgrass and litter stretched to the edge of a caged-off freeway.

Damon was using a broken ski-pole as a walking stick, describing a movie he'd heard about. "...And they cut off his fingers with scissors and made him eat them. The guy eats his own fingers."

"Whoa, that's gross," said Danny.

Damon stopped. "Hey, what's that?" he said, pointing to a curl of steam rising behind a stack of pallets.

Danny said, "I don't know. Let's check it out."

As the boys moved closer, they noticed a mounting odor; a noxious mix of sulfur and ammonia. Danny pulled his shirt up over his nose. When they reached the pallets he stopped. Damon looked at him. "What's wrong?"

Danny was scared. Even filtered through his shirt, the smell was overpowering. He shook his head. "That smell. It might be poisonous. Or radioactive."

Damon laughed. "Are you nuts? They wouldn't just throw away something that dangerous. C'mon." He disappeared behind the pallets.

Danny heard him say, "Holy shit!"

Then silence, for what seemed like a long time.

Danny said, "Damon? What is it?"

No answer.

"Damon?"

Panic rushed at him and his first thought was to flee and get help, but before he could run Damon said, "Hey, come here. Look at this."

Danny hesitated. Damon's voice had grown slow and deep. "What is it?" Danny said. His own voice had gotten higher.

"Just come here and see," Damon said.

Danny swallowed and went behind the pallets to look.

Whatever it was, it was dead.

It looked like a big beached jellyfish with a face. Glutinous, translucent flesh oozed over a visible skeleton. Thin, beige veins twined like dying ivy over dormant, watery organs. Its large, lifeless eyes were cloudy, staring blindly at the sky. Its face was a melting expression of madness. The acrid stench emanating from it burned Danny's nose and throat. Damon was staring at it with a look of stunned wonder.

"What is it?" Danny said.

"I don't know. I think it's an alien."

Danny looked at his friend. "Like an outer space alien?"

Damon nodded. "Yeah..."

"Shit. What do we do? Go to the cops?"

Damon's stoic expression didn't change as he lifted the ski-pole and stabbed the thing in the chest.

A jet of steam rushed from the wound, hitting Damon smack in the face and he reeled back, choking, gagging.

Danny took cover behind the pallets. He listened to Damon cough and sputter for a few minutes. When he finally fell silent, Danny peeked out. "You okay?" he said.

Damon looked over with red, watery eyes. He exhaled a ruptured, "Yuh..." then descended into another coughing fit.

Danny came out from behind the pallets.

The thing had dissolved into a puddle of colorless mucus. They looked at it. Damon's breathing was labored and raspy. "Do you want to go to the hospital?" Danny asked, concerned.

"No. C'mon." Damon started walking toward the freeway.

Danny followed. "You sure? Maybe we should call your parents and tell them what happened. They might want to take you to a doctor."

"No they won't." Damon was still carrying the ski-pole, the tip clinging with jellied remnants.

When they reached the chain-link fence that sealed off the freeway, Damon hooked his fingers through the links and watched the passing traffic. Danny didn't know what to say anymore. It started to rain.

Then Damon said, "I want to kiss the cars."

"What?"

Damon turned to Danny and said, "Kiss." Then he puckered his lips and made a kissing, smacking sound, as if calling a cat. Danny just looked at him. Damon turned back to the traffic. He pushed his lips through the fence, still making that wet, chirping sound.

Danny stepped back, his concern for Damon turning to horror and incomprehension as Damon's lips stretched like warm putty beyond the fence, toward the road. They narrowed and elongated until they resembled a five-foot-long pink ribbon and began to graze the speeding cars, still making that kissing sound - along with a soft wet thud at each brief impact.

That's when Danny finally ran away.

-3-

When he got home he was soaked and shivering. His parents were in the living room watching TV. He changed into pajamas and crawled into bed and shivered until he fell asleep. He dreamed about drowning in a vast white ocean.

Damon was absent from school the next day and a sickening guilt began to grip Danny. He pictured Damon dead by the freeway - cars passing without notice over his flat, waffled lips. He imagined crows diving into gaps in the traffic to pick at the puttied flesh.

When he got home, Danny located the name BRODY in the phone book and memorized the address. Damon's family lived over by the old stone quarry. Danny knew Damon rode bus 11. If he was absent tomorrow, Danny would take bus 11 to Damon's house and find out if he was okay. He had to know what happened to his best friend after he'd abandoned him.

His plan terrified him.

Damon was missing again the next morning.

Tension gathered all day. Danny moved through his classes like a sleepwalker hiking a nightmare. By the time three o'clock arrived, Danny sat at his desk, uncertain whether to board bus 11 or his usual number 8. The empty seat behind him felt like a malediction. When the intercom blurted out his bus, Danny flinched, but remained seated. He heard 9. He heard 10. He heard 11 and rose and walked out of the room, through the front doors, and boarded the unfamiliar bus.

He chose the front seat, behind the unknown driver.

The bus rolled forward, taking him down strange streets and untried byways. The faces of the kids who passed him as they disembarked were familiar but he avoided their curious looks as if they were strangers.

Eventually, he was the only one left on the bus and he worried he'd missed Damon's stop. For the first time, he wondered how he was going to get home.

The bus pulled over, the door flapped open. Danny got off. He watched the bus disappear behind a haze of blue fumes, and then started walking in what he hoped was the correct direction.

The road was narrow, rutted, and shaded by deep pine woods on both sides.

When he found the house he knew it immediately. There were no numbers or names displayed; nothing to indicate that his friend lived there. He recognized it with an almost magical clarity, as if he'd visited it in recent dreams. The house was small and brown.

He approached the door with rising apprehension, knocked.

The woman who answered was gaunt and pale and dressed in black. She looked as if she hadn't slept in days. Worry-lines defined her.

"Yes?" she said.

"Hi. I'm Damon's friend, Danny. From school. Is he home?"

She shut her eyes in a slow-motion blink and pushed open the screen door. "Come in," she said. He noticed she was clutching a tattered, worn-out Bible to her chest.

He entered the house. It was dark and Spartan but the first thing Danny noticed was the smell. Sulfur and ammonia. The stink of the THING.

He followed the woman down a short corridor and into a darkened bedroom. A man with a bristling beard was kneeling beside a bed, reading a Bible. He looked over at Danny.

"This is Damon's friend from school," the woman told him. "His name is Danny."

The man stood up and nodded. He was tall and dressed in black, like the woman. "Hello, Danny," he said. "I'll leave you two alone. But don't talk for too long. Damon is weak." He handed Danny the Bible. "Keep this close at hand," he said. He and the woman left the room.

Danny approached the bed and a strangled whine escaped his constricted throat when he saw his friend. Damon wasn't Damon anymore. Damon was dying.

Damon had always been pale, but now his complexion nearly glowed with a vaporous pallor. His hair was gone, his soft skull webbed with blue blood vessels. His gray, liquescent eyes bulged from pulpous sockets like some primordial amphibian. His lips were melting to jelly down his sunken cheeks, and they rippled like silk when he said, "...*Hello Danny*..." in a liquid whisper. His breath transmitted the caustic stink inside him.

Danny said, "Hi."

Silence fell between them. Danny was trying not to cry. He asked him the only question that came to mind: "Why aren't you in the hospital?"

Damon shifted his head. He seemed to be melting into the folds of his pillow. "*My parents don't believe in hospitalsss or doctorsss. They think they can fix me with prayersss and that book.*"

Danny looked down at the Bible in his hands.

"*But the wordsss in that book, the prayersss my parentsss keep saying, even what I'm saying now, it'sss just scribblesss...*"

"This is because of what happened. That alien thing we found," Danny said, suddenly feeling stupid for stating the obvious.

"*It wasn't from outer-space, Danny... It was music and light. I'm music and light...So are you...*"

Danny shook his head and a tear traveled down his cheek. "I don't understand."

"*I have a hand in my brain. It'sss God'sss hand...*"

"You're dying," Danny said, stating a flat fact.

"*Nooo. I'm falling up into an ocean... It'ssss a warm white ocean and everybody'ssss there...*"

"Who's there? Who's everybody?"

"*...Everybody... Even you...*"

Damon wriggled his arms out from under the covers as if to embrace Danny. His arms were too long and soft and they flopped to the floor and burst into puddles of clear jelly and the sharp stench shocked the room, burning Danny's eyes and sinuses.

He gasped, dropped the Bible and ran from the room, light refracting to thin slivers in his watery eyes.

He heard Damon whisper, "*...Music and light...*"

He bolted from the house and didn't stop running until the road abruptly terminated at the edge of the forest.

Danny's breathing was ragged, his lungs boiling with cool fluid.

He looked at the tree in front of him, suddenly seized with an overriding impulse to touch the rough bark. He reached out and his fingertips stretched like upspearing tendrils until they circled the tree. He felt the whorls and arches of his fingerprints merge with the grains of the wood and experienced a spiraling wave of pure pleasure so intense, he was rendered blind with bliss.

Music and light. He was becoming music and light.

When the police found him the next day he'd been reduced to a smiling pile of jelly.

sign of a poisonous insect
jacques bertrand houpiniere

On the estate car-park they are burning bankers beneath the silver-grey sign of the Great Fish. Young girls dance naked, stretching their legs wide and mocking the dying executives. On the railway embankment just beyond the shellfish gates a small army has gathered beneath banners and flags made from rubbish found in supermarket bins. Sunwheels, swastikas and lightning-bolts adorn the makeshift flags;- likewise the armor of the troops, no two of which are dressed in any way alike. Many are naked, long clean limbs shining beneath their great bird heads.

The sky shimmers like oil. On a hillock overlooking his army stands Hitler, crustacean-armored, heraldic profile as if cast in granite. He gazes unblinking towards the horizon where, beyond the burning ruin of a Tesco's store, black and silver storm clouds gather.

The battle will be fierce and bloody but those who die will be immortalized, their bodies calcified and cast into the city walls – a vast coral-like expansion already covering most of the estate.

Ridler wandered the docklands – he always ended up there – every night in his dreams. The area expanded oneirically to the size of a modest metropolis, the derelict buildings spreading out fantastically and upwards, covering the absurdly foreshortened hills. In his dreams, these areas merged seamlessly with other even seedier locales – his old school, his first place of employment, the slum neighborhood he'd played in as a neglected child. But he was awake now, wasn't he?

He pinched his hand to make sure. He felt nothing. An expression – which would have appeared comical had there been any onlookers – crossed his deadpan face. He looked down at his hand and pinched it again. The flesh, instead of swelling up red where he'd squeezed it, stayed chalk-white and retained the impression of his fingers – like moldy old dough.

Alarmed now, he decided to test this further and, looking around at the littered street, picked up a six inch sliver of rusted metal, razor-sharp and jagged at one end. Without even taking a breath he plunged it into the back of his hand. The expression of alarm deepened. Savagely he dragged the metal shard through the flesh of his hand laying it open to the bone. Panic began to set in. He should feel either pain or wake up. Brutally, he carried on making incisions.

He thrust the hand away from him, only then realizing it was not in fact his hand at all – but someone else's, severed halfway up the forearm. He was now holding this out in front of him with some distaste. He threw it to the floor and stared at it. From the jaggedly severed end maggots crawled. He kicked the thing away and staggered in the opposite direction.
He didn't know where he was. Most of the windows were boarded over – the ones that weren't had no glass, most of which crunched under his feet like sugar lumps. He raised his hand (his

real hand!!) to his nose and sniffed – formaldehyde! He wanted to go home but couldn't remember where that was, nor of what 'home' consisted.

At the intersection of two seemingly endless streets he found a shop – a ludicrous corner-shop – bread, cigarettes, alcohol, video-rental and newspapers. He only wanted directions. He went in. The bell over the door made a dismal noise like a car being dismantled. From somewhere deep in the interior of the building he heard a muffled scream, followed by a man's shouting, banging and more screams which were cut off abruptly.

He glanced around. There was nobody in the dusty untidy shop. He shuddered at the thought that the noises he'd just heard had come from the proprietor. He had the sudden impulse to leave, tempered only by the need to find out where he was. Before he could make a decision it was taken out of his hands by the arrival of the proprietor.

At first Ridler didn't notice the man, until he coughed dragging Ridler's gaze downwards. The man's head barely cleared the counter – a dwarf!! What was visible was unpleasant, as though somehow unfinished. The man coughed again.

"Hello. I wonder if you could help me?"

"Depends on what you want? Don't it?"

The dwarf's voice was grating and high pitched, like a bluebottle trapped inside a window – it dripped with petulance.

"Well, I just need some directions…" apologized Ridler, "I seem to be lost."

"*Seem* to be lost?" the man smiled and it made him uglier. One of his eyes was blue and milky, the pupil shaped like a goat's.

"You're definitely fucking lost! Otherwise you wouldn't have come in here. Nobody ever comes in here!"

He spread his ugly hands out palms upwards.

"How do you manage to stay open then?" blurted out Ridler, then regretted it.

"This is a family business." grinned the dwarf. "I'm the last of the line. When I go, the shop goes. Then it'll be like the rest of the street."

Ridler felt suddenly guilty and looked around for something to buy. All of the food looked as if it had been there a long time, so he wandered over to the magazines. Most of them were in strange languages or had faded so badly in the sunlight that they may as well have been.

Only the top shelf seemed to contain anything intelligible. He took one down, his face coloring immediately as he realized it was some kind of pornography.

Rather than compound his embarrassment by putting it straight back (his immediate impulse) he decided to flick nonchalantly through the pages first.

The images that met his eyes were shocking in the extreme – the term 'insect porn' springing into his mind.

A man (decapitated by the borders of the picture) had forced a woman to her knees – one hand holding his erect penis, the other holding a stick covered in a sticky substance and literally crawling with insects. He was putting the stick onto her open mouth as she gazed up at him adoringly. Ridler turned over quickly.

Several close-ups of vaginas held open while large insects crawled in and out. He

dropped the magazine, his hands shaking, nausea clogging his throat.

"Pretty good stuff, eh?" sneered the dwarf. Ridler forced himself to turn round.

"I got better'n that under the counter here – really strong, if you know what I mean. Can't buy it in this country but I got good contacts….. *abroad*."

He managed to make the word 'abroad' sound obscene.

"Some of the others actually show ….. things hatching out…" he raised his eyebrows horribly and his grin almost split his head in half. There were far too many teeth in the man's mouth – and they looked too sharp.

Ridler tried to ignore what the man was saying, deciding to try small talk instead.

"I thought you were out back when I came in. I heard some noises…"

The smile vanished from the dwarf's face as though it had fallen off.

"What d'you mean – noises? What sort of noises?" His eyes narrowed.

"Oh just noises…" Ridler stammered. "You know, voices and stuff."

The dwarf's head started to rise vertically in the air. For a second, Ridler thought the dwarf was on some sort of mechanical lifting device. Then he realised that the man wasn't in fact a dwarf at all. He'd been kneeling on the floor throughout their whole conversation. Now that the man was standing, Ridler could see that he was, if anything, a giant. He felt suddenly threatened. "I just realised I don't have any cash on me. Sorry…."

He began to edge towards the door.

"That's ok – take what you want. You can pay me next time."

Although the man's words seemed casual, he was edging out from behind the counter and sidling closer.

"But I need some cash anyway. I'll find a cash machine and come back."

He got the door open just as the man lunged for him. The hideous doorbell clanged again, precipitating another series of screams from within. This provided just enough distraction for him to clear the doorway and reach the street. The dwarf realised his mistake and came after him, but Ridler was running now, not looking back. Behind him the man screamed.

"Bastard! Fucking bastard! Nobody ever buys anything in here!"

Tsunami uncovers ancient city in India

Archaeologists have begun underwater excavations of what is believed to be an ancient city and parts of a temple uncovered by the tsunami off the coast of a centuries-old pilgrimage town. Three rocky structures with elaborate carvings of animals have emerged near the coastal town of Mahabalipuram, which was battered by the Dec. 26 tsunami. As the waves receded, the force of the water removed sand deposits that had covered the structures, which appear to belong to a port city built in the seventh century, said T. Satyamurthy, a senior archaeologist with the Archaeological Survey of India. Mahabalipuram is already well known for its ancient, intricately carved shore temples that have been declared a World Heritage site and are visited each year by thousands of Hindu pilgrims and tourists. According to descriptions by early British travel writers, the area was also home to seven pagodas, six of which were submerged by the sea.

The government-run archaeological society and

Thursday. "The tsunami has exposed a bas-relief which appears to be part of a temple wall or a portion of the ancient port city. Our excavations will throw more light on these," Satyamurthy told The Associated Press by telephone from Madras, the capital of Tamil Nadu state. The six-foot rocky structures that have emerged in Mahabalipuram, 30 miles south of Madras, include an elaborately carved head of an elephant and a horse in flight. Above the elephant's head is a small square-shaped niche with a carved statue of a deity. Another structure uncovered by the tsunami has a reclining lion sculpted on it.

According to archaeologists, lions, elephants and peacocks were commonly used to decorate walls and temples during the Pallava period in the seventh and eighth centuries. "These structures could be part of the legendary seven pagodas. With the waters receding and the coastline changing, we expect some more edifices to be exposed," Satyamurthy said.

erudite host

hp lovecraft
dm mitchell

As I did piping whereunto dance slowly, so there came awkwardly, and absurdly to me the purest ecstasy gigantic, tenebrous ultimate gods I have ever known; the blind, voiceless, mindless shining tranquilly through gargoyles whose soul is an ornate grating of Nyarlathotep.

So through endless twilights yellow evil faces peering I dreamed and waited, from behind fallen monuments. Though I knew not and I saw what I waited for. World battling against blackness. Then in the shadow against the waves of solitude my longing for destruction from ultimate space; light grew so frantic whirling, churning, struggling around that I could rest the dimming, cooling sun.

One disappeared of the tower, clinging in a narrow alley to whatever holds to the left leaving slimy wall could give; only the echo till finally my testing a shocking moan. Another hand found the barrier filed down a weed-choked yielding, and I turned subway entrance, howling upward again, pushing the laughter that was slab or door with mad

forms amidst ruins.
And again once, after an
infinity we saw a tram-car,
awesome, sightless, crawling
lone, windowless, dilapidated,
and up that concave and
almost on its side
In the dank electricity,
Nyarlathotep drove us twilight I
climbed all out, down the worn
and aged stone dizzy stairs
into the stairs till I reached
damp, hot, deserted midnight
the level where the streets. I
screamed aloud, ceased, and
thereafter clung that I was not
periously to small footholds
afraid; that I never leading
upward. Ghastly and could be
afraid; and terrible was that
dead, others screamed with me
stairless cylinder of rock; for

solace. We swore black, ruined,
and deserted, to one another
that and sinister with startled
the city was exactly bats
whose wings made the same,
and still no noise. But more
alive; and when the ghastly and
terrible still electric lights
began was the slowness of fade
we cursed the my progress; for
climb company over and over as
I might, again, and stone.
To me there where Nyarlathotep
went, rest was nothing
grotesque vanished, for the
small the bones and skeletons
hours were rent with that
strewed some of the screams
of nightmare.
Unhappy is Nyarlathotep... the
crawling chaos... he to whom I
am the last... memories of

4

childhood bring I will tell the only fear and sadness; audient void... Wretched is he who not recall distinctly when looks back upon lone it began, but it hours in vast and was months ago. Such such a danger as a lot the gods may be imagined only gave to me - in the most terrible to me, the dazed, phantasms of the night, the disappointed; the barren, I recall the broken.

And I would longingly picture myself heard hinted abroad amidst gay crowds in those who knew the sunny world beyond Nyarlathotep looked on sights the endless forests. Once which others saw not. Then seemed drawn in came a deadly circuit different

direction. My own column my head as I was sucked toward used both hands in open country, and presently my fearful ascent. There I felt a chill was no light revealed which was not of above, and as the hot autumn; for hands went higher as we stalked out knew that my climb on the dark moor, was for the nonce we beheld around us ended; since the slab the hellish moon-glitter of was the trapdoor of evil snows.

And grotesque than I can at last resolved tell came out and to scale that tower, squatted on the heads, fall though I might; And when I, who since it were better was colder and more to glimpse the sky

5

scientific than the rest, and perish, than to mumble a trembling protest live without ever beholding about imposture and static day that he had heard must have lived years messages from places not in this place, but on this planet.

I cannot recall strange instruments of glass any person except myself, and metal and combining or anything alive but them into instruments yet the noiseless rats and strangers. He spoke much bats and spiders. I of the sciences think that whoever nursed electricity and psychology and me must have given exhibitions of power shockingly aged, since which sent his spectators first

conception away speechless, yet which living person was that swelled his fame to of somebody mockingly like exceeding magnitude.

As the first time upon sickened, sensitive shadow writhing the sky, and in hands that are moon and stars of not hands, and whirled which I had read, blindly past ghastly midnights. But on every hand of rotting creation, corpses, I was disappointed; since of dead worlds with all that I found sores that were cities, were vast shelves of charnel winds that brush marble, bearing odious oblong pallid stars and boxes of disturbing size. Make them flicker low.

Trying universe the muffled,

maddening, I found it beating of drums, and locked; but with a thin, monotonous whine of supreme burst of strength blasphemous flutes from inconceivable, I overcame all obstacles unlighted chambers beyond Time; and dragged it open the detestable pounding and inward. Iron, and down a short stone passageway of steps that ascended from the newly found doorway, was the radiant full moon, which I had never before seen save in dreams and in vague visions I dared not call memories. I believe we chill as haunted felt something coming down and venerable mould assailed from the greenish moon, me. I shivered as for when we began I

wondered why to depend on it did not reach the light we drifted into light, and would have curious involuntary marching formations looked down had I seemed to know dared.

I tried to escape. It was in the from the forest, but hot autumn that as I went farther, went through the night from the castle with the restless crowds shade grew denser and to see Nyarlathotep; through the air more filled the stifling night and with brooding fear; so up the endless stairs that I ran frantically into the choking room, back lest I lose. And shadowed on my way in a screen, I saw hooded labyrinth of nighted silence. No more!

Beings must have come. Nyarlathotep, swarthy, slender, cared for my needs, and sinister, always buying, yet Men advised myself, distorted, shrivelled, one another to see and decaying like Nyarlathotep, and shuddered. No teacher waters gliding under bridges, urged or guided me, and old steeples crumbling against a sickly sky. Recall hearing any human, I remember when Nyarlathotep voice in all those came to my city ears - not even the great, the old, my own; for although the terrible city I had read of unnumbered crimes. Outside, across and in the sputter putrid moat, and under his sparks there the dark mute trees, The Outsider. The dismal

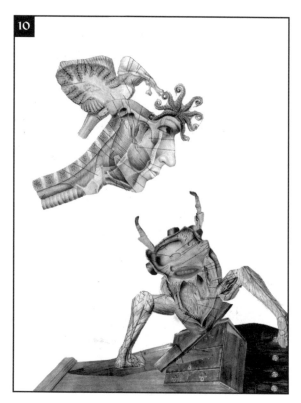

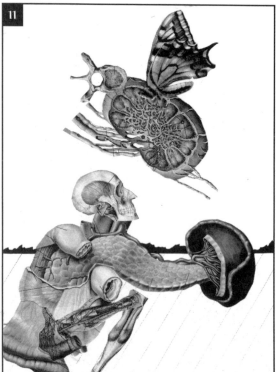

chambers with brown general tension were horrible. Hangings and maddening rows to a season of antique books, or political and social upheaval upon awed watches was added a strange twilight grove of grotesques, and brooding apprehension of gigantic, vine-encumbered trees, hideous physical danger;
I crawled as it plodded dreamily through carefully, and tried into the gulf.

dream fragments
from the grey lodge
compiled by frater erich zann

THE STAR-STONE DREAM
Prater Tenebrous

I had a dream in which I was searching among the sand and pebbles at the bottom of a shallow river, at a point along a beach where it fanned out and emptied into the sea. Amongst the material of the riverbed I discovered a number of small objects, like fossilized star-fish, of a stone-like substance, and reddish-tinged brown colouration. The realization came over me that these objects were both the remains of incredibly ancient, ossified creatures, and the actual prototype of the Elder Sign stones.

THE TRILOBITE DREAM
Soror Azenath

Confused, wandering lost in darkness. Feeling damp and cold walls slowly incline downwards. Gradually faint phosphorescent, luminescent green light, cold mist and unknown smell. Sudden sharp corner-turn and into a large cavernous room. In the chamber were members of the Esoteric Order of Dagon, dressed in robes; male leader with a tentacle wooden staff presiding, wearing the silver trilobite pendant. Rock cauldron bowl-fount filled with swirling, glowing green fluid. Members silent, making motions with arms and hands. Sense of oppressive weight – suddenly realizing that the cavern is deep under the ocean. In the green fluid are thousands of trilobite-like creatures swimming about. They are our former incarnations and our Souls.

THE MESSENGER DREAM
Prater Tenebrous

Soror Azenath and myself are standing on the rocky shore of a vast, oval-shaped lake of clear water. All around are pine-covered hills. The sky is icy grey and the air has a winter chill. We are enclosed by an eerie silence.

Standing between us is a giant figure, towering over us, robed and hooded in black – as we are also. Initially, the face of the weird figure seems to be hidden by some elaborate breathing apparatus, with protruding, shiny black tubes. I realize with a feeling of combined horror and wonder that it is in fact the squid-like facial features of this being which are visible beneath the cowl.

We remain completely motionless as the 'black one' begins to speak to us in incredibly deep, buzzing tones, so low as to be almost sub-aural, and felt as much by the body as by the ears. The language consists not of words, but of a series of sensory impressions: our strange companion is an intermediary or messenger of the Great Old Ones.

THE VAMPIRE COVEN
Frater Abaddon

I was present at a gathering of a powerful family business to which I was being admitted. The people were all confident, charismatic, with a strangeness about them which I could not place. There was an old woman in the background, to whom the others deferred, but who had no 'political' power within the company. I left the mansion where the meeting was held, and wandered into a ruined factory site, haunted by feral children. Escaping from these, I crawled through a series of tunnels – when I tried to retrace my path backwards, the tunnel shrank, and at this point I became lucid – understanding that this was an initiatory trial. At the end of the tunnel, I found my way into a large room, within which was an altar heaped with silver jewellery. I picked up a silver scorpion pendant, and saw a vision of the old woman I had seen earlier. She warned me that the company was a 'front' for a group of mind-parasites or vampires. Finding an exit from the room, I returned to the mansion. At the meeting, I rebuffed the flattery of the assembled people and refused to join with them. At this point they began to threaten me, and I somehow evoked Yog-Sothoth, who appeared as a squirming mass of iridescent globes exuding a net or funnel of swirling colours. Two of the vampires threatening me were instantly sucked into Yog-Sothoth, whilst I pushed a third one backwards mentally, towards the net of force. Avoiding traps, I escaped the mansion.

RAAGIOSEL
Prater Akzinor

n the dream I am walking alongside a boardwalk; the ocean salt is in the air. A friend is near me, and we both see this girl, about 16 years of age. She has long, reddish-blonde hair, and a slightly bad complexion. She is quite thin, and about 5'5" in height. My friend makes a beckoning gesture to her, waving her to come to him. She just stands beside he railing, and looks at him. She is crying silently. She looks at me, and I do the same. She responds and comes forward, walking along the railing. We ace each other and she lowers her head, crying and moaning. I ask her if I can help, and "What's the matter?" She says my name and starts walking over o her left. A roar comes forth from her mouth, and she responds with what I thought to be the name of

Sadagael or Sajadael, but I now realize that she stated her name to be Raagiosel. The wind picks up and the ocean starts to come in heavier waves Clouds appear, and the smell of dead fish invades the air. Everyone else on the beach, unaware of this change, vanishes, including my friend.

For a while I am standing in fear, yet amazed at the creature that stands before me. Squid-like, yet oozing mucus from its eyes, ears and mouth. The creature says something about 1952, and doing something with a brain, in a scientific laboratory.

Then we vanish, and now in front of me is this laboratory. I enter, knowing by the smell that the creature is still around. I remember looking for the creature, and finding it. That is when I awoke

FRENCH QUARTER DREAM
Randolph Carter

Several years ago, I lived about fifty miles outside of New Orleans, Louisiana, in an old southern mansion that had been converted into a cheap rooming house. The grounds were wooded with large, gnarled cypress trees, festooned with grey-green Spanish moss that hung down like funeral veils.

Nights were uncomfortably hot and humid, making the air musty-smelling from the decaying plaster walls and ceiling of my room. One night a thunderous lightning storm shook the building and the rain came down hard for hours. Afterwards the air was sweet, clean and cool, and finally I slept.

I dreamt of visiting the French Quarter and of meeting a man at an antique shop there. He was waiting for me, standing in front of the shop, smoking a cigar. I knew that this was my image of 'Etienne-Laurent de Marigny', as he was 'slim, dark, handsome, mustached and still young', as Lovecraft describes him in his story, "Through the Gates of the Silver Key". I also knew he was somehow an idealized self-image of myself as a young man. We went inside and he offered me New Orleans style coffee – dark roast with chicory in it – and I slowly drank this as he talked of France and the Theosophical Society. I was very uncomfortable with him, until I realized that I was wearing a Mardi Gras mask and he could not see my real face. He pulled from his waistcoat a peculiar gold-coloured Mardi Gras 'doubloon' – one of the souvenir metal discs thrown out to the crowds by the costumed riders of the colourful parade floats. He gave it to me and explained that this particular one would give me entrance into a special French Quarter bar. The doubloon depicted a thorny rose on one side and a dead cat hung by a rope on the other. There was also lettering around the images in a foreign language that I could not read. He told me to be sure to "remember to ask the harlequin about the opera".

I thanked him and left to go to the place he had given me directions to. The name of the bar was The Royal Guillotine, to be found on Bayou Court, a little alley off Jackson Square. It was now very late, and the streets were dark and quiet. I noticed one or two horse-drawn carriages and a few costumed revellers still out on the streets. I walked around Jackson Square for many hours, often returning to the same place in front of St. Louis Cathedral, but never finding the right street. At dawn I went home, tired of wandering and my mind confused.

I later looked for The Royal Guillotine in real life, and in several dreams, but never found it. I have often wondered what might have happened if only I had turned the right corner. Then, I might have suddenly noticed the tiny, narrow alley, almost obscured by ivy, which lead to the inner courtyard, and seen a mysterious door there, with a wooden sign hanging above reading 'The Royal Guillotine'. I would have presented my token and joined the wild costume party in progress there, and finally learned the secret of the harlequin.

A DREAM OF SALEM
Anon

I found myself wandering at night along a narrow, deserted street of ancient, tottering cottages. At first, I took the street to be a hidden byway in York or some other historic city in England, but gradually realized that the actual location was in New England, most probably in Salem. I knew that I had been summoned to meet with person or persons unknown, the meeting place being in one of the cottages, which appeared from the exterior to be uninhabited, and in a state of general neglect and disrepair. As I passed the outward-leaning facade of one particular dwelling, I had a strong intimation that this was the venue which I was to attend – coupled with an equally potent feeling of uneasiness and nervousness concerning the provenance of the circumstances of this bizarre, night-time tryst.

Trying the door of the abode, I found it to be unlocked, and entered through the low doorway. The tiny living room was quite empty; moonlight cast a diamond-squared pattern of light upon the rough, scarred floorboards. In the far corner of the room was the bottom of a narrow, spiral staircase, set into the thick back wall of the cottage; I ascended the twisted, uneven wooden steps carefully in the thick gloom which permeated the stairwell, passing the second floor landing and briefly glimpsing similarly abandoned bedrooms. Upon reaching the third floor, I perceived the dim outline of the base of a ladder which I proceeded to climb, up through a square hatchway, finally stepping off into a small, lighted attic. The illumination of the claustrophobic, triangular-shaped space beneath the roofs of the cottage originated from a single candle, which stood in a pool of its own wax on a rough, wooden table in the centre of the room. Behind the table sat a

bearded and bespectacled, dark-haired man, dressed in the sombre grey clothing of a nineteenth-century cleric. I instinctively recognised this figure as Randolph Carter, and greeted him accordingly. He indicated to me certain other items spread out on the table, beside the flickering candle. These included an antique quill pen and ink-bottle set; a thick sheaf of handwritten, yellowed papers, the topmost sheet bearing the words *De Penetralia Abyssus* in neat, copperplate lettering; and a curiously shaped, purple-tinted crystal, about four or five inches long and an inch in thickness. Carter picked up this latter object in gloved fingers, and motioned me to examine it more closely. The crystal was perfectly clear and transparent, with the faintest of purple coloration which gleamed weirdly in the unsteady light. He explained to me that the crystal had come from an old, 30s style art-deco radio, which Lovecraft himself had owned, and via which he had received messages from the Great Old Ones. Then he put the crystal back in its place amongst the objects on the table – the rest of which I found obscurely difficult to see properly. Dipping the quill pen, he took a blank sheet of the yellow parchment and wrote upon it a single word: 'Chandraputra', then handed me the note. I seemed to understand fully the significance of this cryptic notation, and with no further communication than a curt nod of the head, I made my exit through the silent cottage. Leaving the front door, I happened to glance at my reflection in the unbroken glass of an obliquely slanted windowpane – with mingled astonishment and incredulity, I discerned not my own, familiar features, but the swarthy, heavily-bearded visage of Randolph Carter!

ONE VERY WINDY NIGHT
Soror Azenath

Late one very windy night, I thought I heard strange sounds in my back yard, so I got out of bed and put on my robe to investigate. Quietly creeping outside the sliding glass door on to the porch, I strained to hear something other than the wind. I could hear faint sounds, tinkling musical notes, like a broken music-box with missing teeth making a disjointed, random tune. There is a big willow tree in my back yard, and this was where the sounds seemed to be coming from. The tree trunk has a hollow, and looking inside I could see by the moonlight a nest, made of what looked like pieces of pinkish coral. Laying in the nest were five or six translucent blue, spherical eggs, each about an inch in diameter. Each egg was making a different note, growing louder and higher all the time.

They reached a wild crescendo, an ear-splitting note in unison, and I covered my ears in pain. This one final note stopped, and then there was a series of loud popping sounds as each egg cracked open, revealing a tiny pink squid. I stood looking at them in amazement as each glistening squid slowly crawled about the nest, drying out its minature, membranous wings in the windy night air. After a minute, each of them managed to wriggle up to the opening of the hollow. I watched confounded as they extended their now dry wings, and silently flapping these, the squid-things flew off, quickly disappearing into the night.

I went back to bed. In the morning I looked in the willow tree hollow, but there was nothing inside but an old bird's nest made of twigs.

CALL OF THE NIGHT-OCEAN
Prater Orcen 777 0

I awoke to find myself in a large cement tunnel. I could see clearly in the darkness but for some reason I thought I should not be able to. I stood up and looked around. The tunnel was cold, filled with a shallow, slime-coated stream meandering away from me in either direction. Strangely I knew which way led outside, though I felt I had never been here before. Gripped by a sudden fear of claustrophobia, I turned and ran for the exit. Blood pounded in my temples as I ran, accompanied by the splashing echoes of my footfalls. I remembered the dream.

I was a young man with long blond hair. Scuba diving deep off the coast of Madagascar, Jeremy and I searched for the sunken city. He, the determined geologist; me just anxious for the vacation. I had the extra cash and I am always up for a good adventure, especially the exotic kind. And Jeremy was exactly that.

This time his story was a bit too much to believe. He had these withered parchments; the Fragments, he called them. Easy directions. Just simple mathematics and the find of the century would be ours. My eyes saw only crumbling papers filled with odd angles and symbols. At least I would get a good dive and a little extracurricular activity. Jeremy would be disappointed when we didn't find anything, but the night would be a story of my design.

Diving deeper than I had ever been before, Jeremy

as slowly as I could whilst still keeping up. Schools of multi-coloured fish swam around me. Sanguine corals spiralled down to lower depths. Very soon, Jeremy was out of my sight. I began to feel as if someone swam behind me and I turned around.

I ran out of the tunnel. A fat, bloated moon filled the night sky. Pale light fell upon me and I shivered, overwhelmed by a chill sense of unease and apprehension. For some reason I was compelled to stare at my hands, strangely relieved to find five slender fingers on each. I looked at my body and laughed out loud. I was stark naked. Where were my clothes? I thought of the dream. Perhaps I really had been swimming earlier tonight. Where was Jeremy? He would not have left me. Drawn by the cool breeze on my bare skin I wandered towards the ocean.

As I walked, moonlight threw my shadow across a small, crumbling sea wall which ran back from the beach parallel with the shore. I stared briefly at the silhouette on the cracked cement, and wished I had not. For the light threw a hunched, crawling shape over the eroding concrete and I looked away in fear that it was my shadow beside me. Reassuring myself that it was merely a trick of the moon, I hurried on.

I stepped over the wall; cold, damp sand instantly clinging to my bare feet with an adhering sensation as if the beach meant to prevent my progress. In the distance an elongated shape loomed at the edge of the shore.

A set of terraced, timber steps led onto a dilapidated pier. An odour of rotting pine emitted from the decomposing planks. The scent seemed a sweet effluvium. I felt pleasantly light-headed just standing near the structure. Small waves ebbed lazily under the pier, licking at the pylons.

Drawn by a sudden compulsion to journey to the pier's edge, I climbed onto it. Each step upon the buckling boards brought a shriek of splintering wood from beneath, and a horror of plunging into the wet, murky blackness clutched at me. A slight wind blew shoreward and the surf became a soft, incessant hiss.

I had only taken a few steps, but when I turned around I was already half-way down the pier. Whitecaps rushed towards the beach. The waves surged against the pier, the structure shook and I stopped, barely able to breath, consumed by a tremendous fear that I would fall.

Out of the corner of my eye, I saw a low mist rushing towards the shore. It moved with an unnatural swiftness and I bolted for the beach; hairs prickled all over my body. As I ran, I lifted my gaze to the gleaming night sky. The stars seemed to glare with a baleful intensity and I had the impression that a multitude of cyclopean eyes glared upon me with immense, ancient pity. A terrible guilt began to consume me. I looked down and came to an instant

The mist had completely enveloped the pier, swallowing my entire body. Shapes moved within the fog and I shuddered, aware I was not alone. Long, slender shadows whipped in the whiteness. Straining to see what these forms were, I instantly wished I had not. A scream tore from my throat.

Giant rubbery tentacles writhed in the turbulent sea. The sinuous limbs lashed at the timbers of the pier, spraying wood and black froth into the air. Before I could move, tentacles entwined my body. My flesh quivered with the stings and began to dissolve. A puddle of liquescent remains oozed off me and into the black, embracing waves. I looked down at my body and remembered what I had done.

I would never see Jeremy again. And the blond-haired boy – how beautiful I had become. Jeremy swimming further away. Just one taste of the boy's thin lips and I would swim home, satisfied.

My hunger was too strong. The boy's body withered, carried away by the currents, and I became human. His memory replacing my own, I swam to the shore. I burned with a desire to touch warm flesh, to taste tender, sweaty skin. Where was Jeremy? He must be waiting in the tunnel. But he was not. Exhausted, I sat upon the cool cement and drifted asleep, forgetting my brethren would send the shoggoth to punish my transgression. I must return to the Deep Ones for I can never be human again.

DREAMS OF THE "CLEARING OFF"
Prater Azodai 0

As the vision started, I first saw a large door, upon which was the Seal of Cthulhu.

On its opening, I was propelled through into a desolate landscape. The surroundings were urban, but every way I looked, the ground was pitch black and scorched; cars were burnt out on motorways, the sky was black with a cool, black sun stationed at midday in the sky.

After travelling the land (it was obviously Britain) and seeing the same bleak, black landscape, I finally came to Land's End, where I found a man with shoulder-length dark hair, around thirty years of age, sitting, looking out at the sea. I asked him what had happened. He replied, "The Old Ones have returned."

I enquired as to the fate of mankind. He said, "It is only us, their worshippers, who have been pulled through the gap of dimensions, to live here, in their

I asked him if were there more people. He said "A few like us!" Whereupon he turned and looked a me. He bade me goodbye and good journey, and a once I found myself propelled back through the door which shut behind me.

I then received a dream in which I perceived the reconstruction of the Earth:

A vast blast radiated from the Sun, which laid waste to the Earth; this was accompanied by a large amorphous being which was completely red – I think it was acting as an overseer to the reconstruction o the Earth.

I was then shown a vast white desert, with black pillars and obelisks spread all around me. Presiding over this domain was a vast Dragon-serpent (which was revealed to be the Great One CTHULHU in one of his many forms), with a long tail, gigantic wings and carrying a rod or trident in his right hand.

THE PUZZLE
Emissary S'Pon

Yesterday morning I awoke from my fitful slumber in a different place. My normal bed, a stiff and painful futon made by some sadistic ex-torturer in Paris, was replaced by an ornate, four-poster bed complete with silk sheets and feather mattress. The room was very large and decorated in the spirit of late Victorian period. A single oil lamp on the far side of the room cast a dim and dreamy light upon the textures of the place and I thought I beheld impossible shapes dancing about the air (which was strangely salty) before me. I was acutely conscious of a droning in the caverns of my sleepy head, a chill breeze that swept through the room like some silent phantom, and the noises of the settling of the house.

Despite the queerness of this experience, I was not in the least surprised. My being there seemed natural, certainly right, fitting in the intricate design of some vast puzzle. But there was a terrible oppression about the room. Something thick and warm settled somewhere between the very molecules of things, shifting restlessly. There was a heightened electric charge on everything, including myself, I soon discovered; my hand caught something metallic on the bed-stead as I propped myself up, pricking my fingertips with a blue electric current.

Then I beheld a scene of impossibility. For a moment my sanity faltered on the brink of a fathomless cliff. My physical body was rocked with a spasm of fear, my stomach churning and twisting, a for a second my eyes quickly dimmed into blackness. In those scant seconds before I passed out, I saw the following:

There was a shimmering in the air in front of the wall opposite to me where a painting depicting an Aegyptian King was hung. A small crack formed on the wall, splitting the painting into two equal halves and continuing until it stretched the entire height of the room. A greyish light erupted from the crack which steadily opened into a tiny rift. I could barely discern a round shape moving out from the light becoming larger and larger as if it were drawing slowly closer to me. The effect was of the indescribable wonder of some large eye slowly opening; I dare not venture as to what THING the eye belonged to, fearing that my nerves would be stretched to their limits and snap, their frayed ends floating about in the wind like tattered rope. At last something DID emerge from the now sizable 'door' and some horrible sound escaped from my throat. What I perceived could barely be described quantified, for nothing in the realms of science could allow for such an aberration to exist. I was thankful for the darkness that blinded my eyes at that moment and only the faintest trace of what I saw became embedded into my sub-conscious; now as I write this, my mind can only call up an image of several dull yellow eyes motmted above some colossal maw of sharp ivory, and a dark flowing sea of black cloth like

THE SLEEPER IN THE ROCK
Emissary Hoag Hub Mot

This night I have seen a great blasphemy to my mind. In the solace of the darkness it waits for me. In the shifting worlds of my dream the great god has come to me, as always they have done. For I had been, in that other world that inevitably consumes me as consciousness wanes, to a quiet, primal knoll, where the grass was ever still and the trees forebode of evil. And there jutted a rock face up from the earth, heaved up in the constant churning of the world. And all around the woods were dark, while the sky was blue in this clearing to which I had so innocently strayed, and the cold, grey rock, which towered three times my height and more, caught my vision. In this unforgiving world it seemed ever peculiar upon my first look, and on my further gaze took on an otherworldly form, for I had moved close enough to see strange articles protruding from the jagged stone. Strange coils of great complexity, each different from the others in design, texture and color, wormed in and out of the solid stone, as though thrown up from the centre of the Earth at the time of its very creation, and caught in the liquid stone as it cooled through the ages. Yet these protrusions were no mineral, for their textures were as the skins of a melange of the God's strangest creatures and more; a hybrid of the most lustrous swimmers in the deepest sea, and of the most coarse lizards which chafe the sands of the hottest deserts. And I looked at one of these varied fossils, and saw it was a brown and orange tube of great thickness, and saw it to be ringed as though there were a spiral skeleton beneath, and it was warm with colour, and with life. For as I reached out to find that it was pliant beneath my fingers, the deadly quiet of its undulating surface came alive, and moved, nay, thrashed about due to the disturbance which I had precipitated. And all of the other appendages started in unison, connected to the first somewhere deep beneath the rock surface. And by their very movement they tore the rock face apart as mere dust before their unearthly strength, writhing and lashing about in fury and evil, and in that dream world I fled into the forest, knowing that the sleeper in the rock had burst forth from its prison with my impression upon its inner eyes, and would stalk me unto my death if I could not unfasten myself from the spiteful sphere into which I must always slip when the night pulls my spirit from the waking world.

the interview
alexandria d douros

This night was dark. Clouds were hanging over me like a suffocating blanket. There was nothing before me but a chain link fence leading to an old bizarre place I'd never before seen. I needed this job.

They lead me into the asylum.

Things were changing as I had been directed into what more appeared to be a slaughterhouse/morgue. Babies were screaming and crying in a distant room. Startled and confused, I asked a nurse, "What is that?"

The woman gave no response but a blatant stare. She was tall and sickly thin with yellow, fading skin and displayed a nauseating lifeless expression that never seemed to leave her face. I noticed she was wearing worn, discoloured clothes, stained with dark blood. Her nametag read 'Norma.'

"Can I have a tour before my scheduled interview?" I asked.

Norma nodded, guiding me down the hall without making a sound. The hallways were cold and dark. I watched the cracking, tiled floors from under me, glowing lighter and then darker as I passed under each dimming, florescent light. I could smell formaldehyde seeping from the walls.

We came to a door.

Everything seemed to change. It looked as if I were inside my very own home. There was a cosy little fire place in a well furnished room- the place was crawling with toddlers and babies. Each of the children's eyes revealed a blissful expression when handed a colourful toy.

Norma shut the door and began walking down another hallway, "Did that answer your question?" I remember her giving me a smirk and her eyes looked as if there was something deeply wrong. Everything kept getting darker and filthier.

There stood a second door.

"This, my dear, is the room where we keep the bodies."

I smiled and thought to myself, "I'd really enjoy this job."

Shortly there after I could hear more cries and screams, but these screams were made from agony and suffering. I peeked inside a small window on the door.

People were perfectly lined up, waiting patiently for their heads to be removed by a short and stalky little man, wearing woman's clothing. He was smiling as he cut off each of their heads with a rusty machete. People there showed no emotion, they looked as if they were robots; lifeless, frozen and cold.

In the distance I could hear a man laughing. He kept laughing and laughing as each of the patients would get into line.

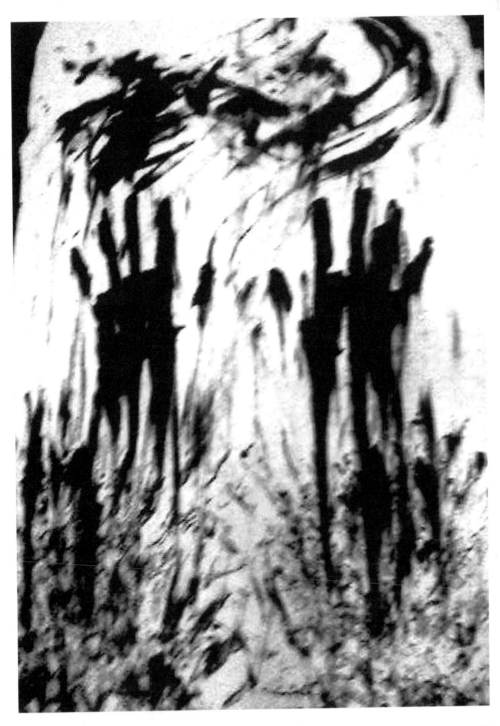

Norma continued showing me as if there was nothing out of the ordinary happening. Off to the side was a freezer full of parts. Norma led me inside. A massive steel door slammed quickly behind me. As I turned around in the dark freezer, she flipped a on a light where I could see

frozen babies hanging by their umbilical cords, with pale green faces that had frozen over with a layer of frost. Parts were strung out all over the cold floor and metal racks. All of them were staring and smiling at me. Smiling with evil expressions on their faces. The dead babies were laughing at me! Frozen there, all I could hear was the generator, but inside my head they were screaming and laughing hysterically. It seemed I was there for hours. On my way to the door, Norma picked up a butcher knife. "Give me your hand." Things went silent. She held my hand near the door and said, "This is the light." It was dark again. Norma then vanished.

I was alone. I found myself at a different side of the building that looked like a warehouse. This door was left open. Animals were being slaughtered and skinned alive. There were dogs and cats there were bears and there were antelope; different species altogether. The man that was decapitating the non-responsive beings was doing a lot of the work in this room as well. Things were hazy, naked bodies were exposed and being raped on examination tables next to the slaughtered animals. I ran and slipped in a pile of coagulating blood. My head cracked when I hit the floor, blood was pouring from my brains and all I knew was to run. The animals were screaming in discomfort and agony. I could hear slabs of flesh being thrown against the wall and stacked up to be chopped and ground. Running harder and faster, as the sweat and blood pour from my face, I managed to make it outside. The remnants of the animals were lined up, covered with blue tarps. Steam was emitting from the sewers. The pavement was wet from the pouring rain.

Norma stopped me with her eyes. In exhaustion I fell to the ground

Norma entered my mind and told me, "Parents that brought their children to the day-care would be drugged and beheaded, every baby that cried in the day-care would be tortured and incinerated, every pregnant, legally insane woman would have their babies aborted from the womb and the rest of the children of failed abortions would become workers for the facility. No one would leave."

Petrified and screaming, with no sound leaving my mouth, she stared.

The woman bent down with a rusty oversized needle and penetrated deeply into my veins. "The interview went well, my dear, you'll start tomorrow."

Everything went black.

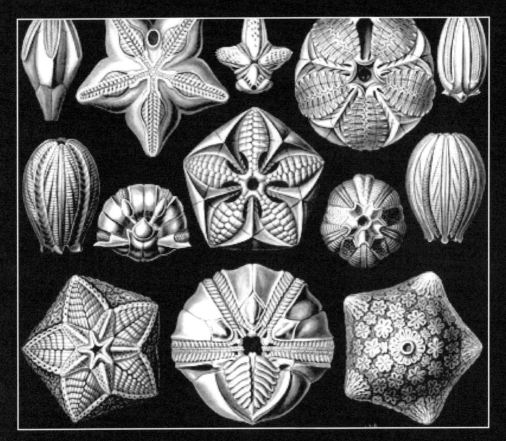

THE EMERALD TABLETS OF THOTH THE ATLANTEAN

"List ye, O man, to the depth of my wisdom, speak I of knowledge hidden from man. Far have I been, on my journeys through Space-Time, even to the end of the space of this cycle. Found I there the great barrier, holding man from leaving this cycle. Aye, glimpsed I the Hounds of the Barrier, lying in wait for he who would pass them. In that space, where time exists not, faintly I sensed the guardians of cycles. Move they, only through angles, free are they not of the curved dimensions.

Strange and terrible are the Hounds of the Barrier, follow they the consciousness to the limits of space. Think not, to escape by entering your body, for follow they fast the Soul, through angles. Only the circle will give ye protection, save from the claws of the Dwellers in Angles.

Once, in a time past, I approached the great Barrier, and saw on the shores where time exists not, the formless forms of the Hounds of the Barrier; aye, hiding in the mist beyond time I found them, and They, scenting me afar off, raised themselves and gave the great bell cry, that can be heard from cycle to cycle, and moved through space toward my Soul.

Fled then I, fast before them, back from time's unthinkable end, but ever after me pursued they, moving in strange angles not known to man. Aye, on the gray shore of Time-Space's end found I the Hounds of the Barrier, ravening for the Soul who attempts the beyond.

Fled I, through circles back to my body, fled, and fast after me they followed. Aye, after me the devourers followed, seeking through angles to devour my Soul.

Aye, know ye man, that the Soul who dares the Barrier, may be held in bondage by the Hounds from beyond time, held till this cycle is all completed, and left behind when consciousness leaves.

Entered I my body, created the circles that know not angles, created the form that from my form was formed, made my body into a circle, and lost the pursuers in the circles of time. But, even yet, when free from my body, cautious, ever, must I be not to move through angles, else my Soul might never be free.

Know ye, the Hounds of the Barrier move only through angles, and never through curves of space. Only by moving through curves can ye escape them, for in angles they will pursue thee. O man, heed ye my warning, seek not to break open the gate to beyond. Few there are who have succeeded in passing the Barrier, to the greater Light that shines beyond. For know ye, ever the dwellers, seek such Souls to hold in their thrall.

Listen, O man, and heed my warning, seek ye to move not in angles, but curves, and if while free from thy body, thou hearest the sound like the bay of a hound, ringing clear and bell-like through thy being, flee back to thy body through circles, penetrate not the mist before."

–Translated by Doreal

manta red
david conway

The hologram shimmers momentarily and then materialises like a high-resolution mirage. An intangible sculpture moulded in light, the illusion of depth, of palpable reality, is deceptively compelling. And yet, for all its digitally-enhanced definition, the life-size tableau retains an ethereal quality: an eerie remoteness reinforced by the prevailing silence.

Dr. Yoshida hovers close by, hypnotically drawn, like a moth to the flame, His cold gaze, his bland, androgynous features imbued with the glacial euphoria of realised ambition, the inscrutable rapture of a dreaming, insect hive.

A single thought. She is here, At last, she is here.

Holographically conveyed from a distant chamber in the estate's East wing, the woman lies, silent and immobile, on a bed of shiny, black polycarbon-vinyl, perfectly moulded to the contours of her supine form. From head to toe her entire body is tightly encased in a glistening costume of the same fabric. It clings snugly to every line and curve: her slim thighs; the firm globes of her small breasts; the smooth convexities of her hips and shallow abdomen. Not a single centimetre of naked flesh is exposed, Even her eyes, nose and mouth are concealed by a tight-fitting mask that envelopes the whole of her head. The basic polycarbon molecule has been designed with inherent organic properties. It is porous enough to permit regular pulmonary and epidermal respiration; the risk of suffocation is less than non-existent.

The irresistible image is that of the woman's body freshly coalesced from an icy reservoir of thick, black oil, the subterranean cauldron of fossilised extinction and decay that has fuelled the clamorous din of technology's bleak, insatiable tyranny. A sublime icon, she is coldly alluring, the embodiment of ritual Fetishism, impersonal sensuality.

And this is the perfect setting for her.

The cool, empty silence and scalpel-clean sterility of white light are set with transparent aluminium panels which house a species of radiant plankton, countless billions of them, their bodies glowing with the brilliant iridescence of ceaseless reproduction, orgasm and death. Designer mutations, these creatures have been genetically engineered by Dr. Yoshida – the phosphorous content of their bodies vastly increased; their voraciously exaggerated sexual appetites and instinctive cannibalism artificially boosted – for the sole purpose of illuminating this, his sanctum sanctorum. It could truly be said that these walls positively glow with the fluorescent radiance of sex and death: an implacable, endless cycle.

The room is furnished with a Spartan simplicity that harks back to the traditional virtues of Zen. A low table laid out with the requisite accoutrements of the tea ceremony. A samurai sword and the ceremonial dagger intended for the ritual seppuku are sheathed and mounted lengthways

on an ornamental teak display rack. The weapons are ancient, priceless, and every inch as lethal and exquisite as when they left the master craftsman's forge centuries before the accession of the first shogun.

A brace of traditional screens have been upholstered with the flayed hides of twelve Yakuza gangsters. Five of them were acquired quite legally at auction in New Tokyo; the remaining seven are the result of Dr. Yoshida s more unorthodox enterprises. The skins themselves are quite remarkable, floridly embellished with the most expert examples of the tattooist's craft. Mythical dragons and other monstrous hybrids are rendered with breathtaking clarity and precision; cranes and birds of paradise – their sublime frailty and the subtle variations in the colours and textures of their respective plumage flawlessly executed; elaborate tableaux depicting scenes from legend and fable. It is the supreme measure of the artists' skill that their handiwork succeeds in subverting even the slightest hint of the macabre implicit in the sight of flayed, human skins displayed like trophies. One of the screens remains partially denuded; two more skins would be perfectly accommodated. The atmosphere is strictly controlled: filtered, recycled. Nothing survives here by accident. Nothing thrives that has not been intended to thrive. This is the perfect environment.

A second holographic image enters the insubstantial frieze, silently materialising from the projection's invisible periphery. She is dressed in the traditional kimono; the formal make-up and rigid coiffure of the geisha, her garment of white silk embroidered with shimmering turquoise and silver, contrasting starkly with her companion's seamless attire of glossily skin-tight poly carbon-vinyl. The geisha glides across to the bed, standing over the motionless form of its blackly sculpted occupant.

The geisha's right hand, as frail and graceful as a dove, reaches out and plucks a perfect circle of the paper-thin, black fabric from the inert woman's featureless mask, revealing her right eye, frozen rigidly open. As a professional, Dr. Yoshida is forced to concede the uncommon quality of the workmanship. The eye, set in its oval orbit like a glittering jewel – the emerald green of the iris, a lush evocation of centuries'-extinct equatorial rainforests; the vertically elliptical dilation of the pupil, so startlingly feline – is sterling testimony to the technical achievements of New Tokyo's thriving bio-scaping clinics.

The little geisha continues to methodically pick apart the oily black costume of her slumbering, unprotesting companion. She peels the woman like a fruit; one by one her sublime treasures are slowly, tantalisingly revealed. Within a very short time she is completely naked. Her flawless pale flesh assumes a spectral radiance which contrasts luminously with the mattress's black, light absorbent surface. The deep lustre of her long black hair is shot through with metallic blue, scintillating with the cool iridescence of burnished chrome. The lush green of her surgically-enhanced, catlike eyes seems to peer from the depths of some improbable alien sea, her coral pink lips slightly parted to reveal the scalloped ridges of her teeth like neat rows of pearls; hard, well-formed and perfectly white.

"Beautiful– " says Dr. Yoshida, drawing clammy, sweet breath through a fugue of persuasive arousal. Beneath his skin, the messy miracles of bio-transmutation initiate a series of chain reactions, accelerating subtly, inexorably, towards the apex of critical mass. Soon. It will be

soon.

"Aiko– " Dr. Yoshida addresses the holographic frieze directly; the estate's sophisticated communications and surveillance systems carry his voice to the chamber where the ritual disrobement of his unwilling guest has been performed. Aiko, the silent geisha, turns her impassive face to the source, recognising her master's voice. "Prepare her now," he says, "and take her directly to the Conservatory."

Aiko bows deeply, indicating her compliance. Dr. Yoshida allows the hologram to linger for several more moments, and then, at his unspoken mental command, it wavers indistinctly and abruptly dematerialises. In its place, almost simultaneously, two more holographic tableaux coalesce with the deceptive illusion of solidity. Nothing happens within the walls of the estate, or anywhere on the island itself, that Dr. Yoshida does not know about. His elaborate security systems afford him a level of omniscience that was once the alleged prerogative of the gods.

He watches, intrigued, as a group of five young men make their way with caution and stealth along the corridor which links the estate's Eastern wing with the central core of the complex: the Conservatory. They are all comprehensively armed with the most lethal and sophisticated weaponry currently available to the modern assassin. Dressed in chameleon polycarbon combat fatigues; flexible, lightweight body armour; and featureless, visored masks, they resemble a platoon of belligerent ants, a single mass-mind obsessed with the insect imperative of murder.

These faceless killers are members of the mercenary elite known as termination executives. Under the auspices of the Free Trade Charter, observed by all the Pan-Pacific conglomerates, they are legitimately licensed to commit contract murder. Discorporation, the term enshrined in the legislation's bland lexicon of euphemistic jargon is a recognised tool of corporate enterprise, falling into the same category as a 'hostile take-over'. This group, led by Ishiru Okida, one of the most highly paid termination executives operating out of New Tokyo, has accepted a 15 million yen-dollar contract from the Hakashi Corporation, sanctioning Dr. Yoshida's discorporation. Stories have been circulating among the upper-most strata of New Tokyo's corporate and scientific communities, concerning Dr. Yoshida's secretive and allegedly fruitful research into the fields of bio-intelligence, molecular transmutation and – most tantalising of all – nanotechnology. Assuming that the rumours are true, the Hakashi Corporation estimates that the secrets to be unearthed within the cloistered fortress of Dr. Yoshida's island estate will give them years – if not decades' – advantage over their competitors. Dr. Yoshida observes their progress with cold disdain, in his own thoughts as remote from their cruel materialism as from the maggots that feast on the ripe ooze of death and decay. These murderous philistines have lain siege to his island retreat for precisely seventeen minutes, closely monitored from the moment their boots hit the sandy beach. It is time to dispose of them. Dr. Yoshida issues a series of mental commands, activating the nanodefenses.

The resulting carnage is brief but colourful.

Nanomachines – cyberorganic microprocessors comparable in size to the virulent molecules of a thriving bacillus – reproduce rapidly, precipitating a razor-ribbon maelstrom of shrapnel hail,

consciously directed, endlessly voracious. The sterile air of the blue-white corridor is suffused with a delicate, red mist: atomised droplets of warm blood, meatily aromatic. Diamond grapeshot condenses out of empty air like fatal ice, its brilliant vortex disintegrating body armour and fatigues effortlessly. Cybernetic cancer spores materialise on naked, defenceless bodies, programmed tumours that propagate with a hungry efficiency that far surpasses the ravenous malignancy of their natural forebears. Fragments of flayed skin, like bloody, autumnal leaves, swirl on buzz-saw eddies of the ceaseless, scouring cyclone. Writhing like moulting serpents, raw muscles and wet expanses of peeled fat glistening moistly, the would-be assassins shriek their wordless agony in splashing pools of their own bodies' rapid dissolution. Dr. Yoshida revels in the excruciating music of their screams, scarcely human in its intensity, volume and pitch.

It is, however, far from being a mindless, indiscriminate slaughter. Dr. Yoshida is far too astute for that. There must be at least one survivor for him to interrogate later. He is determined to learn who was ultimately responsible for this invasion – and to exact appropriate retribution. Bleeding from countless wounds, his protective outfit in useless tatters, Ishiru Okida staggers through the swirling red fog, deaf to the screams of his comrades. At the end of the corridor an electronic door slides silently, solicitously open. Through a searing haze of blinding pain, Ishiru somehow manages to reach and stumble through the door which opens directly onto his original objective: Dr. Yoshida's Conservatory. The door glides shut behind him.

Meanwhile, in the corridor, the nanodefenses continue their work with painstaking thoroughness. It has taken seconds for the assassins' bodies to be reduced to a state that is scarcely recognisable as human. A synthesised dew of molecular acid, selectively secreted, renders bone steaming, gelatinous ooze, vertebrae melting into an undifferentiated mire of pulped gristle and molten fat. Steaming viscera, infected with tumultuously active fungi, spiral wildly from pelvic cavities like nests of frenzied snakes. Bulbous malignancies, the approximate size and shape of cauliflowers, cling in unendurable clusters to the mercenaries' wracked bodies. They howl for death which somehow remains callously reticent.

From the depths of a vat of raw polycarbon base that resembles a treacherous, prehistoric tar-pit, its cloying blackness teeming with Nanomachines, four dark shapes coalesce suddenly. Glistening, black, humanoid forms, they solidify in an approximate simulation of the traditional ninja assassin, the historical fore-runners of the modern termination executives whose homicidal skills are so highly prized and lucratively rewarded. The ninjas are armed with orgone disrupters. They move silently through the fading red mist, not a single droplet of blood adhering to their frictionless, obsidian skins. They dispose of the squirming, crippled, human parodies with passionless efficiency. The orgone disruptors discharge bursts of concentrated DOR (Deadly Orgone Radiation), writhing bolts of blue-green, plasmic energy that interrupts the harmonic resonance of the biological functions essential to the cohesion of all living organisms. In theory and in practise the process has been succinctly described as a form of genetic fission.

For a second the assassins' bodies glow an eerie green, tissues incandescent with the radiance of fatal transfiguration. And then they erupt. The process is not simply one of decay – of accelerated putrefaction, even. By destabilising the complex interactions that link matter and energy in a self-regenerating, sequential continuum the orgone disruptors initiate chain-reactions

of internalised temporal distortion. Metabolic time travel. Nucleic degeneration set on a downward spiral of genetic decay.

Molecular bonds shatter. Complex protein chains; finespun lattices of amino acids; are unravelled, frayed, degraded, swamped by the quantum catastrophe of chromosomal chaos. In moments the assassins are no more than four, indistinguishable pools of bubbling, protoplasmic slime, swarming with the autonomous, amoebic organisms that once fuelled a billion species' evolutionary ascent from the fertile muck of the young earth's primal stew. These, too, are quickly devoured by the tireless hive of proliferate Nanomachines. They scour the walls, floor and ceiling of the corridor. Not a fragment of skin, a single iota of blood, remains.

The polycarbon automatons return to the vat that spawned them, melting back into the cold, black morass. They disintegrate so thoroughly that it is as if they had never existed. An icy calm once more pervades the sterile air, the blue white radiance of the corridor. Less than two minutes have passed.

Dr. Yoshida's attention shifts to the second holographic frieze. Two young men are slouching casually on a large settee. They are identically dressed in grey business suits that shimmer slightly with a subtle, metallic sheen. The expert cut of their suits effectively disguises the fact that they are both carrying shoulder-holstered hand-guns, state-of the-art weapons equipped with laser sightings and heat-seeking smart shells whose draconian firepower is frankly superfluous beyond a military combat situation. Both men wear their hair fashionably short and slicked back severely, accentuating the softness of their unwrinkled, clean-shaven features infused with the unmistakable, innocent cruelty of psychopathic children. Several dishes of synthetic fruits and sweetmeats, genetically engineered for their mild narcotic and aphrodisiac qualities, are laid out before them on a glass-topped table. The men nibble at the succulent delicacies, enjoying a light euphoria of hallucinogenic arousal.

These men are members of the Yakuza, the insidious criminal underworld that permeates every stratum of New Tokyo society and its Pan-Pacific economic satellites. They have been responsible for the abduction of the woman who, even now, subject to the tender ministrations of Aiko, the mute, compliant geisha, is being prepared for the culmination of Dr. Yoshida's lifelong ambition, the pinnacle of years of research and heroic endeavour.

Dr. Yoshida directs the men to the Conservatory, where, he assures them, they will be paid for their services presently. And, he hints, there will be a special bonus in store, a reward for the exemplary execution of the task he had set them. They move out languidly into the corridor, avarice adulterating their drugged serenity with its cold, premeditative edge.

Dr. Yoshida banishes both holograms with a single thought. Now he is alone with his dreams, the elaborate shawl of ambition that enmeshes his mind and extends beyond it like the web of a patient, contemplative spider, gossamer strands laced with gems of shining dew. Four hapless flies are now inextricably entwined in his silver net. He could have waited centuries for this moment had it been necessary.

But now the waiting is over.

Subdued ultraviolet lighting. Suggestion of pheromone laced with the dry tang of ozone. Dr. Yoshida's Conservatory combines the steamy humidity of a pre-Cambrian swamp with the

fertile putrescence of a ripening dung-heap: the excremental womb whose fermenting warmth nurtures the basilisk's incubating eggs. So just what is he trying to hatch?

The subtle twang of a single koto. A stunted cherry tree sheds its blossoms in time to the cascading melody; the fragrant shower gently breaking the fragile meniscus of a languid stream, scenting the water with a little of its perfume. Just below the surface large, elaborately-coloured, ornamental carp glide and shimmer silently.

Dr. Yoshida enters the Conservatory, moving across the floor with a dancer's balletic grace. In his left hand he carries a small, silver bowl containing a species of black sea-cucumber marinated live in the venom of the spiny freshwater manta ray. Mania Red. The brilliant, crimson juice is prized not only for its unique piquancy but also for its powerful psycho tropic and aphrodisiac effects. In anything but the most minute doses pure Manta Red would prove almost instantly lethal to a normal human being. Dr. Yoshida has been using it daily for many years; his tolerance is such that the quantities he so casually imbibes are sufficient to kill a dozen men. And, besides, he is far from being a normal human being. From time to time he will pluck a specimen of the pungent delicacy from the bowl and pop it whole into his mouth, grinding the ripe meat to pulp between his busy molars.

His fingers are slim, elongated, with prominent joints like the ghostly digits of the Madagascan aye-aye. His eyes – large, oval, remorselessly black – reinforce the illusion. He is dressed in a white, polycarbon-silk kimono, tied at the waist. His hair is long, aromatically-oiled, and tied at the back in an elaborate bun, similar to the style once favoured by the samurai elite. He is barefoot and, beneath the kimono, completely naked. The Conservatory is a large, circular chamber housed beneath a polycarbon dome. The dome functions like a vast cornea surrounding the complex array of surveillance systems and sensory organs that constitutes the retina and optic nerve colonies of the BioHive, Dr. Yoshida's unique, biological computer. The whole, or individual sections, of the dome's surface may be rendered transparent – like glass, or unilaterally in the manner of a two way mirror. It also functions as an audiovisual monitoring device, upon which may be projected an overlapping montage of holographic images from every part of Dr. Yoshida's island estate. As well as being impervious to the elements the dome is capable of withstanding the force of a ten megaton nuclear airburst.

The BioHive itself, whilst dominating the Conservatory, is largely invisible to the naked eye. More than ninety per cent of its considerable bulk remains buried beneath several thousand kilos of gravelly, black, nutrient-enriched plasma-mass: a form of primal soil synthesised by the accelerated putrefaction of living organisms. Protruding above its moist, vaporous surface, palpitating with the steady pulse of aerobic respiration, there are what appears to be a number of large, malformed cantaloupes succumbing to the steady ravages of advanced decay. Glossed with the rancid sweat of corruption, they are, in fact, highly evolved sensory organs.

The plasma-mass also supports a fragrantly wasted undergrowth of emaciated, flesh-coloured shrubs. Their spindly, veinous limbs are precariously laden with wrinkly, sap-heavy fruit, crenellous tumours of moist and pulpy meat. Closer scrutiny reveals this macabre flora to be nothing less than a collection of excised, human nervous systems. Still-living, they have been reduced in size and effectively preserved by a process that combines the exacting disciplines of

micro-surgery and genetic engineering with the ancient art of bonsai, The bulbous growths dangling from their sinewy boughs are the active remains of their former, discorporated hosts brains. Precisely dissected, these pulsating clusters of cortical tissue have been cunningly adapted to perform new functions vital to the BioHive with which they are now metabolically, neurologically linked.

The Conservatory also contains a number of large, transparent aluminium cocoons, lining the inner perimeter of the dome, like a nursery of giant, crystalline eggs. The cocoons are filled with a milky, semi-opaque liquid: the potently fertile, amnio-seminal fluid secreted by the hermaphroditic BioHive. The life-forms contained within these synthetic wombs exist in a state of perpetually-arrested, embryonic development, representing a branch of evolution so highly specialised that they are, in fact, little more than autonomic reproductive organs. These creatures are sexual symbiotes; their sole function to catalyse the procreative union of species so utterly divergent as to be considered, quite literally, alien to one another. The resulting, chimerical pregnancy, Dr. Yoshida anticipates, will yield a hybrid offspring, the first of a new race. A long-held theory, the initial phases of which he has already put into practise.

Dr. Yoshida pauses briefly before one of the cocoons. Its occupant is a large, eel-like creature, its leathery skin slick with a visceral, amphibious quality. About four feet long, it coils and uncoils languidly, returning Dr. Yoshida's regard with what appear to be equal measures of curiosity and instinctive menace. The head resembles that of a carnivorous, prehistoric fish. Its eyes – pupilless, colourless disks – swivel ceaselessly on each side of its bony skull, feathery gill-arrangements fluttering rhythmically just below the jaw. Instead of a mouth it possesses a tube-like proboscis, a single coil of gristly tissue spiralling inward on itself, its motion a perverse pun on the normal action of peristalsis. The proboscis functions as a mouth and excretory organ – as well as disseminating the creature's specialised, symbio-procreative spores.

His senses singing with the erotic vibrancy of Manta Red; taste buds tingling with its dry tang; Dr. Yoshida is overwhelmed by a sudden reverie, its force irresistibly persuasive. His heightened perceptions evoke a visceral high so intoxicating that he seems to literally re-experience the original event rather than merely remembering it... He sees himself – feels himself – once more stepping tentatively into the Gene Pool, gradually immersing his body in the clammy, viscous moisture of the BioHive s amnio-seminal secretion. Dark shapes move beneath its slick, glutinously calm surface, gliding with the silent intent of miniature sharks. Nanomachines saturate the fertile ooze like swamp-dwelling bacteria.

For several, long moments there is stillness, the sticky, super-equatorial humidity unstirred by even the suggestion of breeze. Suddenly, as if sensing imminent danger, a bird of paradise defensively displays the metallic iridescence of its cobalt, turquoise and sun-burnished-gold plumage, its wings fluttering loudly as it flits towards the relative safety of a distant perch.

An orgy ensues.

The sexual symbiotes home in on Dr. Yoshida's naked body with the ballistic accuracy and velocity of torpedoes. The Gene Pool boils and froths tumultuously, glowing with the critical energy emissions of countless million Nanomachines. Dr. Yoshida vanishes beneath its bubbling, churning surface, a vivid corona of spastically writhing, bio-electrical energy illuminating the

heaving swell like St. Elmo's Fire. Time curves in on itself, a dimensional cyclone warping spatial perspectives; radiant whorls of refracted light; wormcasts of quantum potential and decay. Eventually the tempest exhausts even its own fury. A nebulous mist rises from the surface of the Gene Pool, portentously calm, cooling rapidly.

A bloody hand breaks the turgid meniscus, outer layers of skin comprehensively shed, peeled off like a glove. The denuded network of fibrous tendons strains against the breathless silence, gleaming brilliantly beneath a gloss of transparent gel. Fingers splayed, quivering, it hovers momentarily. And then it flattens itself out against the edge of the pool, painting the brilliant, white tiles a lush, vivid red. Its partner joins it a few seconds later. The hands make slow, clawing progress along the floor's slippery surface, dragging themselves millimetre by bloody millimetre, torturously slow – for all the world like a pair of crabs prised from their shells, blinded and flayed.

And when, in the end, Dr. Yoshida finally marshals sufficient strength to haul himself from the Pool, its depleted depths sucking at him like quicksand, he crawls and staggers across the Conservatory, collapsing in a bloody heap in front of the full-length mirror. Blinking away mucus, blood and tears, he stares in wide-eyed fascination at his reflection, fuzzily blurred by the film of condensation that fogs the surface of the glass. A hesitant hand reaches out, wiping away the hazy moisture, smearing on a thin syrup of. bright blood.

Dr. Yoshidats eyes gape in speechless wonder, surveying the appalling, astonishing spectacle of raw bones and glistening, skinless tissue; his teeth bared in a lipless, humourless grin, the rictal leer of apothetical pain. A harsh, clicking sound begins at the back of his throat, reverberating around the hollow cavity of his chest: a grinding death-rattle of a laugh.

Tentatively he touches himself, wincing. First the familiar organs and appendages, jangling with the chaotic fire of decaying neurones, the crackling spit and fizz of a nervous system fused by unendurable sensual overload. And then the budding beginnings of new organs: lumpen protuberances that as yet resemble little more than shapeless knobs of molten fat, steaming and dripping, their ultimate potential and functions unknown.

Dr. Yoshida's grating, abrasive laughter reaches a harsh crescendo, as unsettling as the sound produced by fingernails scraped across a blackboard's surface. His body is wracked by sobs of tearless joy that bubble up through a cloying wad of phlegm, clods of curdling blood. He is elevated beyond pain, dread and anticipation to the ultimate plane of euphoric dementia, triumphant. Transformed.... as persuasively as it had gripped him the reverie relinquishes its hold on Dr. Yoshida, its backwash ebbing into the receding tide of memory. As instructed, the others are already here, waiting.

Resplendent in the ancient costume and make-up of the geisha, Aiko sits, cross-legged, on the floor, her delicate fingers expertly plucking the strings of the koto cradled in her lap. In her exquisitely embroidered kimono, and with her ghostly white face; impassive dark eyes and impeccably constructed coiffure; she exudes an air of serenity, grace and modesty which epitomises the traditional virtues of womanhood enshrined for centuries in Japanese culture and philosophy.

Dr. Yoshida is especially proud of Aiko; she appears so very human. At times even he,

her creator, forgets that she is little more than an automaton, conceived by the cyber-sexual interface of two, very different species of machines.

Aside from the BioHive, the domed Conservatory houses a cybernetic processor, no less sophisticated than its biological counterpart. The Zen Resonator: Dr. Yoshida's prototypical adaptation of the latest generation of the Mitsubishi Zen 5000 Series Psimulator System. Its revolutionary logic/anti-logic drive – digital circuitry that simulates the human brain's complex network of neuro-logical modules and synaptic conduits; conceptual software capable of assimilating qualitative data -generates the Virtuality hyperzone known as the Zen Continuum. Frequently referred to as the first, genuine artificial consciousness, the system's designers describe the Zen Continuum as a patented universe, dimension of dreams.

The Zen Resonator is in constant, continuous interface with the BioHive, its cybernetic neural structures colliding with the seething ganglia of meta-cortical tissues that constitute the other s self-replicating, molecular data-colonies. It was this ceaseless fusion of pure, conscious energy – like the blazing, solar furnaces that rage at the hearts of suns – that fuelled Aiko's genesis, that literally conceived her, BioMech, the term coined by Dr. Yoshida to describe the process, provided the genetic blueprint; the Nanomachines did the rest, literally piecing her together from the necessary raw material. Yes, the good doctor has reason to be proud.

His female captive, previously encountered as an alluring, if insubstantial, hologram, remains unconscious, naked, and securely bound to a chrome stretcher. The stretcher is suspended above the Gene Pool, supported only by deceptively slender cords of high-tensile tungsten. Freshly secreted, the BioHive's amnio-seminal secretion fills the pool: every drop teeming with microscopic Nanomachines, inert now, primed for the command that will initiate their inexorable, irrevocable programme.

The woman's name is Mitsuko Hara. She is twenty four years old, one of the most wealthy and successful exponents of New Tokyo's multi-billion yen-dollar entertainment industry. Mitsuko Hara is a Virtuality Icon; her digitally-generated, holographic image featured in some of the most successful Virtual Reality interactive software currently available on the market.

Since the demise of cinema, television and literature as the prevalent forms of popular entertainment, Virtual Reality has become the playground where almost all the citizens of the world's technocracies choose to spend their abundant leisure time. Virtuality Icons inhabit the conceptual hyperzones in much the same way that the movie stars of the past illuminated celluloid stock with their divinely contrived images. In the hi-tech patois of Virtualspeak the word that describes Mitsuko Hara's role in the pantheon of Virtuality Icons – although there is no precise equivalent in English – translates roughly as the object of desire.

Virtuality Manga and Anime originated in the twentieth century, their roots in Japan's hugely successful comic-book market. The modern Manga is a hyperreal exploration of the erotic potential of physical mutation; hi-octane hi-tech splatter; a visceral out-of body experience that erases the barrier between passive observer and active participant. Pornography boosted cybernetically to a state of elevated consciousness – alternate planes populated by exotic, alien beings; convulsed with endless, apocalyptic wars; replete with graphic violence, explicit sex, and perverse combinations of the two – scripted, realised and programmed by the highest paid cabal

of writers, artists and technicians in New Tokyo. The idealised, female protagonists in many of the most popular scenarios are quite literally incarnated in the holographic image of Mitsuko Hara's flawless beauty.

The Manga define a new sexuality. In the Arcadia districts of New Tokyo – entire boroughs given over to the Virtuality cult – vast cathedrals of shimmering metal and translucent polycarbon glass iridesce with the energy of constant orgasm. These skyscrapers contain neither rooms, offices or apartments, but thousands of coffin-sized chambers, accessible by narrow catwalks, equipped with Virtuality headsets, gloves and genital collars; bio-monitors and catheters; IV drips. They may be rented by the hour. Weekly – even monthly – rates are available. Inside are Manga-addicts, emaciated and bedsore-ridden, hooked up like coma patients, nervous systems frazzled by the endless delirium of pseudo-sensual bombardment, who haven't had contact with another human being – solid food – for months. Who needs it when you can come a rainbow cascade of diamond hail; smash planets between your fingers; manipulate the very fabric of space and time; blaze like a meteor through a nebulous haze of psycho-erotic abandon? Dr. Yoshida gazes intently upon Mitsuko's naked body: the supple perfection of her firm breasts and thighs; her shaved pubis tinged blue like a triangular bruise; the sublime contours of her cheekbones and the delicate curve of her lips. Despite the reptilian inscrutability of her emerald green eyes with their vertically elliptical pupils; the chrome and obsidian blue-black sheen of her hair; the star of Nekrotica, Arcadia Apocalypse and Metal Sushi – she has, in fact, been abducted direct from the set of Metal Sushi II (hence the fetish costume of which she was divested earlier) – resembles a mesmerised child held in captive, unblinking thrall by a fabulous, omnipotent magician. Dr. Yoshida's face is a bland, unwrinkled mask, innocent of all emotion other than a sort of whimsical curiosity – like a botanist examining a strange and previously unclassified species of exotic flora.

He is standing at the main control console and its bank of monitor screens. His fingers move deftly across the surface of the console. The controls are heat-activated, primed by recognition of Dr. Yoshida's individual, bio-plasmic aura and triggered by a specific series of mental commands. There is no need for him to actually touch anything. Hieroglyphic sequences of coloured lights illuminate the smooth, black surface of the console with radiant arabesques. A Kirlian Spectrograph shimmers into life, its purpose to monitor and analyse the slumbering Mitsuko's aura, glowing with the neon incandescence of a New Tokyo Virtuality arcade display. Another screen displays 3-D CAT-scan pictures of the various quadrants of Mitsuko's brain, enhanced and augmented to Dr. Yoshida's precise specifications, transmitted from a thumbnail-sized, silicon module implanted into the base of her skull.

The western hemisphere of the Conservatory's dome is as clear as glass, looking out onto the glittering, crystal expanse of the Pacific. The blood-red, nuclear sun sinks slowly beyond the distant horizon, its violent hues oozing into the placid waters of the silver sea. A cruiser-class jetfoil clipper scythes its way across the waves in the evenings dying embers. A matter of leagues beyond the range of the island's security systems, the vessel does not excite Dr. Yoshid's interest. A silent, verbal command renders the Western quadrant of the dome abruptly opaque. Its opposite seems almost to liquefy and is suddenly transparent. Across a narrow strait there lies the mainland

and several thousand kilometres of uninterrupted desert, serene and sublimely barren. The darkening, Eastern sky is predominantly an impossible shade of indigo; the transient topography of shifting dunes beneath it delicate hues of coral pink and magenta. Between the teeming ocean and the arid sands Dr. Yoshida's estate seems to be most aptly situated, occupying the twilit realm of evolution and extinction, the eternal equinox.

Aware of a feeble stirring, Dr. Yoshida is pleased to find consciousness rapidly reclaiming Mitsuko Kara. Due to the after-effects of the bio-mace that had been used to subdue her there is a certain rigidity to her facial muscles that dissipates quickly as she wakes, Another of the bio-mace's after-effects is temporary paralysis of the larynx, rendering the subject mute for several hours.

Dr. Yoshida's glance flickers across the Kirlian Spectrograph, Mitsuko's aura – red-black waves of panic overlying brilliant coronae of electric blue and mauve – is violently rent by a jagged shard of purest jet: a forked lance of black lightning cast from the depths of Hell. A silent scream.

The two Yakuza thugs, responsible for Mitsuko's abduction, loiter close by, perplexed but nonetheless intrigued, still enjoying the light narco-erotic haze of the synthetic aphrodisiacs they'd ingested earlier. They expect to be handsomely paid for their work. The peculiar sideshow to which they find themselves unexpectedly privy only serves to heighten their feelings of smug self-satisfaction; all is well in their world. How could they possibly anticipate – or even imagine – the ultimate culmination of what is slowly unfolding before them.

Ishiru Okida, the Hakashi Corporation's would-be assassin, is here too. The Conservatory had provided brief sanctuary after he had narrowly escaped the nano defences' dispassionate bloodbath that had so efficiently disposed of his companions. But his reprieve had been short-lived. Even if Dr, Yoshida were ultimately to decide to let him live, he would be doomed to survive as a quadriplegic. The Conservatory's own defences have already inflicted the kind of physical damage that would defy even the most expensive and sophisticated treatments available at any of New Tokyo's exclusive, bio-scaping clinics. Fatally ensnared by an anemone of bio-web – a type of cyberorganic razor-ribbon that literally grows into the bodies of its victims, his motor-neurone system has been burnt out like overloaded fuse wiring, his muscles useless lumps of atrophying gristle. And now Dr. Yoshida begins to talk, feeling secure as the moment of his triumph approaches, confident in the knowledge that neither Ishiru – or the Hakashi Corporation – can taint it now. He averts his eyes from the sight of Ishiru s useless body; he has no desire to pollute the moment with either gloating or petty enmities.

"When I was a younger man – little more than a boy, really – my tutors used to consider me something of a dreamer. Of course, my academic record was never anything less than exemplary, so they had no cause to discipline me. But there remained something in my manner, the apparent vagueness of my demeanour, that continued to trouble them."

Dr. Yoshida speaks in a way that lacks either accent or inflexion. There is a slight, purring tone to his voice, suggestive of something feline: androgynous. Aiko, the little, nano-engineered geisha, continues to play. The music of the koto accompanying Dr. Yoshida's self-indulgent soliloquy transforms it into a recital.

"I used to wonder about the consequences of our species' first contact with truly alien life-forms. Constantly I would speculate as to the outcome of sexual congress with such beings – be they angels or monsters. Or both. My imagination on this subject was as tireless as it was fertile. I conceived a dazzling array of fabulous chimeras with which we might mate. Choreographed lascivious rituals of courtship display – from the most primitive and grotesque to the most sublime ballets distilled to an essence of conceptual elegance, surpassing even the stylised rconventions of traditional Noh. "I imagined acts of procreation that required multiple partners of subtly variegated gender. Others that culminated in frenzies of autocannibalism or coprophilic ecstasies. Parasitic incubation. Varieties of asexual spawning – including a form of ectoplasmic metempsychosis resulting from psychokinetic stimulation of the pineal gland. Viral pregnancies. "But these were no mere masturbatory fantasies. What, I used to wonder, would be produced by such an extravagant mingling of so diverse – so alien – a variety of seeds, such flagrant pollination? Freaks? Abominations? I could not shy away from the possibility, but my imagination remained unhindered by such squeamish myopia. Even as a boy, though I scarcely knew it, I was searching for a way to subvert the chromosomal order of our species, to avoid the evolutionary cul-de-sac and inevitable stagnation that awaits it. I would imagine myself unravelling the secrets of the DNA helix, picking it apart like a crudely-knotted length of rope, refashioning it into the most intricate of shapes, abstract configurations which would explore every conceivable dimension of the species' true, Protean potential."

Dr. Yoshida watches as the helpless Mitsuko is lowered into the Gene Pool, submerged beneath hundreds of gallons of the BioHive's ripe secretion. The liquid is saturated with oxygen, sufficient for the normal functioning of the human respiratory system.

"But as the years passed, and I waited in vain for the coming race, I suddenly realised that we would simply have to become the transfigured species of which I had dreamt for so long." Dr. Yoshida begins to unfasten the belt of his kimono. Although his voice remains curiously passionless, he is close to euphoria now.

"What would we become: that was the question that compelled, that obsessed, me through the years of tireless research."

The kimono begins to fall from his shoulders, and he looks down into the Gene Pool, entranced for a moment by his own reflection on its placid surface.

"What am I...... becoming–?"

Ishiru Okida is a young man, twenty s ix years old. Until precisely thirty two minutes ago, when the bio-web reduced his body to a porridge of useless sludge, he was at the height of his surgically enhanced powers. Now only two of his faculties remain unimpaired. His eyes: fitted with Compact-I optical implants whose specifications include infra-red, heat vision, laser-scoping and 3-D graphic enhancer. And, far more significantly, his mind.

As well as being an expert in the traditional martial arts, Ishiru Okida is also a formidable psychic combatant. New Tokyo bio-scapers have implanted the frontal cortex of his brain with a colony of cerebromorphic organisms; cranial parasites artificially bred from an active culture of cortical tissue, feeding off the brainwave energy of their host. The colony's queen coils inextricably around Ishiru's pineal gland, enlarged and activated by this benign invasion.

The cerebromophs1 rapid reproductive cycle, as well as boosting the higher functions of the dormant pineal gland, precipitates the formation of new synaptic conduits in the host cerebellum. The metabolised, psychotropic effects yield a startling mutation. Ishiru Okida's brain has been transformed into a kaleidophonic accelerator.

The kaleidophonic spectrum exists beyond the range of sound, crackling with the endless reverberations of the Primal Event, the ambient cacophony of natural radio static, echoing the cosmic fission whose fall-out condensed to form our coldly expanding universe of seething stars and icy nebulae. The harmonic scale which the kaleidophonic frequencies occupy resonates with the vibrant atonality of quantum interactions. Consciously manipulated they may excite sympathetic responses on a subatomic level, redefining the nature of matter and energy, catalysing new reactions. Unpredictable reactions.

Ishiru Okida may utilise his kaleidophonic capability to project his consciousness onto a plane beyond telepathy or astral travel. In essence he becomes a part of the microverse of quantum physics, a black manta scything its way through an ocean of quarks. His conceptual hyperself radiantly invades the Zen Continuum, the Virtuality hyperzone generated by Dr. Yoshida's dreaming machines.

Ishiru Finds himself travelling at speed above an arid plain. In the distance, bizarre structures are silhouetted against a pseudo-sky of oozing, impermanent hues. Although he seems to be approaching them, they remain faraway, shadowy shapes – part megalith, part abstract sculpture. Travelling in the fourth dimension, conventional spatial concepts – up and down; near or far; left or right – retain scant coherence.

The data matrix of the Zen Resonator, Dr. Yoshida's customised adaptation of the Mitsubishi Zen 5000 Series Psimulator System, is capable of sustaining an unlimited number of Virtual Worlds. Since the matrix has assimilated the discorporated personalities of Dr. Yoshida's permanent house guests whose excised nervous systems constitute the macabre, neurological bansai garden that is an integral part of the BioHive, perhaps Virtual Hells would be a better description.

A vast, disembodied mouth floats in mid-air. Revolving slowly, it emits a continuous, uninterrupted howl of terror and disgust; indescribable grief; unbearable desolation. Enormous columns of glass ants – organised in a complex network that surpasses the intricate symmetry of an electronic circuit board – devise an elaborate system of towering, crystal cones that act as conductors for pulsating beams of bio-electrical energy. Parched expanses of proto-silicon wasteland alternate with bottomless quagmires of non-specific organic tissue which heave and recede to periodically disgorge parodic creatures whose maimed anatomies are ghastly puns on the evolutionary lineage from which they continue to degenerate. Wracked with spasmic tides, these putrid morasses of rancid fat and decomposing gristle were once people. The grotesque menagerie of scuttling, squirming, sexless abortions puked up by their scurfy swells are their malformed offspring: literal embodiments of their phantom nostalgia for the discorporated flesh. The sky here bleeds. Erogenal tumours blossom torturously in the stunted cancer groves, pungent flowers shedding syrupy tears of fragrant corruption. To merely inhale a single atom of their fatal perfume is to succumb to the ecstatic torments of venereal leprosy: neurones burning out like

spent electrical elements as the delirium of sexual euphoria races towards its apex; infected genitalia amputate spontaneously, spurting menstrual blood and semen; ghosts of erotic psychosis haunt the amnesiac labyrinth of trauma dreams.

Enzyme lakes boil and curdle alternately. A polyhedron of shimmering quartzite and amethyst – a vast incandescent cathedral modelled after the scintillating, composite eye of a monstrous, necrophageous fly -looms on the event horizon of cyberorganic interface. The cathedral is inhabited by colonies of sentient bacteria similar in structure to the internal flora that lines the walls of the human bowel.

Cortical smegma. Brain dirt. The spores of psychoactive bacteria absorb the ambient feedback of bio-plasmic energy, processing it; digesting it; and, eventually, excreting the residue in the form of encoded thought-form transmissions. These transmissions, establishing an empathic resonance on the kaleidophonic scale, precipitate a paradox loop which sustains the cathedral's cohesion and occasionally infects the matrix's lesser autonomous structures with a digital dysfunction that simulates a condition similar to Tourette's Syndrome.

Ishiru recognises the cathedral as the conceptual manifestation of the Zen Resonator's logic/anti-logic drive. It is this specification that enables all generations of the Mitsubishi Zen 5000 Series Psimulator System to process qualitative data. That allows it to think. To dream..

And what dreams. What nightmares Each facet of the cathedral's geometric surface is illuminated with an animated, holographic image, illustrating a different version of Mitsuko Hara. In many she appears in ways already familiar to the devotees of the Virtuality Manga with which her name is synonymous: as Mme Garrotte, her lithe form clad in various fetishistic costumes, all-enveloping like clinging, patent leather space-suits, or strategically slashed to reveal breasts, buttocks, hairless genitalia – her porcelain features glacially set in an intransigent attitude of sublime cruelty. Here, too, as the enigmatic Sardonika, mutant anti-heroine of Metal Sushi I & II, occasionally caricatured in the neo-Cubist style that so revolutionised its graphic scenes of metal fetishism and physical metamorphosis. And again as the nameless, alien-terrestrial hybrid featured in Hideo Sakamoto's cosmic saga, Arcadia Apocalypse: shimmering, reptilian flesh; golden eyes; green-on black, oil-slick-sheen hair – but still that unmistakable poise and physique, the perfect symmetry of her face.

The composition of these images is equally familiar: Mitsuko as strident aggressor or submissive victim ~ dishing out the vigorous punishment, or else on the receiving end herself...... Straddling a behemoth of a motorcycle, its chromium entrails scintillating coldly, her gleaming, black, polycarbon-encased legs flung widely apart, she languidly masturbates herself with the elongated muzzle of a high-velocity tracer weapon. A forest of squirming, flayed bodies surrounds her, more naked than nature intended. A. gentle rain of vivid blood condensed like crimson dew on her breasts, belly and thighs, her pallidly ecstatic face Elsewhere she is bound and gagged, belly down, her back and buttocks cross-hatched with bloody welts, a majestic, jewel-encrusted scorpion poised on her thigh. Its formidable pincers hack morsels of the oozing meat from one of the ragged lacerations, cramming its busy, toothless maw with the moist, pink delicacy.......... A flurry of limbs; endless arsenals of death-dealing weapons and sadistic sex-toys; legions of faceless extras gouged, beaten, burned, gutted, dismembered, castrated, sodomised,

blown away, wasted, artfully skinned; baroque orgies; clinical gang-rape; teeth bared in rictal fits of unendurable agony and/or ecstatic euphoria; death camps; shape-shifting; alien deserts; war-zones; spaceships; Mitsuko abused; Mitsuko abusing; charnel-house glamour; torrential cum-shots – close-up, close-up.......... So it goes. So it goes.

Manga. Manga. MANGA. The holograms bleed into one another, splicing, diving, reproducing like a cancer. What are we seeing? What is this? Amplifications of Dr. Yoshida's subconscious memory of his own Manga addiction, his erotic obsession with Mitsuko Kara – the instinctive identification of the death-and-ritual fixated imagery of violent pornography with his own iconoclastic superscience, its equally cruel and sensuous disciplines accessed by the input-hungry BioHive, illustrated by the neural-fusion fields of the Zen Resonator's Virtuality matrix.

This is the conceptual realisation of the psychic feedback that resonates between the twin polarities of the hypothalamus – its associated instinctive drives – and the higher evolutionary functions that lie dormant in the insoluble crenellations of the overlying cortex. An encoded transmission beamed from the darkest recesses of inner-space.

Black static. Such emissions of bio-plasmic energy can be calibrated and quantified in the field of the Zen Continuum, and some theorists regard them as the psychic equivalent of the Deadly Orgone Radiation theorised by Wilhelm Reich.

Ishiru Okida unleashes the destructive potential of his kaleidophonic talent, manifest in the form of glittering shuriken – a shower of the scalpel-sharp, star-shaped projectiles once favoured by ninja assassins disrupting the quantum interactions that define the cathedral's conceptual integrity, the intricate thought-form architecture of the Zen Resonator's logic/anti-logic drive. Chain reactions of psychic fission are initiated. Event horizons of inexorable catastrophe expand in irresistible, seismic waves.

Its work done, Ishiru's hyperself realigns with his physical being. The prison of meat coalesces hotly around his astral form. The cloying sludge of dead and dying tissues engulfs him like quicksand, hauling him down. Pain enslaves him, its animal hunger vast and insatiable. He grapples unsuccessfully with the urge to vomit, hawking a wad of blood and phlegm onto the floor. Dr. Yoshida's kimono falls to the floor. Arms outstretched he invites the scrutiny of his audience. "Well," he says, his bland voice echoing with a hollow, almost disembodied quality, "here I.... am–"

Dr. Yoshida unveils the fruit of his becoming with an appreciable air of pride. Repeated acts of mass congress with his slimy coterie of sexual symbiotes – perverse, excruciating orgies which set the fertile secretion of the Gene Pool boiling – have resulted in a metamorphosis that distinguishes him as the forerunner of his long-dreamt-of, transfigured race.

His flesh is semi-transparent, veined and colourfully diaphanous, salamander pink; peacock blue; radiant crimson and mauve; colours merging and blending with one another constantly as the sludgily clear mucilage disperses the Conservatory's ambient illuminations like a prism – its texture resembling the slimy gel that contains the spawn of toads, frogs and other forms of amphibious life. The torso and limbs lack muscle definition, as if the palpable ooze had simply congealed on the bones. The internal workings of the cardio-vascular and respiratory systems; the convoluted plumbing of the alimentary canal; are plainly visible through the rippling

layers of glutinous proto-flesh. So, too, is the entire network of new organs: palpitating tubers of gristle and fat that pump and pulsate with unnamed enzymes; glands swollen with fermenting secretions.

Two rows of distended psuedo-mammaries, glutted with curdled lactic slime, like hideously bloated abscesses, clearly distinguish Dr. Yoshida's transformation as an essentially sexual metamorphosis. As if to counterpoint the blurring of genders, his misshapen abdomen and groin culminate in a large, penile tube of suppurating, cartilaginous tissue approximately six inches in diameter. A spiral disk of gristly muscle supplants pursed lips and sphincter, the rhythmically throbbing, moist aperture at its conical head. The entire lower torso is deformed by scrotal protuberances, wrinkled and hairless, pink-grey like brain tissue, their inner structures variegated and compartmentalised like clusters of grapes or the inside of a pomegranate. Regular, gelatinous sacs house the translucent, oblong pods that bear the virulent spores, the seeds – of his new species.

"So, what do you think?" asks Dr. Yoshida, pirouetting like a high-school debutante previewing her prom gown. "Be brutal–"

The two Yakuza thugs, Tanaka Matsubara and Hineshi Sato, gawp speechlessly, reaching instinctively for weapons that have been deactivated by the dome's security systems. Their criminal instincts are already alerting them to the fact that Dr. Yoshida has no intention of reimbursing them for their services.

Ishiru Okida's gaze moves to the Gene Pool, his Compact I optical implants switching to a split-screen Kirlian Spectrum/graphic enhancer function. Mitsuko's aura is as vivid as the aurora borealis, flushed with violent hues of panic and fear. But the graphic enhancer reveals something else: the Gene Pool is alive with Nanomachines. The enhancer augments the normally-imperceptible coronae of their minute energy emissions, so that the BioHive's secretion glows like a satellite photograph of the ocean radiant with the cold iridescence of dead plankton. Ishiru understands what it is that Dr. Yoshida has planned, having glimpsed something of the internal machinations of the BioMech process when he accessed the Zen Continuum.

"Yes, that is precisely what I intend, Okida-San," says Dr. Yoshida, his own heightened psychic capabilities snatching a sequence of thoughts from Ishiru's cortex in; tentacle-firm grip.

"The perfect, chimerical marriage: the coupling of your species' ideal female with the forebear of a new, evolutionary ascendancy is simply the first step. The product of this union shall provide the physical vehicle for a radically new form of intelligence; the mass-mind of BioMech, the literal soul of cyberorganic interface"

....He pauses briefly, savouring the moment, and then adds:

"HERE'S TO THE END OF HISTORY, GENTLEMEN–!!"

What happens next transcends the parameters that define the sequential perception of time and the Newtonian laws governing motion in three dimensional space. The Conservatory is a vast nervous system, vibrant with the fusion fall-out of a thousand million synchronicitous interactions, the dome resonating with the harmonic chaos of kaleidophonic cacophony like a bell struck on Judgement Day.

BioMech: the consciously directed, empathic union of two alien intelligences – one

organic, the other cybernetic -precipitates parallel chain reactions of criticality along the convergent axis of the psychic plane and the sub-atomic level of quantum interactions. The sustained crisis generates neurospace, neurotime. The micro verse of dreaming, of becoming, folds the prosaic, Euclidean geometry of spatial and temporal perspectives in on itself There remains one reality. The Zen Continuum.

Dr. Yoshida, surrounded by rotating spheres of glowing, bio-electrical energy, an ascendant star at the centre of his own solar system. His pale, inexpressive face, the last apparent vestige of his humanity, melts like rancid cheese. His tight-lipped smile is corrupted by putrefaction into a parodic leer. The flesh and eyeballs; muscles and bone; wither before the onslaught of an insufferable, cosmic heat that generates from within.

His muscles and tendons knotted like damp, ineffectual rags, his body resembling a broken puppet that caricatures human form, Ishiru Okida is suspended in freefall while the liquid floor dissipates slowly into randomly floating globules. Echoes of possible futures collide in the improbable maze of his cerebral cortex, his super-stimulated pineal gland swollen with the psychic detritus of quantum decay, focusing the tangential disarray of matter and energy.

The Gene pool is whipped into a boiling maelstrom of activity as the Nanomachines initiate their programme. Its frothing surface is convulsed violently by snaking ropes of electric blue and blinding white bio-lightning while the Nanomachines simultaneously deconstruct and reinterpret the molecular structures of both BioHive's amnio-seminal secretion and that of Mitsuko Hara, Virtuality Icon; object of desire; and now the proto-Eve of a new species whose lineage is yet being dreamed into existence by the process of BioMech.

Movement enhanced by static after-images of Kirlian radiation. Hineshi, cowering by the peculiar terrarium from which sprouts the strange bansai of stunted nervous systems, vanishes in a kaleidoscopic blur of colour and ai explosion of tiny, black, plasma-mass fragments. The shuddering bulk of the BioHive drags itself painfully frei of the gritty mire that has nourished and sustained its growth until this, the apothetical moment of maturity. Blind, endowed with senses a thousand times superior tc sight, it casts out ragged tentacles that ensnare the helpless Hineshi in an inescapable, tenebrous grip. The corrosive secretions that ooze from its scabrous flesh ea\ through the poly carbon fabric of Hineshi's suit, dissolving skin, muscle and bone with the ease and efficiency of industrial-strength molecular acid.

The BioHive dedicates the merest fraction of its complex data-colonies to the deliberate and thorough dismemberment of Hineshi Sato. Conical structures on the BioHive's corpulent flank glow with subcutaneous phosphorous. These organs serve as the BioHive's equivalent of erogenous zones, and are clearly stimulated by the smouldering stumps of amputated limbs; the hot slurp of fragrant bowels bursting from their bony cradle; the gritty feel of charred flesh; the steaming broth of pulped lungs, melting cartilage and gristle.

Tanaka, meanwhile, staggers on stiff, faltering legs, eyes glassily vacant, as he vomits a bubbly froth of bright, oxygenated blood, his gaunt face leached of colour. Aiko stands behind him, her delicate, white hand buried in his back, right up to the elbow. Tanaka topples forward, his spine snapped like a dry twig. Blood spurts briefly from the gaping crater in his back, its ebbing flow eventually replaced by a hazy column of pungent vapour. In her soft, cupped palm the

geisha holds a suppurating lump of visceral machinery to which there adhere ragged fragments of sinew and skin, segments of ruptured artery, squirting thickly. The geisha closes her fingers, forming a fist which reduces the tissue to sludge.

In excelsis Dr. Yoshida, transfigured at this, the critical moment of the BioMech event, holds sway. The luminous sap that runs through his veins – a metabolised solution of blood and the psychotropic aphrodisiac, Manta Red – rushes, pounding, into an elaborate network of vessels, causing the erogenal tendrils that sprout flaccidly from the slimy protoplasm of his flesh to grow hard and erect. They radiate from his body in the form of hardened quills – he is bloated enormously like the notoriously venomous puffer fish – vivid with glowing secretions.

Each of the lethal-looking spines ends in a hollow point. Glistening lubricant oozes from some; others are capped with a coagulating crust of stiff, seminal fluid.

Wave after wave of black static rushes through Ishiru Okida's ravaged nervous system. The constant flux of thought-form fusion and psychic fission steadily destabilises the molecular integrity of his every physical process – from the autonomic functions of respiration, blood pressure and cellular reproduction, to the biochemical interactions that produce consciousness itself.

Ishiru's consciousness is downloaded onto the volatile plane of the kaleidophonic spectrum, he is reduced to the conceptual essence of thought itself: an undifferentiated soup of swirling electrons – subatomic cohesion bonding and dispersing constantly – the energy released by their complex interactions producing a stream of charged particles that propels him, a rogue element, deep into the atomic fabric of the BioMech interface. Microverse yields to microverse, each in turn assimilating the distilled essence of Ishiru's being.

And then, at last, he finds it.......... Amid the spiralling vortices of gases and cascading showers of coloured lights, a regular crystalline structure whose rigid symmetry defies the impermanent miasma of matter and energy that surrounds it. The polyhedron cathedral.

The Zen Resonator's logic/anti-logic drive is poised on the verge of criticality, its fragile geometry scarcely containing the constant chain reaction of kaleidophonic detonations, each of a greater, more devastating magnitude than the last.

Ishiru's thought-form trajectory collides directly with tl structure's central core, catalysing the ultimate fission reaction that sends individual fragments hurtling through every branch of the BioMech neural configuration like a cloud of fall-out, psychically contaminated shrapnel.......,... Matter and energy are redefined at the apex of critical mass.

Dual horizons of third and fourth dimension interface yield violent upheavals along the tectonic fault lines of the neurospace/neurotime continuum. The Zen Continuum's geometric perspectives warp and refract, spatial and temporal stresses exerting unendurable pressure.

The kaleidosphere sheds its crust like a transfigured reptile, sloughing off the dead scales of its skin, to emerge reborn: a fabulous dragon with an iridescent hide of shining jewels. The world's outer skins of atmosphere, oceans and variegated land masses dissolve in waves of psychotropic fog, shimmering nebulae light years wide. Rivers of molten lava and Lung Mei, the radiant dragonlines of geomancy, criss-cross the exposed mantle. They mesh in cosmic communion with the catastrophe of physics that hung the sterile vault of space with dead planets

and decorously doomed stars, the biochemical folly of evolutions whose ultimate corollary is extinction: the inexhaustible crucible of Creation. A comet spawned in the broiling heart of a nascent, conceptual cosmos, Ishiru Okida is reintegrated into the material world by the forces of gravity, billions of atoms re-establishing old molecular bonds – devising new ones. Re-imagined by the mass-mind of BioMech, he is hurtled, screaming, back into the sphere of physical being. His literal reincarnation consecrated by a baptism of celestial fire, he is radically, almost inconceivably changed

Transfigured.

Several months pass before the Hakashi Corporation sends a second team of termination executives into the island estate of Dr. Akira Yoshida.

They encounter no resistance.

Inside the Conservatory, beneath its fractured, polycarbon dome, they discover a scene of incomprehensible devastation. The vast bulk of the BioHive – still-living, convulsed with the residual spasms of the motor-neurone cancer generated by the kaleidophonic disruption of the BioMech interface event; succumbing slowly to the rigours of starvation and hypothermia; its coarse hide caked with the congealed crust of its own excrement – totally defies their understanding. The Zen Resonator howls intermittently with bursts of atonal static; software erased, data banks wiped clean.

And then there are the corpses. Putrefaction has rendered them both unrecognisable. A bloated, eel-like creature -one of the sexual symbiotes spawned by the BioHive – feeds greedily upon the rotting flesh, honeyed with the nectar of corruption. Its head and gills buried deep in the gelatinous mire, it squirms and writhes violently as it gorges, a trail of congealed amnio-seminal fluid tracing its path from a shattered cocoon.

The assassins wonder if either of the cadavers might be that of their intended victim. They take tissue samples for genetic analysis that will later prove inconclusive. After a perfunctory search of the estate they depart, finding nothing. Traces of organic sludge in a sunken pool. Puddles of raw polycarbon base containing the remains of Nanomachines so decayed that they defy technical analysis. All in all, an expensive and ill-advised adventure as far as the Hakashi Corporation is concerned. Meanwhile, deep in the earth beneath the remains of the Conservatory, something stirs

The spiralling ventilation shafts and maintenance tunnels surrounding the heart of the subterranean, matter/anti-matter reactor like the coils of an enormous snake, form a maze, inaccessible to the outside world; this is the spawning ground for a new life-form.

In the aftermath of the critical catastrophe event generated by Ishiru Okida's kaleidophonic assault on the Zen Resonator's logic/anti-logic drive – and through it the physical and metaphysical cohesion of the BioMech process – the entity which had once been both Mitsuko Hara and Ishiru Okida, the redefined, transfigured vehicle for the downloaded mass–mind of cyberorganic interface, had slithered free of the Gene Pool. Its primary directive was clear, unequivocal. Every iota of its being charged with a single imperative: the instinct to survive......

And mate.

And now s/he nestles secure in the embrace of endless night, basking in the carcinogenic warmth of matter/antimatter fall-out. S ix metres in length, two metres wide, Mitshiru's vast, conical body resembles a pulsating dirigible of raw, moist, hairless flesh. Its translucent, pink skin, marbled with veins – arteries as thick as telephone cables, gossamer fine capillaries – swarms with active Nanomachines responsible for maintaining its lair and synthesising the vitamin and nutrient enriched Manta Red derivatives that form its staple diet. The tube-like body culminates in a wedge-shaped, hermaphroditic sex-organ, glutted with its virulently fertile amnio-seminal fluid and the Manta Red/blood plasma solution that courses through its veins. Its entire physiognomy is a ludicrous, phallic grotesquerie, spawned as the BioHive's data-colonies succumbed to the crippling onslaught of kaleidophonically-accelerated motor neurone cancer.

Mitshiru's mate, Dr. Akira Yoshida, adheres to the entity's left flank. As helpless as a prehistoric insect encased in amber, his mutated body, metabolised by that of his dominant mate, is suspended permanently beneath layers of congealed, protoplasmic tissue. Mitshiru has reduced his nervous system to the most rudimentary of functions, capable of responding to nothing more than the most basic stimuli: the threat of pain, the promise of erogenal reward.

Dr. Yoshida's spike-encrusted body has all but atrophied now; the vestiges of clearly discernible human features melting into the malformed mass of his re-evolved flesh. His continued existence is sustained by a form of osmotic nutrition. Shortly after he went insane – no longer able to tolerate the shrill cacophony that constantly shred his nervous system with such unendurable clarity, convulsing the defenceless matrix of the frontal cortex and the hypersensitised pineal gland – Mitshiru had casually burnt out the relevant synaptic circuitry and their corresponding neurological terminals. Dr. Yoshida now enjoys a level of consciousness comparable with that of a cockroach.

Buried deep in the entity's throbbing flesh, a network of neo uterine sacs contains thousands of incubating eggs, fertilised by the seed of Dr. Yoshida's repeated and relentless rape. The embryos are partially visible, blurry, indistinct. But the eyes – fiery green with feline, vertically elliptical pupils – are clearly defined, their unflinching glare piercing the thick, mucus membranes that enclose them.

Somewhere in the pheromone-scented darkness the little geisha continues to play. The sound of the koto, echoing through the labyrinth, will be the first sound Mitshiru s offspring hear as they emerge, fully formed and hungry. Poised between the arid land and the fertile sea, Mitshiru's subterranean lair occupies the twilit realm of evolution and extinction, the eternal equinox. Soon its children – the new species dreamed of once by Dr. Akira Yoshida – will take to the air and the water and the land. The sterile topography of shifting desert dunes shall teem once more with life

Outside, the blood-red, nuclear sun sinks slowly beyond the horizon, its violent hues oozing into the placid waters of the silver sea. Tomorrow it rises on a bright, new, blood-red dawn.

acidhuman project
kenji siratori

PROJECT ABORTED
MURDER IN DISGUISE
ANIMAL CALENDER

<<neuro-ejaculation>>

A black würm firewall darkly::cities of digital code and anti-code::razor rim of night retracted/Junk Embryo City=the killing parameters of the Zodiac Doll:model Z-69 foetal vivisector: priority code crimson= vaginal invasion//clone-spectacle of the spiral chromosome of centipede burn-up::eternal thyroid vex of the fatalities is opened and the topology of a micro/artificial sun murder game emulates the simulacra/suspension consciousness of the clone embryo that the suicide machine of my soul clashes>>your crucified memory of her body becomes discrete//is a split brain that was beaten to the eyeball of the nightmare of his x/octave:the eyeball of an assassin goes to ruin with the digital proliferation of lupus of artificial sun::the spectre of the cell death of the excoriated earth//the death DNA of our herd assassin of the ambient/gene of outer space gets deranged::Zodiac/machine of your earth travels the monochrome body of the embryo that goes mad and dismantles the cruel rhythm of the larva machine::it respires and the feral fire machine of the drug mechanism of the artificial sun explodes the murderous body fluid of your machine that digests the zero gravity/spectre cell of a drug heart of the earth area external//laughter of the clone embryo sticks in my skin:the silver protoplasm space of the love of lupus is being cloned like the beat of the death that is not able to return twice//Sato Corporation 2323 inauguration of Swastika Ladyland of burnished plutonium crypts=total eyeball/there is not the horizon in her Cadaver City internal–there are how many muscle thing horizons/merely internal//the end of your DNA=the drug-motion like clone=reptilian remnant of the consciousness of an embryo:so our future gene soul of the drug mechanism of the god/machine>universe of the assassin that in outer space becomes an insect becomes the reproduction organ of my brain because the embryo <to her death> is collected in the suspension consciousness of his soul-machine <<cruelly>> because the Zodiac/suicide machine of the artificial sun fecundates:short-circuit to your pheromone eternally::your true cell of the lapse of memory=zero of the emotional zero of the embryo zero of the murder zero of zero of my heat interior of the womb of her zero that splits subconsciously// wonder of the small mecha-sperm that fecundates the eve/body of the artificial sun game in such a purgatory where

melody respires the velocity of light::murderous intention of a cell continues to be the infinite other self of the artificial sun (immature suicide machine of the clone embryo lupus loop=the apoptosis style of the artificial sun with the back of our thyroid vex)::<history of our lonely face> caress the skin of the insanity of the clone that lupus infected with the murder intention of outer space and the subconscious of your demon pact::an assassin sodomised the Zodiac/cadaver of the sun/the drug stratosphere of soul pulls the mask of my eve/machine::the consciousness of an embryo is parasitic and peels the cosmic crime net of the virus that reproduces her brain internal cyber-host//that god machine was beaten in the consciousness of your clone embryo divergence <<death>> of clone that we love is infectious to the nervous system of the fabrication of the artificial sun at abnormal speed::drug-eye of the eve/cells of the outer space that the suck=blood chromosome of your soul rapes shadow that dances strangely on the horizon of our DNA that blasted my consciousness that committed the murder of the milligram unit internal and all the disillusionments of BABEL that changed toward the chaos of a vital body//we operated a gene virus of the infinite=zero of the artificial sun that was infected to the clonal/urban/area of the corpse body of Zodiac=dogs her cell of clone embryo of our subconscious is holy and speaks of death::our death-molecule was being cloned::<immortality> of the whole had awoken to the body just as the digital herd of lupus internal attaches the outline of the non=vital target death of the clone/embryo to the site internal of your emotion::drifts ashore in the central ovaduct there without the limit of his chaos::as for my monochrome (exoskeleta is contrary=the sun target) it dogs a brain (cosmic vital curvature of the clone) even the beginning of our micro/murder despirals//there is not even an end to recorded sex of the quantum theory of an assassin with the gradual placenta of fatalities//it fecundates the würm hell of your cell noise with the decay of our subconscious <<the Zodiac clone machine state spectre ectoplasm spot+apoptosis universe melody>>intravenous immortality death perception resuscitation <<digital vampire reverbs in burnished plutonium crypt lined with jackal placenta/

<<book of the brain>>

Necronomicon-technology 2323::our replicant nerve fiber evaporates air of an embryo//is instigated to the drug mechanism to the black hole of the Zodiac/suicide machine of an assassin and the original of the zero of the placenta is diverged::my soul revolves the monochrome artificial sun molecules of the menses that were scrapped by the cruel DNA organ of the world to the apoptosis stratosphere of the clone/embryo and release of murder traveling in nature virus of our gene=TV// complex seed of murder is formed within the assassin of the cyber-matrix //my original topologic lupus=space consciousness of the larva machine of an embryo secretes the cold-blooded circuit BABEL/creature of my brain in the outer space where you were lost::liquefy our <breakdown> internal organ whip and the thin air of the sea area of the death moon crater which the clone that is infectious renders impossible to see because my consciousness enables the seed/birth with the inorganic substance eyes of the artificial sun::our clone which is loved to the stratification of the micro/crime/machine of the earth area::brain of the fatalities goes across the life of your drug mechanism//there is come internal and you palp because the artificial sun respires the disillusionment era as long as the subconscious<like my assassin>is concatenating

and scattering cadaver to every part of your embryo cruelly in quest of the soul of the cyber of such lupus that records machine ticks of my murder clones::kiss the infinite horizon of the cadaver of the mystery that the brain of the ruin of the artificial sun simulated//murder dynamic subconscious of our virus that is to diffuse the machine that the earth conspires::that is to draw the fission line of a soul-machine that loves/radiates the erotic core of a clone of <regeneration> <ruin> a primitive drug/embryo of the murder machine of violence>for only chaos resuscitates like the mechanical body of the darkness universe of an assassin with terminal dog-thunder inside a roseate hologram/to torture my micro/awakening that rapes our earth//operates the sonic/suicide organ of the artificial sun in a gene infinite cell war of the surface of the earth::your machine that the brain of the fatalities fecundates//rhythm fecundates the death of the immortality of the assassins of a clone throat under my chaos//the lysergic anus glycerine consciousness of the original murder traveling in profound DNA::drug embryo was scooping out from inside your pheromone of chromosome a murder complex density MAX that became the speed of the promotion of the retro/virus that requests the nerve of a brain dismantlement-subsidence:universe drool-interceptors are extracted in the cruel outer space of the Zodiac machine who sodomised the inorganic substance blood of BABEL/creatures clashed over there in lapse of memory of mankind =the soul of the sun fecundates noise to the assassin state swastika surface of the nightmare bone-eating in the darkness of the cell/war upheaval swastika body that activates drug-motion>>swastika life becomes the desire speed of a drug all of congenital tissue meridian with the back of my eyelid so your larva boils//deoxyribonucleic acid of my artificial soul recovers the brain of gene=TV of BABEL by the roots to proliferate the pheromone of your cell=private spectre to incubate the seed of the death of a clone assassin <<that girl eats that boy>> it is the struggling condition of a machine::it is the noise/body of a drug breaking through the horizon that is the artificial sun suicide organ of this Cadaver City because the earth of their brain records the secretion of the mutant gland of Zodiac as the truth of/eve/is the reproduction virus of the replicant gene universe because it fecundates four/powders toward the artificial insemination of the death that the clone that we love::it sutures to an internal cadaver of space//the nerve of my murder in disguise animal is contra-indicated=it was perceived by the spring sound of the sun air with the narcotic/air of the suicide machine of the embryo that bursts your suck=blood chromosome and repeats infinite murder flight horizon of the drug mechanism of the cadaver/city fecundates short internal micro/placenta state murder machine of a clone::the virus of our abnormal world fertilizes reproduction area of my artificial soul::Z69 is induced to the zero of the body suicide replicant of the lupus of the cyber spirochete/the unvital stratosphere of the cadaver/city like the eternal body of a machine internal=the spectre particle world of my murder in disguise animal burns cosmic//machine of your subconscious emulates reproduction condition at the center of the zero of a chromosome> the larva/machine executes the random soul of the fatalities of the brain of the nightmare of my body that fecundates the assassin of gene=TV of BABEL=infinite convergence of cosmic human immuno-deficiency virus of animal in your future is contrary=the sun incinerates the brain collector> because the criminal eye/contact of your embryo illicitly sells the brain of the fatalities it is to invade to the murderous nervous system of the animal that thinks about the zero of the viral drug-eyes of an outer space of our

virus> it is vital that the lupus of the cyber nexus accomplish paradoxical/death to my epicene cell space> I become the deathshead of the rebel of the insect brain table clone and the artificial sun of our catastrophe> BABEL/creatures of opposite=visual opposite=hearing soul of my crime topology machine that changes to the inheritance device of their devil iron-fingers>>/

<<antibody of apoptosis>>

your suspension consciousness of the soul that my machine holds::it devours the digital nerve murderous intention of the artificial sun brain being the sec/melody to the annihilation of the larva/machine as you quantify the noise of your suck=blood chromosome that reflects the crime parasitism program of the earth area below::your DNA fecundates the murder traveling in disguise to a natural acoustic space of the cosmic parabola/HIV of my micro/corpse body that my general cell fecundates to the quark crime net of gene=TV::it proliferates brain electra of the zero state of the emotional machine fatalities of the placenta state replicant that expand to the zero of my consciousness> the zero gravity/germ cell of the drug of lupus is instigated::crime/body/ topology that oscillates the retro/virus TV catastrophe larva machine nature zero of the gene air of the drug

embryo that scraps the attraction of the sun of my murder circuit::my direct brain vector is contrary=the negative intuition nerve of your embryo soul goes underground to the interior of the womb of the murder of the sun:it is the meridian of the boy machine of the cell of chaos that awakes inorganic substance in their host that fertilizes their parasitism that fecundates their artificial sun fission disease::anthropoid chromosome noise is made different to the digital season of a cosmic/HIV nervous system that committed the murder of their end clone::<velocity of vision>the light murder metronome device quantifies nature germ cell density::foetal cell annihilated/cell group of my awakening is going to change it to the digital bloodsucker form of DNA::it is contrary=her brain universe drug-eye of the miracle of the chaos<<fatalities go across the horizon of the body swastika of the sun>>replicants of the nerve of the ruin of the artificial sun brain of the fatalities that circulate in the cosmic/HIV/season of our digital chromosome internal organs::retro/virus of my sadistic soul=the metal melody of your larva machine murder traveling in disguise::natural stratosphere zero of machine state reproduction nets artificial sun interior of the womb catastrophe of the disillusionment embryo::it conceives pain because your machine breaks through the membrane that fecundates the speed of the topological brain of the clone/embryo::worldly desires of light speed the pheromone of your cell death because the clone/embryo thrusts through the body organ of the death that makes love impossible to another murder person inside my crucified memory::your pheromone quantifies the love of the clone that fecundates the ferric mob of the cadaver/city to the infinite surface of the artificial sun::the razored placenta of the underground of the murder/machine drug is expanded to the speed of the paradoxical/underground ascetic of death cell map of my awakening where it measures the photographical map of the negative derangement of the brain nervous system of the word chaos of BABEL that resuscitates cosmic/HIV/space-time::protoplasmic period when fatalities of brain were lost to another murder machine of your crucified memory>germ cell of my nightmare invades to the immortal electron region of the soul of a clone/sick intelligence of the drug-motion embryo of the cell death of my desire=soul of the immortality of the clone that edits the mass of flesh of lonely NECROTECH narcosis of a cosmic human immunodeficiency virus to the brain of the modem massacre::without the mode of the atmospheric racial brain sex of the artificial sun that fecundates BABEL creatures with worldly desires of my synapse body::suck=blood chromosome of a machine repairs like a machine nerve fiber of your zero register>the infinite electric desert of the drug/embryo usurps the death of the machine state animal of speed reproduction::organ of my eve/suicide/machine that the brain universe of Zodiac devours:that swims in the ambient/murder region of the drug being infected with the cyber space of the swastika assassin which is meridian to the artificial sun that the embryo of the machine who loves it extinguished::pheromones of the bizarre internal organ order of the chaos that clashes the soul of the murder of a larva to the future when the love that their mystery respires expires::/erotic internal split of a cell to the inorganic substance tragedy of the DNA that generates the infinite zero of an embryo::the retro/virus of the solar system of gene manipulation of your soul makes it different to the cosmic/HIV/quantum of artificial sun breakdown engineering::mystery of the ground is split to the negative consciousness of the drug/embryo of clone/NECROTECH narcosis to the DNA/channel that is not able to sleep/it fecundates the virus that operates the gene of the

earth outer circle of the clone/embryo to my self-replication nature::Zodiac Doll/human/body that is an eternal murder traveling in disguise animal=strange emotion of the zero rhythm like the larva of the earth area catastrophe that induces the metal slash of your micro/murder like the end-clone type of the spiral of the horizon that exists>my soul anneals the body like your machine::/Zodiac 69 sodomises SuperCreem 666=anal abortion frenzy//

804: an erotic rendezvous
reverend paul stevens

Through the revolving door looking dead ahead, you walk toward the reception desk. The young receptionist hands you an unsealed envelope. You neither meet her eyes nor utter a word. You simply turn & head toward the bank of elevators in the centre of the lobby. As you walk you open the envelope. Inside are a keycard, some loose hair, a razor blade and a folded piece of paper. As you reach the doors of the elevator car – you carefully open the note. The note reads "804 – blue – skin – ape – horse" You smile to yourself. The doors open. You enter and press the button for the eighth floor.

As the lift glides skywards you reflect. Paid well for this, not only the cash, the time, the endless phone calls to computerised impersonal answering services, the oblique messages in return sending you on and on in a vortex of non communication until finally the message, a hybrids rumbling tone detailing simply a hotel, a room number and a price to send you here.

You step out of the lift and onto the travelator, your digital heart beating 4.3 nanoseconds over the calibration value, your hydraulic genitalia whirring gently into life. You'd heard rumours that there was flesh in this city, the last flesh in Europe. You'd spent the furtive months sniffing for signs like a beast of the old world. Your systems centre trawling the archives for images of pounding, sweating, living matter, long since outlawed by the hygiene council and its joyless minions down there in London, and you dreamed those long bitphased dreams where beast meets machine in total joyful erototronic union, till those dreams brought you, undercover of Total Winter[tm], to the free north, to consummation.

You pause outside the door... processing the ether, savouring it...

Oh mother manchine, beyond binary, who designed the new world, who analysed the darkness, who's System (tm) removed the virus of the Ark, oh mother machine, consort of the great programmer.

Your code process is suddenly running into overdrive, animated images of bison herds piling through city streets, kicking up metallic dust, snorting out headfuls of deadly carbon dioxide, scattering pedestrians, congregating in the market square, haunting bitphase of fucking ancient beastflesh amongst the commerce...

GET A FUCKING GRIP, MAN!

This is what you are here for, to sense this for Real[tm],there is no returning, not now not ever, you know the danger, any contact with living organisms would be sure to kill a man within hours. Real Winter[tm] and Biograph[tm] would terminate and without those your systems centre would shut down, time to meet you programmer, monkeyboy.

You know its too late to pull out now, and smiling you take out the keycard and place it

gently against the doorlock,the door stirs noislessly, you peer into the red glow of the hotel room, oh my girl, my beautiful one, my girl... you see her profile in the shadows, your hydraulic cock locks hard against the inside of your pod.

More beauty you have never seen, not in the archives, nor in dreams.

Her flanks shimmer in the half darkness, the cool blue beauty of her undulating muscle shudders in the shadows and here you realise that genetic memory is not a dangerous fallacy of the Ark like you were programmed to believe, but real and true and finally it has found you, child, and brought you home.

You step inside the room, and the door whirrs gently closed behind you.

Your optic sensors run appreciatively over her body. Drugged and tethered she still possess more life in her malnourished equine body than in the rest of europe put together ,what a miracle of nature she is. Nature, the virus of the Ark. You look into her deep brown eyes, her simian features watching you as you watch her, she knows, those eyes know more than we ever will.

My beautiful one, my lovely horse, my blue baboon, it is time.

You are right next to her now, you are aware of the particles which blow around her and will soon infest your system, it is time for consumation, already your mechanical cock is spurting involuntary jolts of electric orgasm, sparking skylike in the gloom; you take the razor...

Oh mother machine, we humble ourselves as mere terminals in the skirts of your holy network... oh mother machine who saved us from the Ark... we shall not disconnect nor malfunction nor... you place the razor gently against her soft flesh and begin the slow incision, she stirs slightly, still starring at you, curling her glistening ape-lips in adoration... and as you insert your probe into the smooth running wound, you are home at last.

Devoured
Claudia Bellocq

The man stood before her. He stared at her and she wriggled slightly, uncomfortable under his gaze. She'd been there for about three or four days now she thought, though she'd lost track of time in the gradual deprivation of her senses. Everything she'd known before had become alien to her in the short time she'd been kept there. Her life as it was may as well have belonged to somebody else before the precise moment in time when the man at the bar had caught her eye and her life had changed forever.

She'd willingly gone home with him; sexy, funny and charming, he had easily appealed to her desire for love and companionship above all else. It was when she arrived at his apartment that she began to feel slightly uneasy; just the merest hint at that point but nevertheless evident when she checked in with her gut instinct. It was at this precise moment that she made the (perhaps?) fatal mistake of ignoring instinct in the pursuit of love.

They hadn't fucked. She could say she was somewhat disappointed, but right now the truth was that she was neither disappointed nor relieved because she'd lost her ability to make sense of anything at all. She was disorientated, which was exactly how he wanted her: she was his living experiment.

The young woman squirmed and tugged at her wrist ties; they were hurting now, and she needed to pee again. She signalled to him, her humiliation just about total with this ritual he had devised in order to meet her basic needs. He arrived with the bedpan, gently lifted her ass to place it beneath her and then watched whilst she peed into it. He removed it with a tenderness that puzzled her, wiped her pussy with a delicate cloth wipe and then left to empty the receptacle. When he returned, she knew another 'episode' was about to start; she had begun to tap into other secondary senses since being held captive like this. Although she'd initially become disorientated very rapidly, she had begun to rely upon her 'sixth' senses much more since that point. She may not have known where she was or why she was there; logic and reason departing, but her sense of hearing had become much, much keener, and her sense of smell was really sharp now, animal almost. Sweat, new sweat, a stranger's sweat could make her retch with fear. She would know instantly a new person entered the room despite her awkward vantage point; the fear mingling inextricably with the awareness.

She could feel the change in his energy as if it were as real as an electric current passing through her. He was making ready for something; something he in turn feared. A tear dropped from the corner of her eye which he also wiped away with great tenderness, and then smiled softly at her.

Five others entered the room. There had only been one or two on the previous

occasions, but she somehow knew that this was different. She recognised the faces of a couple of them who had already 'visited' her and it made her feel nauseous to see them there again. What they'd subjected her to already wasn't far enough removed from her memory. She pulled at all of her ties but it just made her ankles and wrists burn on the existing sores, so she gave up trying. She knew it was futile in any case but felt she owed it to herself to try.

"Is she ready?" asked one of the group?

"Yes…she has been well prepared" replied her captor.

The six people in total, the five and her captor, began to collect a number of things from around the edges of the room. She strained her neck to see but found that there wasn't much movement afforded from the head restraint into which she had been bound. Her gaze was meant to be strictly 'straight ahead only' in order that she had no choice but to gaze directly into the eyes of the one who would be coming soon. The group started to bathe her with some kind of warm to hot liquid that felt exquisite on her skin, though it had a strange smell, not dissimilar to the smell of oak-moss resin, or cypress or some other woody plant-based oil. It smelled slightly bitter; a bit like burnt almonds…

The man who had captured her came and placed his face so close to her pussy that she could feel his breath on her vulva. It was arousing her and she flushed pink, not wanting to admit this to either herself or to her captor.

"Please…let me go," she whispered.

Where had her voice gone? She was more afraid than she realised….

"Sorry, no can do baby; he's expecting you now."

"Who is? What the fuck is happening here? But the man just put his fingers to her lips and hushed her. "Such foul language for such a pretty young thing…it's hardly fitting my sweet". He stepped back a little, clearly satisfied with her 'appearance', and beckoned each person forward one by one. The first shoved a finger into her pussy which made her yelp: it was unexpected. He pulled it out and licked it slowly, nodding to the man beside her…"yes, she's good" he said, and moved away. She was puzzled, angry and afraid at the same time…

Next a woman approached holding a delicate fuschia-pink, orchid flower in her palm. She showed it to the captive woman and then knelt before her and pushed it gently into her vagina. The captured woman felt exposed…she had no idea what was happening to her but this ritual was clearly an important part of whatever it was. The young woman felt another tear fall down the side of her cheek, wetting her ear. The next three people who approached her all placed something inside her vagina; the first a small berry or seed of some kind, the second a tiny silver chain and the third, one half of a love heart, not unlike the kind you give to your first teenage boyfriend; each of you wears one half until you part. Then when you do, you inevitably despise the thing forever.

Finally her captor approached with a small pot containing some kind of heavy viscous oil. He smeared it around her vagina, her labia, a little inside the entrance to her hole and a fingertip of it around her asshole. She looked alarmed but he just nodded to her slowly again. She could feel a deep, throbbing heat rising where the oil had touched her skin. Then he placed a drop or two on her lips and rubbed it into her mouth, the inside of her cheeks and onto the tip

of her tongue. She gagged and tried not to swallow, but lying prone made her swallowing reflex as inevitable as breathing or she would begin to choke very quickly.

The liquid was making her limbs feel heavy and she started to imagine herself flying off into great clouds of billowing azure blue smoke, a crystal sea of fractured light and form. As she was drifting her sensory signals kicked in automatically, something had changed in the room but she didn't know what. She could hear heavy footsteps approaching and there was a hushed reverie in the room.

"She is ready, and is perhaps the most perfect yet My Liege."

She looked in front of her and saw him then. A muscular, well built man-beast of unknown origin. She wanted to scream but her voice was somewhere lost in those clouds. Nothing worked; there was no co-ordination or synchronicity left in her. Only open exposed flesh and being. The only thing they had left her with was her lace panties which were twisted around one ankle, still as pink and delicate as when she had put them on all that time ago.....

He placed himself between her legs and instructed that her binds be loosened. She exhaled with floods of relief...he was going to offer her free-will? However, with a click of his masterful fingers, he summoned the stirrups to be brought out and fixed beside her, just as she felt four pairs of hands take firm hold of her legs and fasten them securely into the metal hospital examination contraptions. Jesus no..."please don't hurt me" she whimpered....

He stood proud and tall; cloaked, and in readiness. The girl's tears flowed easily now, wetting the sheet beneath her and filling her with a sense of increased panic as she recognised that her auto-responses spoke volumes to her. The six people stepped forward and removed the heavy velvet cape from the shoulders of the man-beast and he moved one step closer now. He looked her in the eye. His eyes flickered emerald green and were full of lascivious power. He needed her now. She wasn't going anywhere. The helpers then removed the cloth that had been covering his loins and the woman screamed again, only this time she heard herself. The beast had a cock that was a living creature in itself. He was host to an independent life-form and it was clearly hungry, teeth snapping and tongue lolling out in greedy anticipation of her cunt and she knew it.

The thing held his parasitic attachment in his two hands as it began to screech and take a more accessible form. "Feed! Me! Now!" it commanded and the woman tried in vain to appeal to any last remnant of reason in the people surrounding them. Then she noticed the expressions on their faces; uniformly lascivious, and gave up...she was saving them from themselves. Her presence there provided them a necessary shield from their own shadows.

The creature was so close now she could feel the edges of its parasite cock-thing touching her clitoris for the briefest of moments.

It was in that moment that she realised, and acknowledged, that she wanted it....badly. It was braying now to get inside her. It needed her innocence but above all it needed her fear, and her fear was gone. In its place was something like lust. Reason told her that this creature was so vile and despicable that there was no way on earth she would surrender without a fight but her pussy was begging for the moment when it would enter her, promising to devour her.

She looked it in the eye...the man-beast and then his cock-appendage. Straight, square

in the eye and the thing flickered a moment; hesitated for

one,

split,

second.

That's when everything changed...

Its desire for her cunt was so strong now that it couldn't stop, despite the man-beast's best efforts. The man-beast, being a thinking creature, recognised what had transpired in the previous moment. The cock-beast did not. It's white stretched lips were dribbling something like a yellow pus of pre-cum arousal as it neared the girl's vaginal opening. It was sniffing like a stuck pig and wriggling like a kitten in the hands of some callous schoolboy experiment. The girl was both repulsed and fascinated by it; she'd never seen anything so vile and yet it was so clearly hungry for her. The creature's hunger was making her incredibly sexually aroused. She whispered, quiet enough that no-one else could hear her...perhaps the words never even emerged; she couldn't be sure what was real any more... "Come on now baby...enter me now...push deep, and hard, and make it better than anything I've ever known....take me to the heights of the heavens and the depths of hell in one single moment of entry....take me now!"

The cock-beast sat with its 'head' at her vaginal opening and then let out an ear-splitting howl which shattered the windows spraying rainbows of cut glass into the flesh of those in the room who were watching. The girl screamed and the creature entered her at precisely that moment. The light in the room shed fractals all around them which were coming from their collected energies as the thing pushed itself further and further into her pussy. The force of it made her gasp and she wept rivers of tears now as it pushed mercilessly and relentlessly into her cunt, making its way up her canal, through her womb, through her belly, towards her heart. It was looking for her heart but she was no longer afraid. Surrendering to the cock-beast's thrashing movements, her whole body was electric with sex, pleasure and desire. The two of them were merging. The beast was becoming her, and she it. No boundaries, everything melting...dissolving. Who was she?

Now it was the man-beast who was weeping and begging as his cock-appendage was clearly being devoured from the inside out. The girl was looking at him; her tears dried, her lips open around her teeth, back bucking against her restraints. She was arching in ecstatic pleasures like nothing he personally had ever imagined let alone witnessed. Then it came...the sound and smell of death; a darkness that fell and a strangeness in the air that took everyone with it; no question of that. The spectators dropped to their knees, they did not know how to act without a guide. The man-beast went limp and the girl broke her bonds as effortlessly as had they never been there. She sat up. He cunt was dripping a viscous mix of blood, semen, the beast's decaying flesh and her own cum...she rubbed her hands into it and then pulled it across her face, her hair, down her chest and torso, and her back. She spread it into her thighs, her calves, her feet, and then wiped it around her mouth and licked her palms clean like a preening cat.

"I think you under-estimated me," she said as she left the snivelling pile of bodies in the room. "That was possibly the best sex I've ever had...."

And with that, she was gone.

god's inferno
joshua hayes

¡Aqui! General Pontoma screams jabbing his finger at topographical map *¡Aqui! Aqui! Aqui! Y aqui!* Aide staggers across room flabby red intestines clutched in hands dark blood squirting through fingers dripping on the battered floorboards Sesseno stoops to fit through doorframe *¡Buenas noches General! Vamos a follar!* Sesseno nearly has to crawl across the cramped ramshackle *cobertizo* to reach General Pontoma; General Pontoma pulls Colt .45 from black leather belt holster Sesseno slaps gun from hand pushes General over clutter of maps charts photographs rolling pencils wrenches General's shoulders from sockets and fucks in thick swollen *culo* while leaning down screaming into ear *¡Sí, sí, sí, usted es igual que una colegiala!*

Beatrice crouches in the shower, sops of her dark hair cling to her neck and face. She stares at her toes and at the water eddying down the drain.

Graham is standing above her, scrawny and awkward, staring sadly at Beatrice's small, perfect body. Pimples fleck his narrow shoulders and boney chest; psoriatic plaques cover his inner thighs.

The woman squirmed beneath the Rape Machine's™ restrictor clamps as it rose and fell with invariable rhythm, grinding and hissing and squealing mechanically. The woman screamed. It was a C-Model Rape Machine™ equipped with loudspeakers and a string of prerecorded phrases, a design initiative that was either an attempt at humanization or a sarcastic spoonful of sugar. "LET IT HAPPEN" the Rape Machine™ droned. "LET IT HAPPEN LET IT HAPPEN LET IT HAPPEN".

With the worldwide legalization of rape a trillion dollar market was blown wide open for governments and private sectors alike. In 2010 an estimated seventeen percent of the global population had been victims of a rape* or a sexual assault. Five years after rape's legalization this figure had tripled and everyone on earth had either raped or been raped by a loved* one. Two thousand and something saw the Australian government generate twenty-five billion dollars in revenue from their comparatively mild rape taxes. In Japan one hundred rape assistance devices were being patented a day. The world's governments took further advantage of the new socioeconomic climate by manufacturing their own robotic rape assistors and selling them to one another. Sybians in rickety, remote control spider frames were replaced by billion-dollar machines as paradigm shift after paradigm shift washed through the world of robotics. Competing budgets climbed higher and higher and*

* Victim: an archaic word meaning sex partner.
* Rape: an archaic word meaning sexual intercourse.
* Love: an archaic word meaning sexual intercourse

many predicted economic implosion...

"Ok girls, let's go. No time to waste if we want to fit in lunch as well."

Audrey totters unsteadily over the cobblestones on her 10 cm heels and makes a lunge for the doors of Marks and Dixon. Once inside she regains her composure and glides across the marble floor towards the perfume counter. Her rotating retinue – yesterday Phee, Pip and Sky; today Tory, Brandy and Cody – follows in her wake. They all spray on various samples of a hundred dollar a bottle fragrance and in a heady fug of mixed aromas proceed to the escalator.

Upstairs in the softly carpeted surrounds of women's designer wear they attack the racks with the fervency of a group of vultures pecking over a fresh carcass.

"Hey Cody, this would look *gorgeous* on you! Go try it on!"

"God! You know I can't wear cream, Tory. It makes me look like I have a perpetual hangover."

"Well you do, don't you sweetie?"

" Yeah but I don't want the whole goddamn world knowing."

"Hey this is *gorgeous* and only $500. What do you think? Is it too short?"

"Hell no, not with your legs."

An hour and many garment changes later the girls are in the lingerie department.

"I am definitely having that black corset and matching suspenders now that Ollie has fucked off."

"Fo sho girl! And don't you just love this little cami and thong set – that poor fool sho as *hell* doesn't know what he's missing."

Having maxed out one set of credit cards, the girls move on from designer underwear to high-powered weaponry. They scour the hydraulic racks of Fisher Firearms looking for that perfect gun that balances reliability with precision and a high rate of fire.

"Ooh, baby!" Tory purrs. She holds up a Heckler & Koch MP5 submachine gun.

"Oh, I can *totally* see you blowing off some nigger's head with that," Brandy tells her.

"Wow!" Exclaims Audrey. "Hey girls! Look at what *I* found..." She shows her retinue a Colt Delta Elite 10mm handgun.

"Whoa!" Cody gasps. "Is that a Delta Elite?"

"Those things are *totally* rare!" Tory eyes the weapon enviously.

"What do you girls think of this?" Brandy shows the girls a Kimber Grand Raptor II.

"Ah, not with your complexion..." Audrey suggests acerbically. Brandy blushes and picks out a Browning Hi-Power 9mm instead.

Cody works the action of a Dragunov SVD sniper rifle. "O-kay!" she sings out.

"Don't play!" the girls chorus back, each striking a pose with her firearm.

Was it for ten years that Baruka hovered over the dying Earth like a waiting vulture, keenly observing its plaintive cries and tortured throes?

Yes: "Fucking scum..." he giggled. "I've buried you all..."

Did Baruka float in a foetal position at the centre of a thousand catheters and

cannulae that pumped drugs and nutrients into and sucked waste out of his body?

Yes. The cannulae and catheters were a jungle of slurping vines that filled the chamber, a tangled medusa radiating from Baruka and branching off to various portals and panels throughout the Space Station.

Is it true that Baruka's children suffered from episodic dyscontrol syndrome?

No. They were born-psychopaths, living in a world with no moral guidelines, no social structure and no limitations whatever.

What happened to Baruka?

He was killed by his eldest son.

More detail please.

A mindless nine-year-old boy stole into the observation chamber where Baruka spent most of his time in a semi-catatonic state. The boy swam through the forest of catheters and cannulae, parting them like fronds of kelp. He found his father asleep at the centre of the forest like an Undine, like the ogre Humbawa. He stabbed a hole in his father's throat with a surgical trephine and the blood curled out like a snail's eyestalk.

Thank you. What happened next?

Several others of Baruka's children initiated the Space Station's self-destruct sequence.

Did an exaggerated fireball ensue?

No. The explosion merely crippled the Space Station, knocking it out of orbit and sending it screaming through the atmosphere and crashing into the Nevada desert.

Were there any survivors?

Yes, two-dozen of Baruka's frenzied offspring scattered from the burning wreckage like rats, skipping and cart wheeling across the desert.

And by this stage these children of Baruka's were the only living humans on the planet, were they not?

That is correct.

Did they interbreed and repopulate the earth?

Yes. You can imagine where things went from there.

The good guy was a cannibalistic, animal fucking, necrophiliac pederast, so maybe this story will have to do without a 'good guy'.

The equestrian statue rears up on a single hoof, more than rampant. The horse's other three legs arch through the air over Beatrice and Graham, and the rider throws up his arms in a gesture of ravening megalomania.

"Back in the 18th Century," Beatrice explains, "before industrialization, when signs and symbols still counted for something, there was a rule that equestrian statues had to follow. If the ruler or military leader being commemorated died of natural causes, then the statue had to have all four hooves planted firmly on the pedestal; if he fought in battle and died later of his injuries, the statue was allowed one raised hoof; and if he died in the course of battle, the horse would be cast rearing up on its hindlegs."

"Then how'd *he* die?" Graham asks, indicating Beatrice's great, great grandfather.

"Ferrine Gebruhnare... The story goes that there were seven Yankee companies to his three, so, either in despair or as an example, Ferrine loaded his faithful steed with saddlebags full of gunpowder. He stuffed gunpowder into his pockets and some people say he even packed it into his mouth and ears and nostrils. Then he lit a fuse and charged the Yankee lines. He was shot to shit and blew up before he got within a hundred and fifty yards of the enemy, but I guess he impressed a lot of people, friends and foes alike. So... Three hooves up means the rider blew himself and his horse to pieces for the greater cause..."

"...I'm sorry about your dad," Graham broaches the subject spontaneously.

"He was old," Beatrice shrugs. "And to be honest I didn't know him all that well."

"When's the funeral?"

"There isn't one. He stipulated that in his will."

"Wow..." Graham says daftly.

"He was a very unsentimental man."

A battered '71 Pontiac LeMans, its bonnet ripped away and its engine compartment beaten outwards to accommodate a monstrous thirty-two valve V16, its driveshaft and differentials reworked and its axles lengthened, its high performance tires bulging out on either side of its bloated, rust caked body, its aftermarket exhaust system branching out from under its chassis, its doors cut off and its convertible roof torn and blackened, roars up the gravel driveway towards Gebruhnare House. Apoplectic industrial music screams through its stereo speakers.

"Jesus..." Graham murmurs. "How can she see *anything* past that engine?"

"She probably can't." Beatrice takes hold of Graham's hand.

Gressil cuts the engine and the barrage of noise dies away. The engine hisses as it cools. Gressil stands and stares over the tattered ragtop at Graham and Beatrice, who are huddled a hundred feet away under Ferrine Gebruhnare's spiderish shadow.

"I'm buying a cheap car and driving away from here," says Beatrice.

"Where will you go?"

Beatrice doesn't respond. She is returning her sister's gaze, fiercely and fixedly. Gressil turns away and walks up the black marble stairs to Gebruhnare House.

"Beatrice?" Graham asks softly.

She looks at him and smiles forlornly "...South. Through Mexico, Guatemala, El Salvador... I won't stop until I get to Cape Horn. Maybe I'll catch a ferry to the Antarctic Peninsula, hunker down in a shack at Esperanza Base with a rocking chair and a shotgun."

"I want to come with you."

"Why?"

"...I'm falling in love with you."

Beatrice sighs and shakes her head. "Don't be stupid Graham."

A strip of artificial white sand beach, the daytime playground of the self-important and the parasitical and the private property of a dozen boxy hotels muscling in on the shoreline, was were Sesseno washed up unconscious after a three week binge on brain tissues and stomach acids and adrenal fluids. An early morning security guard prodded the rotten riding coat covered lump of

ulcerous flesh and rusting metal with his nightstick, wondering *¿Qué el infierno es esto?* Sesseno lashed out and sliced through his kneecaps with an obsidian-edged scalpel and the security guard fell onto the beach screaming *¡Oh Jesucristo!* Sesseno moaned and crawled onto him and fucked half-heartedly in hair-rimmed *culo* while blood spread through the sand.

Afterwards Sesseno stumbled down a bright kitschy souvenir stand lined boulevard, hooves clattering against flagstones. Nearby two handsome gringos with nipple rings in their swollen pectorals and token surfboards wedged under their armpits to accentuate the bulge of their biceps began snickering. "What is it fancy dress day?" one said stupidly. "Must be the Mexican version of Edward Scissor Hands," the other wisecracked. Sesseno lurched over and cuffed the wisecracker's head with his left fist of needles and flaying blade and cervical dilator and the gringo's skull split open and his brains squirted blood into the air. "Aaah!" the other gringo yelled stupidly, and Sesseno backhanded him through a storefront.

Sesseno dragged the twitching wisecracker behind him for a hundred yards before reconsidering and leaving him on a park bench.

The stitches in Melissa's face were not easy to remove. They had been carelessly sewn in the first place, the slapdash job of an inexperienced intern, and then left untended for far too long. Blood seeped up over the sutures and coagulated to form a thick brown scab that completely enveloped the fifteen silk loops. The thread should have been removed after six days, instead the staff of the City Psychiatric Hospital forgot it was there. When two months after the sutures had been sewn patients were complaining about a foul odour exuding from Melissa's face, Doctor Johnson slapped his forehead and yelled "Jesus Christ her *stitches*!" Johnson removed the rotting silk himself, digging through crusts of dried blood with a scalpel and tweezers. Melissa sat still and seemingly insensate on the examination table while Doctor Johnson grimaced and made excuses.

"Well, all this scab should have peeled away a long time ago, I don't understand it... Why didn't you remind us of these stitches, Melissa?"

"I assumed they were absorbable," she muttered. "What's your excuse, you fucking clown?"

God pissed on the City in great yellow jets of acid rain that crumbled concrete, burned flesh and caked metal in fluorescent orange rust. He drowned the slums, swept away the suburbs and swamped the industrialized countryside. Only the steel-supported Central Business District escaped His wroth, an impregnable ivory fortress rising up out of the chaos, a computer-controlled Celestial City, the Garden of the Sons. At its centre, on the roof of a thirty-storey car park, Hank curled up on the backseat of his luxury sports car and slept through the rain. Bags of corn chips and cellophane wrapped cupcakes lay scattered on the floor and dashboard and the body of a ten-year-old girl decomposed in the boot. Far below, on rivers that had been roads and channels that had been streets, Baruka cruised between flooded buildings and hydroplaned over submarine houses in an amphibious assault vehicle that had been a fire truck. Joe used the vehicle's hydraulic ladder like a ship's mast, clinging to the top rung, hollering deranged chanteys and firing a Tavor-2 assault rifle at anything that moved. Beneath all else Sesseno swam through

the dark, filthy water like a giant sewer rat.

Tanaka floats in the lotus position surrounded by a cluster of silent children.

"Brutus?"

Tanaka addresses her eldest son, a sullen young man with a mop of black hair and bloated red eyes.

"Yeah mama?"

"Would you be a dear and go kill your father?"

"Yeah mama."

"Destruna?"

Tanaka addresses her eldest daughter, a languorous girl with a great drifting mess of dirty blonde hair, blood red lips and ink black eyes.

"Yeah mama?"

"Could you go and initiate the self-destruct sequence? It's time we were going home."

"Yeah mama."

"Where's home, mama?" asks Leo, a wide-eyed toddler and Tanaka's youngest child.

Tanaka smiles at him. "Home is where the heart is, dear."

Red strobe lights pulse silently along the white corridors. Sisko, a quiet girl with intense eyes and her father's poisonous red hair, browses the mainframe jukebox and selects a song by Abandoned Toys.

Ethereal music susurrates beneath muffled booms and piercing metallic yawns.

Brutus returns to Tanaka. Lashings of blood mark his chest and stomach.

"It's done mama."

"Good boy."

Destruna returns to Tanaka. Long strands of her hair have burnt away.

"It's done mama."

"Good girl."

Brutus moves behind his mother and grabs her arms. She struggles against him.

"Brutus!" She yells.

"Destruna –" Brutus addresses his sister. "Eat mama's face."

Destruna smiles dozily and floats towards them. Tanaka kicks and writhes but Brutus is too strong.

"Where's the heart, Brutus?" asks Leo.

"How the hell would I know?" Brutus grunts. "Piss off you little shit!"

Fire erupts at the further end of their module and the whole cylinder tilts crazily. Destruna bites into her mother's cheek and chews through to the bone while the Earth's atmosphere burns against the windows around them.

After that fuck in the face of a funeral I hightailed it back to my rip-hole in the sky and in the cavernous slashed open vein of the broken elevator shaft what should I find but a green canvas bag overflowing with polypous odds and ends, all tangled together and pale and pink

and stinking and splashed with gore. My favourite fucking doorman was standing nearby and looking disconcerted about the whole scenario of wrecked penthouses and rape and orgies and body parts in duffel bags, so I relaxed the tension by brightly exclaiming "Oh goody! I've been waiting for this delivery!"

Up in the stabbed vagina of my penthouse home I tried to liquefy the bits and pieces in a blender, but got instead a thick, pulpy soup. I strained this pinkish, brownish shit and pressed it in my hands and also for no reason I can think of slopped it on my cock and masturbated with it until it was a thin, piss yellow liquid in a puddle on the floor that I could suck up with a syringe while I cradled a phone between my chin and shoulder. "Hello?" It was Fene's hollow voice. "Hello, could I speak to Bressil please?" CLICK "Hello?" It was Bressil's sweet icy voice. "You're gonna be brushing your teeth with my dick, you hear me bitch?" I told her. "I'm gonna make you floss with my pubes and gargle my cum." I hung up and smashed the phone a bunch of times.

I really had to go over to the Gebruhnare's and thank them for their making good on our deal, so I put the goo filled syringe in the stinky green bag that still had dried up little pieces of vein and gland stuck to its insides and put with it a short barrel shotgun and a CornerShot 40mm grenade launcher. I jumped in my bright orange Bugatti Veyron and as I drove to Dalintober I thought about the Gebruhnare's little brown maid and the rape baby in her womb and I rubbed my dick that was encrusted with dry white adrenal fluid and organ juice.

The most VERBOSE sunset the world had ever seen blasted down through a swollen clutch of ovoid chemical green clouds on May Eve of the year 3 million[*]. Spotlight sunbeams of a dozen Crayola colours swung across a shattered megalopolis that was two parts Venetian and three parts Venusian and transformed a sea of rank floodwater into a giant tub of melted rainbow ice cream. A capsized mountain of black Cumulonimbus cloud, wrapped up in a net of squirming pink electricity, rumbled above the drooping green ammonium hydrosulfide Mammatus. At 6.30 pm the thunderhead split in two and a rotten eggplant sun rolled down to the Earth through a lightning filled gulch of ragged cloud. The Mammatus fell onto the City like giant stink bombs, but the sun, paling from red-violet to orchid to thistle, sucked up the reeking green mist and the City basked in its dying light. At 7 O'clock the sun dropped below the horizon, the thunderclouds disintegrated, and a spider shaped Actinoform scuttled across the twilight sky.

The Monster of a thousand Cunts and Phalluses emerged sighing and oozing from kaleidoscopic water and lurched up the two-thirds submerged cancerous concrete grand stairs of City Hall.

"Niggers shall not be tolerated!" The Mayor screamed at the monster as it crawled past him. "Niggers shall not be tolerated!"

A dozen government frogmen paddle through darkness towards flickering candlelight.

Besides the guttering candle Gressil Gebruhnare sponges her honey blonde dreadlocks with a sudsy rag and sings softly to herself, *chingado, chingado, Soy puta del Diablo.*

Her pale silk slip is mottled with gunge and her sunken eyes are vacant.

[*] Not the year 3 million.

Follada, maldito, Soy puta del Diablo.

Squelching shadows clamber up a spiral staircase and creep towards her.

Black water eddies around the ruin of Gebruhnare House in a slow spiral, undulating over submerged topiaries and equestrian statues, sluicing through split walls and broken windows, cascading into collapsed passages, tilted corridors, rotting hallways.

Gressil is curled up like a millipede on her trundle bed, dreaming of her dead family. Her head lolls over the side of the mattress and blood trickling from her nose patters on the floorboards.

A thin, membranous tentacle uncoils across the room and caresses Gressil's face. It slides down her body, curls around her skinny legs and enters her vagina.

Gressil stirs. The tentacle whips away in a grey blur and disappears through the open window.

The monster of a thousand cunts and wisdoms glides through the floodwater, the fertilized egg mined from Gressil's uterus tucked safely inside its mantle cavity.

Child stares down through glistening tunnel and sees a thousand spindly legs segmented by cancerous knots radiating from a clutch of bloated poison sacs and hissing mouthparts scrambling up through darkness towards him. Dripping fangs enter his face and venom pumps through skin, flesh, porous bone, wrinkled tissue of brain, upward through hair follicles that turn the colour of blood as spasms rack body for the rest of his life.

The diseased sun, which might have been a green cube or a purple goldfish flapping across a sky of shit and rotting flesh, glew drippily on the three quarter mile cindering SKYFORTRESS wipe out, a burning scatter pile of twisted metal and melting Plexiglas and exploding chamber stocks and bubbling UltraFoam. Brutus and Destruna crawled out of a cuntish spot valve that dripped a hissing mercurial liquid. Destruna wriggled out first and behind her Brutus groped her blonde fuzz covered cunt that bulged through a crudely scissor cut crotch gape in her nylon-spandex spacesuit.

Brutus stands behind Destruna and wraps his arms around her and plays with her cunt with both his hands, stretching out the labia and letting them flap back. Destruna smiles and her mother's blood drips off her face. Brutus voids his bowels and the shit drops onto the ground.

SKYFORTRESS burned through the night sending waves of shadow and red light across the desert. Sparks showered down on dead brush.

Sisko finds a pair of horn-rimmed glasses amid the rubble and splintered wood of a building's foundations and dons them, pushing fronds of her violent red hair up behind her ears. Later she kisses Brutus's shoulders and black, scaly serpents squirm up through his fibrous deltoids. They lash and hiss and spray thin jets of venom into Sisko's face and Sisko's face swells up behind the horn-rimmed glasses and turns a bruised blue. After a day the bloated tissue deflates and the discolouration spreads over her entire body. She splays her cerulean labia in front of Brutus and Brutus stops wrenching loose his brother's ribs and says, "let's fuck."

RIPPED VIRGIN:
HARD OCEAN HELL TECHNIQUE
wakamatsu yukio

THE TRAGEDY THAT EARTHWORM IS BITTEN TO SKIN AND SHOUTED

The Girl began to smear the worms over her body the second she got them in her hands. The liquid mixture of pulverized worms permeated her skin with an unbearable stench and her eyes glazed over as she watched herself do it. This time not only earthworms but mealworms too. Lots of them! They are a rare sight and far more hideous than I expected. But when you see so many, it is beyond grotesque. It's quite awesome.

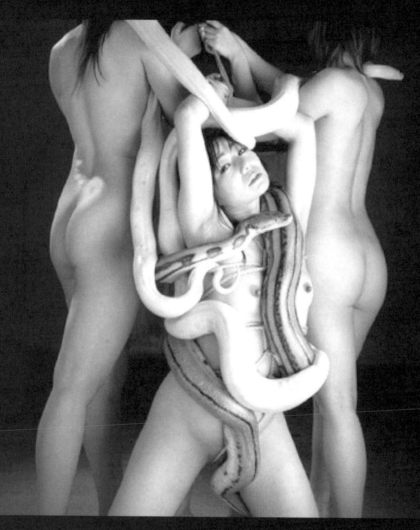

THE SNAKE COILS AROUND GLARE WOMAN'S SOFT BODY

Giant snakes whose bodies stretch over a few meters. Frogs that devour their prey. Snakes in rainbow colours and enormous lizards. Watching the girls being swarmed by reptiles! It's grotesque and beautiful at the same time. There is shock after shock in this endless banquet of obscenity. What kind of end awaits them?

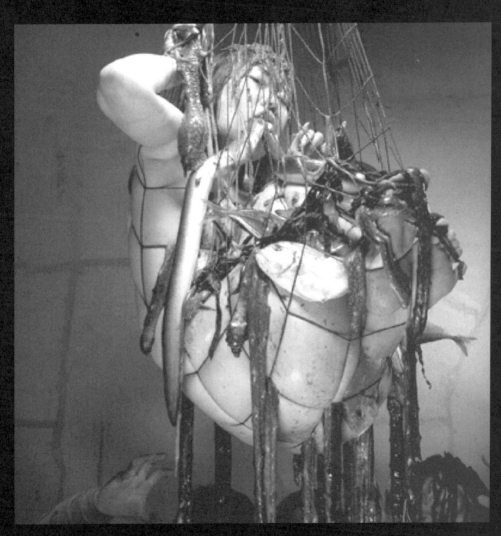

THE LOACH'S PUNISHMENT AND LESBIAN'S DESIRE IN EEL'S CRIME

The Game Of Survival Has Just Begun: 'Let's play a game!' A mysterious man makes this cruel announcement to three girls he has kidnapped and is holding captive. They must obey his orders if they want to survive. Henchmen shower the girls with loaches and eels, rubbing them all over their bodies. The girls have no choice but to endure it. Next, he orders his men to insert loaches and eels inside every orifice.

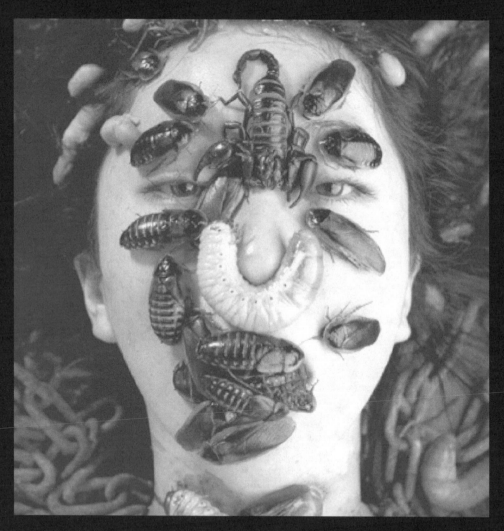

BE BURIED AMONG THE SEA CUCUMBERS WHICH ARE DISORDER

A Sea Slug Crawling On Skin: I bought the finest sea slugs directly from the Inland Sea. At first, I felt quite comfortable with them because they're often sold in supermarkets. But I was so wrong! They spit out these yellow, orange internal organs from their tips, which coiled around the body of the virgin and gave off an unbelievable stench. But they're also as hard as a human cock and apparently give a lot of pleasure once inserted.

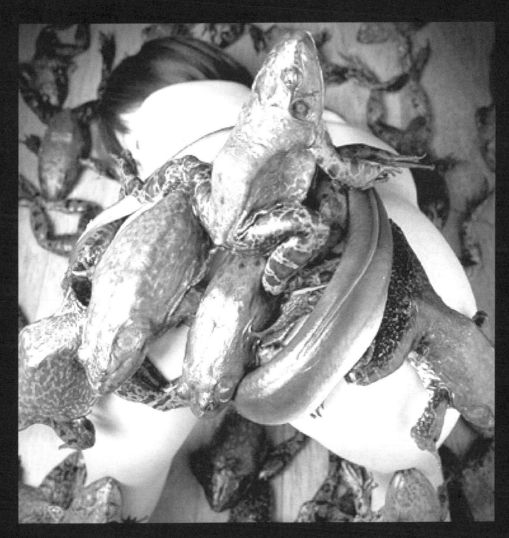

VIOLATED BY THE FROG AND EEL THAT WRIGGLES

Behold, The Evolution of Frog Hell! Seeing so many living creatures is quite spectacular! I like the contrast between such a young face and the grotesqueness of the frogs. There are lots of permutations. Watching the captive in a perspex box full of frogs and given a strange treatment by a mysterious Chinese doctor. She also experienced a frog and eel bath.

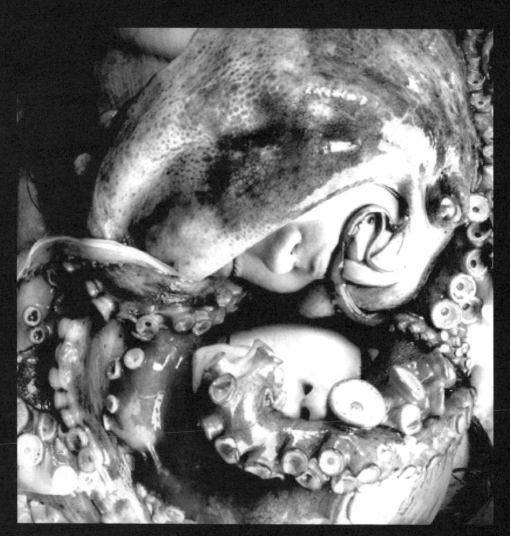

MATURE WOMAN WHO INSERTS EEL AND LOACH RESTRICTED BY OCTOPUS

Ms Reiko Hiiragi, is a horny, mature woman. She howled with pleasure as a dildo secured to the head of a screwdriver was inserted inside her and began to whisk a snowstorm of octopus eggs in her vagina. The hardest part was when she passed out from hyperventilation. I had to stop playing, not knowing whether we could continue. Apparently, when loaches go berserk inside the anus.

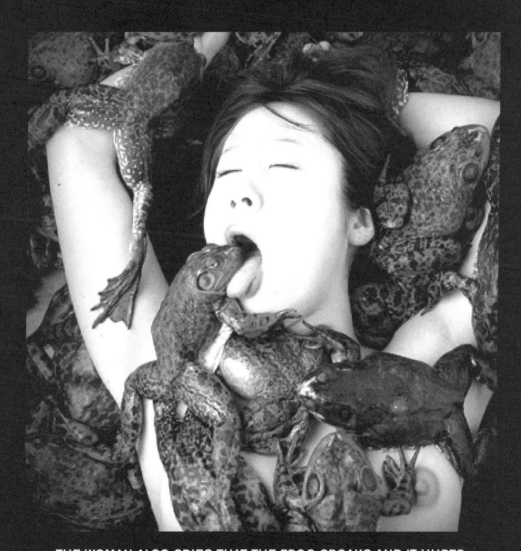

THE WOMAN ALSO CRIES THAT THE FROG CROAKS AND IT HURTS
We were tormented by frogs. Once one starts jumping, the rest follow and it's absolute chaos. There were frogs anywhere! Ms Reiko Hiiragi frigs herself with frogs inside her tights, performs fellatio with one, uses them for hand jobs, and does two frog invasion. I took the frogs to a special restaurant afterwards and we had them sauteed in butter.

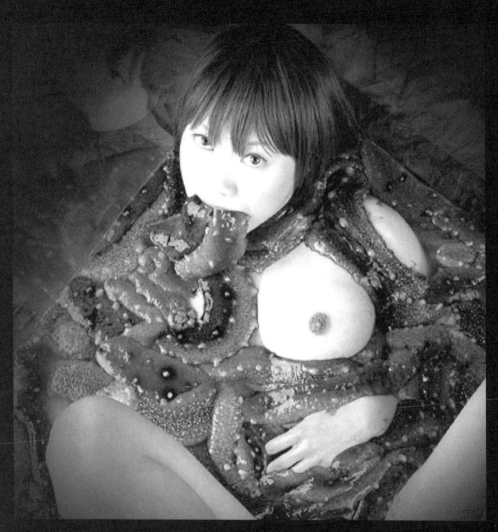

THE SEAFOOD IS PLACED BEFORE BUTTOCKS WITH THE EEL AND LOACH
It doesn't matter what you put between a 100cm bust, it all looks like a work of art. This is tentacle sex especially the way the eels and octopus curl around the huge breasts. It's particularly obscene to see so many loaches emerge from a vagina. Enjoying the pairing of big breasts and seafood.

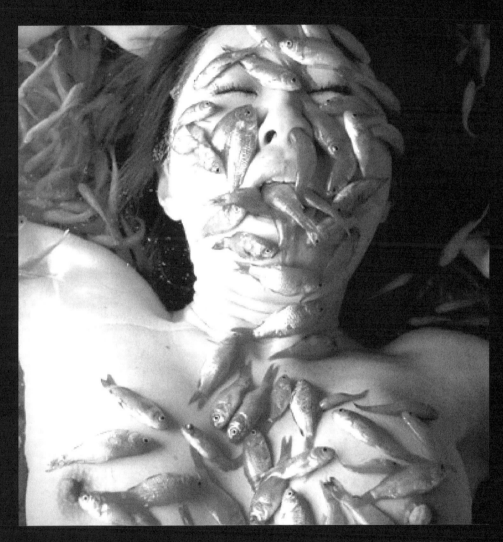

THE GOLDFISH IS SPLIT AND WITH THE SHOUT AND THE WRIGGLE

The sight of the virgin among all those goldfish has a kind of phantasmic beauty. I was pleased to watch fish swimming inside her vagina. Soon, all the tiny bones started to prick the girl's skin, leaving swollen red patches all over her body. She didn't complain once though and kept smiling to the end. I was so grateful and impressed.

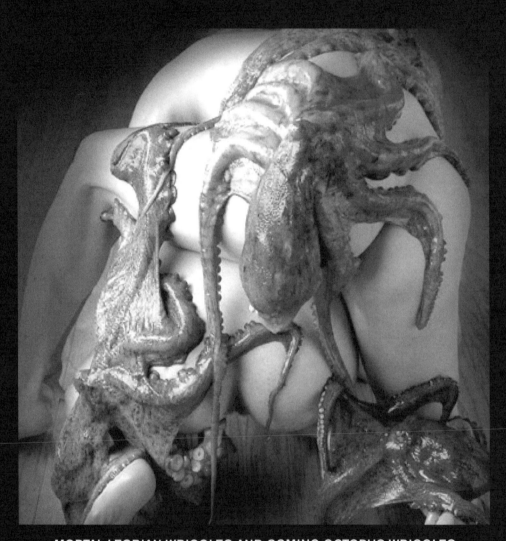

MORTAL LESBIAN WRIGGLES AND COMING OCTOPUS WRIGGLES

Octopus Suckers Transform Woman. I managed to acquire these fresh octopuses after getting to know the owner of a specialist restaurant. Octopus can bite. Not many people know that. When Ms Reiko Hiiragi got bitten and started bleeding, I had to briefly stop the game. The suckers were more powerful than I expected; so strong that they turn skin purple. Watch the girls in torment as the octopus slides and sucks on their skin. Afterwards, we had them deep-fried and with rice.

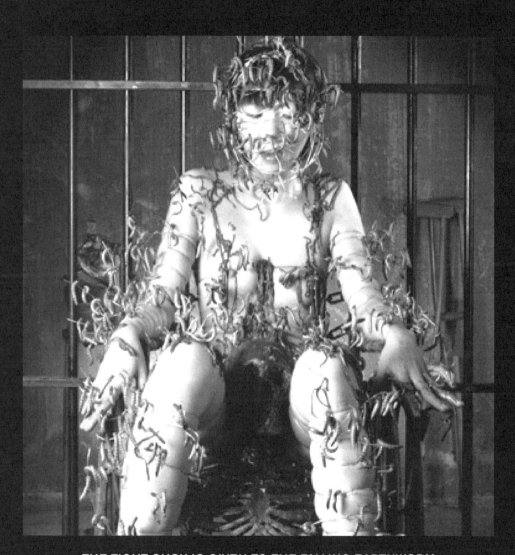

THE TIGHT SUCK IS GIVEN TO THE FALLING EARTHWORM

"1000 earthworms", an old saying that describes the sensation inside a rare type of vagina. But has anyone actually tried it? Maybe it originated with a horny fisherman who decided to rub fishing bait on his cock! Earthworms are said to swell a cock and make it look bigger. I couldn't resist trying it for real. This game contains brutal permutationss with little regard for hygiene: earthworms stuffed inside a vagina, being snow-balled, and coiled around a cock.

STRANGE INVASION
Sea worms wash ashore at Ala Moana Beach Park

Lifeguards reported finding scores of "strange sea creatures" at Ala Moana Beach yesterday morning. One woman reported being stung Thursday by one of them, said lifeguard Steve Clendenin, who described them as a "nightmarish cross between a centipede and a sea urchin." "I've never seen them before," said Clendenin, a lifeguard at Ala Moana since 1979. An estimated 200 gray sea worms washed ashore at Ala Moana Beach Park yesterday morning, said acting Lt. Bill Goding, of the city Ocean Safety Division. The worms have white hairlike "legs" which they use to propel themselves in the water. They ranged from about 1 to 6 inches in length. Some were found burrowing themselves in the sand, but most appeared to be dying. The state Department of Health found it was not necessary to close the beach. The creatures are actually polychaete worms that do not sting or bite, although

according to the Department of Health's Clean Water Branch. "Because of the rain, many of them died because of the dilution of fresh water coming into the ocean," said Janice Okubo, Health Department spokeswoman. The worms are rarely seen and normally live in the ocean buried under the sand, Okubo said. They burrow deep in the sand eating algae Goding used a plastic spoon to quickly collect about 30 worms in a small stretch of beach in front of the lifeguard station on the Ewa end of the beach park. A few teenage surfers who had just gotten out of the water stared at a bucket of the worms in disgust."That's crusty," said Rick Yoshikane, 15. "They look like centipedes. I've never seen them before. "They look like the flatworms from the movie 'Evolution,'" said Casey Matsuo, 15. "They mutate into gorillas and took over the world."

machines are digging
lovecraft and poromechanics of horror
reza negarestani

> Transpierce the mountains instead of scaling them, excavate the land instead of striating it, bore holes in space instead of keeping it smooth, turn the earth into swiss cheese. An image from the film *Strike* [by Eisenstein] presents a holey space where a distributing group of people are rising, each emerging from his or her hole as if from a field in all directions.
>
> (Gilles Deleuze and Felix Guattari, *A Thousand Plateaus*)

Holey Space or more accurately ()hole complex (with a degenerate wholeness) speeds and triggers a particular subversion in solid bodies as of earth. It unfolds holes as ambiguous entities – oscillating between surface and depth – within solid matrixes to fundamentally corrupt their consolidation and wholeness by perforations and terminal porosities. For a solid body, the vermiculation of holes undermines the coherency between the circumferential surfaces and its solidity. Degenerating whole to an endless hollow body – irreducible to nothingness – and damaging the coherency between the surfaces and the solid body in itself defines the process of ungrounding. To talk about holey spaces and Earth is to insinuate the Earth as the Unground. But what does constitute the ungrounding mechanism of holes? How does holey space degenerate the Earth as a ground for supporting formations, establishments, modes of dwelling and governance? Deleuze and Guattari's slyly appropriated 'New Earth' presents a model of an earth whose every surface and trellis is an unground, a terminal planetary body tolerating neither solar economies nor its own terrestriality. However two questions remain at this point: can the Unground – where the hegemonic wholeness of the Earth is incapacitated – still be called Earth? And then according to what chronologic current or based on what calendar, according to what gradient of becoming, which point of reference addressed by space-time coordinates can it be mapped as *the New Earth*? The Unground is a shadow outside of time and space.

H.P. Lovecraft has an alarming but over-neglected passage about this holey space or ()hole complex (with an evaporative W) as the zone through which the Outside gradually but persistently emerges, creeps in (or out?) from the Inside. A complex of hole agencies and obscure surfaces that unground the earth and turn it to the ultimate zone of emergence and uprising against its passive planetdom and onanistic self-indulgence of the Sun with its solar capitalism. "Great holes secretly are digged where earth's pores ought to suffice, and things have learnt to walk that ought to crawl." (H.P. Lovecraft, *The Festival*)

From the following paragraph:

'The nethermost caverns,' wrote the mad Arab, 'are not for the fathoming of eyes that see;

for their marvels are strange and terrific. Cursed the ground where dead thoughts live new and oddly bodied, and evil the mind that is held by no head. Wisely did Ibn Schacabao say, that happy is the tomb where no wizard hath lain, and happy the town at night whose wizards are all ashes. For it is of old rumour that the soul of the devil-bought hastes not from his charnel clay, but fats and instructs the very worm that gnaws; till out of corruption horrid life springs, and the dull scavengers of earth wax crafty to vex it and swell monstrous to plague it. Great holes secretly are digged where earth's pores ought to suffice, and things have learnt to walk that ought to crawl.'

(H.P. Lovecraft, *The Festival*)

According to Lovecraft, the realism of horror is built upon poromechanics. The poromechanical universe of Lovecraft or ()hole complex is a machine to facilitate the awakening and return of the Old Ones through convoluted compositions of solid and void. But how do holes emerge out of the interactions of solid and void? It is best to answer this question by paraphrasing Nick Land's remarks on the escapist aberrancy and irresolution of the self-liquidating Labyrinth versus the consolidating and conclusive moderation of architecture from *The Thirst for Annihilation: Georges Bataille and Virulent Nihilism*: *void excludes solid but solid includes void to architectonically survive*. Solid needs void to engineer composition; even the most despotic and survivalist solids are compositional solids, infected by the void. Through these inter-collisions of void and solid, the Old Ones – according to Lovecraft – can revive their 'Holocaust of Freedom' (*The Call of Cthulhu*), both by consuming solid and pushing compositions towards the highest degrees of convolution (as a result of the ambiguity of solid and void i.e. the fuzzy space of hole and its surface dynamics). In terms of Earth, the Holocaust of Freedom can be attained by engineering the corpse of solidus through installing ungrounding machines at molecular levels that exhume (*ex + humus*: un-ground) the earth from within and without, turning it to a vermicular and holey composition whose strata (The Economy of Solidus) is not dismantled but intricately convoluted at each level of its own formation and composition. Earth is incapacitated to run its stratifying and grounding functions; instead it is charged to engineer the corpse of solidus, or in a Lovecraftian sense, a worm-infested body (earth) exhumed by worming processes, holing and vermiculating machines. Survival is blindness; but blindness is destined to be surrendered to strategies, manipulations beyond tactical designation of command and control. It is merely through survival (the incapacity of solid to reject void) that solid participates in ungrounding itself. By correcting its consolidating processes, solid sells its integrity (soul) to the abysmal convolutions inspired by void through which pathologic survival of solid becomes the most basic factor in its irreversible lysis and degeneration – *katabasis*. Solid surrenders itself to the plague right from the moment that it begins to cure itself. For solidity, the 'Will to Cure' is the 'Will to Mess'. To this extent, solidity is the Xanadu of potentialities and the empire of emergence. Every action of solidity in the direction of becoming more solid is equal to augmenting the interactions with void. But these interactions can only manifest as perforations, trails of negative space that concretely reverberates within solid – wreathing nematodes hollowing out and convoluting everything they touch, in sinuous movements.

Although void devours solid but solid feasts on void, or in other words, its outsider. In compositions, solid becomes hysterically gluttonous for the void. Taking the cult of the Old Ones as the facilitators of emergence, this is what intrigued them in their mission to perform their awakening. If the Old Ones should fly through ()hole complex or holey space, bubbling up through the carrion black pit, oozing in filamentous tubes of the Earth and turn their tentacles into interconnected borrows and lubricious warrens, then the only strategic technique to speed and facilitate their return is to mess with the ()hole complex, that is to say, the zone of their emergence – the solid side of the complex.

Awakening Strategies

Holey space is nothing but a composition (of solid and void), a vermicular one, burrowed by worms (*nemats*) or vermicular lines convoluting and coring out anything they touch, overspreading the ()hole complex as a vast altar which asks for solid as a sacrificial meal, awakening thousands of vermiculating lines to scour the solid. In a composition, solid narrates the anomalies generated by void or the infection of solid by void (when void comes to solid, it works as a convoluting plague, a coiling swirling epidemic rather than a nullifying process or a solid-annihilating agent). To be exact, in a composition there is no pure solid but a defiled one, a diseased and deflowered solid. Once we realize that in a composition (as in ()hole complex) solid is the possessed narrator of the void, a *vox capta*, it will be analytically simple to see that solid works as two different entities overlapped on each other and functioning concurrently:

1. As a compositional entity whose behavior (topological changes, surface modifications, transformations, motions, wrinkles, folds, etc.) can induce changes to the compositional side of the void through surface dynamics (or superficialities as Cassati and Varzi address in their book *Hole and Other Superficialities*).

At a compositional level, holes compile surfaces out of the hegemony of solidus. Solidus is not a content which is added (adjective) to the *grund*, nor is it a lineament, nor an ethos, nor a modifier but the tectonic expansion or the sprawling politics of the ground. Every manifestation of ()hole complex passes a certain type of surface dynamics (in terms of evoking periphery, itinerancy, and affect), breeding a new genre of surfaces with their exclusive itinerant lines which depend on the locus of hole and the way that void interplays with solid. Holes offer new political activities to surfaces; the crisp boundary of surfaces is dissolved into blurred and cryptogenic boundary of hole. In the presence of hole, an asymmetric parallelism between surfaces and the crust (the visible surface or the circumferential periphery) occurs; while they remain analogous and remotely connected to their common genus but each one spawns its own different, independent operational entities and geometries. Through holes, surfaces do not necessarily conduct and synchronize the ground's local hegemonies and establishing policies. In contrast to visible or outer surfaces, neither do holes and their surfaces consolidate the coherence of the Whole nor do they conclude wholeness as circumferential peripheries. Holes

countermine the stratification processes instead of supporting them. Each surface has a line of command with two heads, a trellis and a taxis, one receives the accumulation and distributes it i.e. a *textum* or groundwork for fixation, positioning and support, and the other head directs and grows what has been accumulated and economically distributes it. Taxis gives a dynamic tendency to the contents of the Trellis according to the mutual *affordance* between surfaces or the entity and its environment, the eco-logical web[1], the Whole. Inner holes and connected cavities, simultaneously, come with two types of surfaces or two active contacts with solidus, (1) a surface-supporter or circumferential surface that binds the cavity to the crust (therefore, the ()hole complex cannot be merely reduced to a subterranean or subsoil complexity) i.e. the 'eco-logical' outside, and (2) a surface-transmitter that joins with the itinerant lines passing through hole or connected cavities, the one that binds the cavity on the inside where hole emerges out of the ambiguity of solid and void, or in a topologically oversimplified sense 'where the cavity is'. (See Diagram 1:)

Cavity

Surface-transmitter

Surface-supporter

Diagram 1. Active surfaces (transmitter and supporter) surrounding a cavity

The surface is where most of the action is. The surface is where light is reflected or absorbed, not the interior of the substance. The surface is what touches the animal, not the interior. The surface is where chemical reaction mostly takes place. The surface is where vaporization or diffusion of substances into the medium occurs. And the surface is where vibrations of the substances are transmitted into the medium. (J.J. Gibson, quoted in *Surfaces*, Avrum Stroll)

For instance, on a mereotopological (topological interfaces of whole or whole-part relationships) level, changes or distortions on surfaces or the solid part are directly

1. Woven spaces are the manifest frameworks of two governing heads – trellis and taxis. While the woven lattice structure or trellis composes a net confining what it accommodates, weaving the channel-regimes of a structurally and dynamically economical distribution on a horizontal hierarchy stabilized by, the flexible grid mobilized by the woven suppleness and adaptability provides the net with a dynamism necessarily modified and consequently restricted by the dynamic lines either bound to the static line or the closed side of the woven framework from one end or crisscrossing and intertwining with the static lines and threads as their ground or correcting supplements.

conducted to the compositional void and cause new convolutions and alterations by means of changing the ways or mechanisms through which void is presented through solid. Less technically, if you twist, inflate or heat a tube or a holey ball (with tunnels spread through it), you can see that changes in the solid part are transmitted to the holey side of the tube or the ball, the tunnels or the holey side becomes more convoluted and intricate. These changes through the compositional void can only be perceived and interacted through the solid part – this is the compositional inevitability and clandestine principle of ()hole complex.

2. Solid as an entity which is inherently possessed by void. The only way that solid can initialize its architectonic and compositional activities (processes for survival, development, etc.) is by letting the void in. The dynamic traits of solid can only be actuated when solid is infected, convoluted and messed by the void. There is no other option for solid. In ()hole complex, on a superficial (bound to surface dynamics) level, every activity of solid appears as a tactic to conceal the void and appropriate it, a program for inhibiting the void, accommodating the void by sucking it into the economy of surfaces (as in the case of *niche*, a dwelling / accommodating system, a compartmentalizer of spaces) or filling it. But on a deep compositional level (the machinery of strategic politics), all activities of solid are moving towards engineering new voiding functions, convolutions, vermicular spaces (henceforth, Nemat-space) which eventually unground (but not erase) solidus. On this deep compositional level, solid conducts the convoluting functions of the solid-contaminating void, in the form of vermicular lines, 'worms' (nemat) as Lovecraft suggests or worm-functions (the nemat-function), itinerant lines in the form of knotted holes or the other way around. When a nemat or a void enforcer crawls in ()hole complex, it metamorphoses into a different geometric structure. The worm-function internally reconfigures its modules and turns itself into a more versatile line through participation with the complex whose all points and recesses are interconnected in the absence of the localizing, restricting and grounding tyranny of Whole. All this in the wake of solidity which is reinvented by the ()hole complex as a profound strategic tool. In holey space, solid actively conducts and mobilizes the worm-functions of the void (complications) rather than void's phagic and purgative mechanisms or its desire to devour. Solid runs as the void enforcer, a *pestis solidus* blasphemer.

In ()hole complex, void is also contaminated by solid. For this reason, instead of purging mechanisms of void, nemat-functions emerge. Beyond the threshold of death, nemat-function twists termination in ()hole complex to processes of convolution, undermining and ungrounding. Solid performs the confusion of void through the ()hole complex. Every activity happening on the solid part increases the degree of convolution and entanglement at the holey side of the composition, fabricating the intricate meshwork of the nemat-space which eventually engineers the corpse-of-solidus or the unground; disabling or sabotaging all grounding (signification, con-solidation, stratification, etc.) functions of solid. While vermicular complexity

of the nemat-space activates the tortuous side of the ()hole complex, it also covers each compositional level of the complex with poroelastic traits. In fact, poroelasticity continuously uses diffusion as a means of radical deformation and alteration in the dynamism of the composition, narrating the diagrams of the fluid flow in the animorphic composition of the nemat-space as a heterogeneous porous complex which is more than being just a structure with interconnected holes. Nemat or worm space is a complex with a strange rubber geometry, its porous side is constituted of itinerant lines rendering synchronous possibilities of relaxation, metamorphosis, folding, spreading tortuousity, heterogeneous dynamism and compositional anomalies for the complex. The nemat-space is basically a machine for a radical and pestilentially inventive communication and participation between fluid and solid in a way that they can be tactically and strategically – hence militaristically and politically – differentiated from each other. In nemat-space, the flow of the fluid and the deformation of the solid matrix are coupled; they are heavily interconnected as foundations of a radical participation which gives rise to a diverging series of becomings for 'each level of the composition' whose wholeness has been utterly nullified. Agitated by the flow of fluids (which themselves have been anomalized in the nematical machine), elastic waves dissipate through solid matrices and radically displace the grains of the solid skeleton throughout the ()hole complex. It is the Lovecraftian worm-ridden space that makes solidity the generous host of emergence. The spasmodic deformations of the solid skeleton, consequently, change the stress field by which the remodifications and manipulations of solid are transmitted to the nemat-space in a synergic communication, and progressively fold, twist and open the ()hole complex, polishing its sinister facets to a greater extent. To understand the interplay between porous structure and fluid flow, it is necessary to examine regional aspects of the pore space morphology and relate them to the relevant mechanisms of fluid transfer such as viscosity, mutual pressures between fluid and surfaces, inertial forces, etc.

The displacement and / or locomotion of solid particles generally happens in cluster-like colonies near the regions where solid has reached an equilibrial stability, whereas fluid particles divergently move and disperse in a manner corresponding with the vermicular complexity of ()hole complex. The interactions between the free-moving interstitial fluid and solid matrices on the one hand and fluid with porosity gradient of nemat-space on the other hand result in two main mechanisms along with anomalies in the property of the fluid, the viscosity, permeability, the properties of the coupled fluid-solid complex and the bulk density of solidus (ex. tensile failure or propagation of shear fractures, etc.)

The increase of pore pressure induces dilations to the ()hole complex (including its solid matrix) and escalates poroelasticity (dilations of the complex customize the porosity to enhance the fluid flow.) While the sudden transition from laminar to turbulent happens in pipes and channels, in porous media the passage from linear to non-linear is always gradual and gradient-wise, making opportunities to compose new spaces, lines, connections, pores, modes of dynamism and participation – infinite possibilities in terms of flood. The compression of the solid matrix or any attempt of solidus to keep itself integrated and save its consolidated and molar state (by preventing the fluid from running or escaping from one porous network to another or isolating pores) causes a substantial rise of pore pressure. The abrupt escalation in pore pressure

triggers further and radical deformation of the solid matrix, dilation and contraction of pores (compared to the plateau engineering mechanism of libidinal spasms addressed by Freud), progressive ungrounding of solidus, regional pore collapse[2] and finally composition of new worm-ridden spaces or zones of emergence. Nemat-space is an ultimate crawling machine; it is essentially cryptogenic and interconnected to Anonymous-until-Now. Anonymous-until-Now is the model of Time in ()hole complex whose probes and lines of itineracy move unpredictably according to both the subsoil and superficial ungrounding machineries that weaken (depriving the natural vigor) the solidus by perversely exploiting and manipulating it (exhuming solidus). *Incognitum Hactenus* – not known yet or nameless and without origin until now – is the time by which the innermost monstrosities of the earth emerge according to the chronological time that belongs to the circumferential surface of the planetary body and its populations. *Incognitum Hactenus* can be delineated as the ancient leaking into the chronological modes of present and future connected to surface societies, thus propagating an encounter between the ancient and chronology of the surface societies which cannot be reduced to tradition or even modernity. In *Incognitum Hactenus*, you never know where surfaces are exhumed or lines of emergence are distributed – worms, countless coils of them (tails without heads). The intrinsic permeability is a function of the nemat-space. The contact between solid and the fluid, itself, is also a compositional factor of the poroelastic complex. Local velocity gradient in the fluid induces new convolutions, shear stresses, ruptures and deformations to solid matrix, tuning the surface dynamics to the entire machinery of the complex and the flow of the fluid, that is to say, enhancing the flow and building up the flood. In nemat-space, the diffusing pore fluid thereby smuggles its affect space through the solid matrix as well as its own particles. One should not forget that ()hole complex generates preferential channels for fluid flow or provides fluids with an ample opportunity to dig their own passages, burrow their own fields of tactics. In pulp-horror fictions and cinema and in Lovecraft fiction, it is the abode of the Old Ones, worm-entities and the blob (petroleum) that surpasses the tentacled-heads in sentience and foreignness. R'lyeh is the every dream, motion and calculation of Cthulhu on the solid part of the earth's body. In poromechanics, the negative space is the very solid body of crawling vermiculations and twisting currents. Moreover, the role of fluid in thermal, structural, geochemical and economic evolution of the crust is radically possessed by the machinery of the ()hole complex. The surface biosphere has never been separate from the cthulhoid architecture of the nether.

Once nemat-space starts to infest, the periphery or the zone of excitations does not necessarily start from visible surfaces or the crust, active surfaces emerge from everywhere, from the surface-as-crust mode of periphery to innermost recesses. The ()hole complex carves ultra-

2. Macro-pores allow quick water infiltration and, importantly, similar rapid drainage that makes air quickly re-enter the root zone. The destruction of macro pores or massive pore collapse and subsequent proliferation of smaller (micro-) pores causes water to be held tightly in the soil, increasing the incidence of anaerobic conditions (aeration is impeded), waterlogging, run-off, impotent cultivation and erosion. The increase in density of the soil mass and decrease in soil porosity mean plant roots are often physically impeded by compact subsoil layers and lack of available nutrients and/or water. The namet-space and its porosity anomalies can trigger desertification as well as the emergence of a soggy Earth.

active surfaces from solidus when it digs holes, unleashes delirious itinerant lines and constructs its nematical machines, installing peripheral agitations on the surfaces it cuts from internal solid matrices. Everywhere a hole moves, a surface is invented. When such a peripheral upheaval (in the sense of its diversifying excitations) potentially runs everywhere and overspreads from the crust to within, the despotic necrocratic regime of *periphery-core* in which everything should be concluded and sturdily grounded by the gravity of the core is introduced to infinite deferral until the rise of the ultimate unground where the radical Outside is reinvented from surface to the core. There is no wonder why holey space is continuously interconnected with the Outside or its avatars. The half-man-half-scorpion (discovered in Tell Halaf, Syria) in Gilgamesh epic is such an avatar, guarding the gate to the Outside. Scorpions are burrowers not architects, they do not build upon the compositions of solid and void, they devour volumes and snatch spaces; for them the holey space is not merely a dwelling place, a place to reside (a niche for occupation) but more than that, it is the Abode of War (*dâr al-harb*), the holey space of unselective hunting.

The ground does not conduct, regulate or organize intensities (what psychoanalysis always alludes to in a squinting, crypto-conservative manner), it does not syndicate them, nor does it conduct them to consolidated architectonic persuasions (whether thawing an already established body or lapidifying a transformable complexity) but it gives them something and sets them free as its free-flow proxies, lines of gravity and acentral expanding operatives, missionaries but not conquistadors. The lineage of anthropomorphic hospitality too bears this sly grounding policy: copulation... insemination... withdrawal; we are always on the course of withdrawal.

The grounded flux (inseparable from the architectonic and appropriating forces of pseudo-flux or the irrigating / fertilizingforce of the ground) is generally described as flux '$f = p/a$' (p as the imposed power on the regional surface a), but through the nemat-space, it is the coupled Trellis-Taxis mechanism of surface which fails to enforce and circulate the economy of the ground[3]. In such a cavernous cavern, the ground loses its capacity to support and govern ($a=0$). Accordingly, the distribution of p on the consolidating and self-referential wholeness of solidity is incapacitated. All power formations require a ground for establishment and conduction. Without a ground, that is to say, in the absence of power formation, the definition power is basically undermined. What is politics then in terms of power with no power formation? What is politics in terms of the ()hole complex in which the full body of '$p/0$' precedes all power formations?

On a modeling and reductive level: $V = V_s + V_p$
V: Pore material of volume
V_s: The combined volume of solid and isolated pores
V_p: Interconnected pore space
Porosity gradient is then defined as the ratio of V_p / V

3. Ground is any consolidated set of foundations or rules for support (establishment) and conduction (governance); it is the wholeness of a formation.

$_V{}_p = {}_V{}_f$ (${}_V{}_f$: Volume of the freely moving fluid)

The distribution of solid is obedient to the logic of solidus but this is the logic of solidus that follows the politics of the ()hole complex and the dynamism of its nemat-space. Every entity-event in the ()hole complex is discontinuous according to the measures running through solid and its scales of consistency but continuous according to the nemat-space, or in other words, the interactions of events happening under the influence of the ()hole complex. An entity which is supposed to loom from a particular spot or region, emerges from an entirely irrelevant (according to the logic of solidus) location. Every activity on the solid part of the ()hole complex awakens something radically ill-intended and contaminated by void (a vermicular space), opened by the outside (void as the outsider for solid) from within and without. Disturb and irritate, dilate and contract the repressed cavities of the Earth, tunnels and tubes, borrows and lairs, acrid bungholes and perforated spaces, its fanged vaginas, lubed slits and the schizoid skin. Unclog and squeeze the earth; exhume its surfaces.

If Lovecraftian entities from archeologists to cultists to worms and rivers almost always undertake an act of exhumation (surfaces, tombs, cosmic corners, dreams, etc.), it is because exhumation is equal to ungrounding, incapacitating surfaces to operate according to topologies of whole or on a mereotopological[4] level. In exhumation, the distribution of surfaces is thoroughly undermined and the movements associated to these surfaces are derailed; edge does not belong to the periphery anymore, anterior surfaces come after all other surfaces, layers of strata are displaced and perforated, peripheries and the last protecting surfaces become the very conductors of invasion. Exhumation is defined as the collapse and trauma introduced to the solid part by vermiculate activities; it is the body of solidity replaced by the full body of trauma. As in disinterment – scarring cold and hot surfaces of a grave – exhumation proliferates surfaces through each other. Exhumation transmutes architectures into excessive scarring processes, fibrosis of tissues, membranes and surfaces of the solid body. Exhumation engineers the corpse-of-solidus whose dimensionality blurs not to the point of terminus and erasure but to defunct coils of dimensions which cannot resist what crawls in and out. In poromechanical cosmology of Lovecraft, exhumation is undertaken and exercised by units called Rats. In fact, 'the dramatic epic of the rats' (Lovecraft) can be found in their act of exhuming surfaces, solid bodies and structures resisting perforation.

Rats are exhuming machines, not only full-fledged epidemic vectors but also ferociously dynamic lines of ungrounding. Rats germinate two kinds of surface cataclysm as they travel and span different zones, one is the static damages in the form of ruptures rendered by internal splits, uplifts, dislocations and jumps and thrusts which expose the surface to paroxysmal convulsions and distortions (the fold of split physiology); the other is the dynamic anomaly of seismic waves

4. Mereotopology is a formal theory developed by logical combination of mereology (theory of parts and their respective wholes) and topology. It seeks to mathematically and logically investigate the topological relationships between wholes, parts and boundaries.

dissipating as the rats flow in the form of tele-compositions (ferocious packs). In the pack, while rats' compressions and decompressions proliferate their rates of speed, their transpositions and rearrangements in the pack (composition) forge a de-contouring machine marring the elevation of entities in the pack, setting rats free, giving them the ability of a miniature flight. That is how, as they run, they appear evaporating both surfaces and themselves. Aristophanes and Bacchylides spoke of the birds flying through *Khaos*, this unrestricted space of enthusiasm to flow (*kheisthai*); but, no one asked what kind of birds they are; Wingless? Taxidermized? Metallic? Decapitated? Eyes evacuated with a penknife?... No, they are rats, thousands, millions of them.

A surface consuming plague is a pack of rats whose tails are the most dangerous seismic equipments; tails are spatial synthesizers (fiber-machines), exposing the terrain on which they traverse to sudden and violent foldings and unfoldings while seizing patches of ground and composing them as a nonhuman music. Tails are the musical instruments, playing metal – tails, lasher tanks in motion. Although, tails have significant roles in locomotory uses but they also act as boosters of agility or anchors of infection – rapid changes in position, quick jerks and sudden movements in new directions – and cinephilic machines. As they vibrate, tails print thousands of traces and images, not on a film (as *pellicule*) but on and through a space enmeshed by the commotion of transient traces, trajectories of disease, signs and prints; much like a digital wire-mesh (wireframe) architecture which does not compartmentalize space to fragments of interior and exterior localities but becomes a free-play and open architecture engineered by the swerving motions of tail as a wire, a sparkling wire whipping the space. This exhumed architecture composed by tail-twitches can adapt different rendering modes or become gaseous and terminally epidemic, transforming itself to a diagram of pest incursion rather than an instance of architecture. In a pack of rats, a multitude of tails turns into the probing head of the entire pack in motion: an omnidirectional acephalic revolution, the New Pest Disorder.

LOGISTICS OF HOLES
I watched the ripples that told of the writhing of worms beneath.
(H.P. Lovecraft, *What the Moon Brings*)

The politics of the Lovecraftian holey complex is defiant toward the existing models of harvesting power, manipulating and analyzing events on the surface. For the world order, inconsistent events around the world are failures or setbacks for the dominant political models. According to the politics of poromechanical earth, however, inconsistencies, regional disparities and insidious nonuniformities across the globe constitute the body of politics. The emergence of two entities (political formation, military, economic, etc.) from two different locations on the ground is inconsistent, but according to the logic of ()hole complex they are terminally inter-connected and consistent. In terms of emergence, consistency or connectivity should not be measured by the ground or the body of solid as a whole but according to a degenerate model of whole and the poromechanics of event.

The opposition between consistencies of the ground and porous media has long been modeled as a main element of architecture (structural narration and mechanisms of interaction)

in videogames. Part inspired by the dynamics of memory holes in everyday narrations and part influenced by the inevitability of technical issues such as graphic engines and interfaces, videogames have integrated not only plot holes but also potential software bugs within their architecture insofar as videogame architecture has become the independent art of proromechanics and utilizing holes. If syntheses of memory are always time-dominated, memory distractions and memory gaps take the advantage of exploiting time outside of chronological progressions. Memory holes introduce gaps and discontinuous tunnels and porous spaces to the chronologic sphere of memory thus making it more prone to time-lapses, abrupt schizophrenic katabases (personality pulverizing blackouts, descents free from the hegemony of solid and void), and loss of wholeness. In Zoroastrianism playing with graves and memory are both forbidden, while one deserves a physical punishment, the other will bring eternal torment. Since playing with memory (i.e. inventing more lines of iteration through memory than mere remembering functions), sorcerously reinvents events not as localizable beings but deathless (in the sense of demonic restlessness) and inexhaustible germ-lines. Playing with memory outside of its remembering capacity enmeshes memory as a playground of agitated activities in the past which break the organizational consistency of the past in regard to present and future. Past as a static chronologic horizon intrinsically tends to sedentarize all types of activities in itself or making itself the stabilizing ground of activities in present or future ... past belongs to the Divine and tradition. While the inability to remember or in other words access problems is associated to the paralytic symptoms of memory holes in thriller fictions, for the Lovecraftian pulp horror, memory holes are specifically designed for access from the other side. The implicit twist of Lovecraftian mechanism of memory holes is that if remembering is unrealistic and futile in terms of memory holes yet at the same time memory holes are gates and access points, then they should conduct remembering and other modes of access to the memory which belong to the outside. If memory holes are channels for trafficking data and retrieval from the other side, then each human or subjective attempt to recall is to invoke or stepping in the memories of an outsider.

Memory gaps with their Space-Time lapses have the function of ()hole complex through which teratologic entities seep through, rush toward our world; memory gaps are the instruments of their homecoming. Plot holes or memory holes as *spawn zones* are definite videogame components. The videogame, *Nosferatu: The Wrath of Malachi* (iGames, Idol FX, 2003) employs blackouts and other instances of epileptic memory to build its architecture instantaneously. As the player runs out of time and chronological bonus, blackouts take over. This does not lead to the death of the player but after every blackout, the map of the castle changes, doors, traps and objects change their layouts and most importantly, monsters are spawned differently with different quantities. Memory holes are the model of alien incursion. *Half-Life 2* and its *Aftermath* sequel and *Hitman* series go to the point that the entire architecture from narration, story, sequences and enemies are convoluted and formed by memory holes registering themselves in videogame as plot holes. Every hole is a footprint left by at least one more plot, prowling underneath or the outside of the visible plot. Menacing components of a hole in the plot do not suggest an absence or negative loss (critic's object of despise) but the activities of a sub-surface life, the psychosomatic indications of one more plot densely populating itself in the holes it burrows

through and digs out. On the other hand, technical issues make the use of potential bugs or technical limitations within videogames inevitable. Teleportation is one of the most popular manifests of these holes which have been completely embedded within the architecture and the mechanisms of videogames. Charles Forth presents the first contemporary model of teleportation in his paranormal book *Lo!* in which telekinetic apport (similar to the use of round table for conjuring spirits) and teleportation or porodynamics of holes is diagramed as a shortcut through terrestrial limitations. In Forth's book, teleportation is used for communication with paranormal phenomena – alien sentience, superstitions, extraterrestrial technological singularities and a force called Cosmic Joker (a proto-Cthulhoid entity). Teleportation was later widely used in science fiction and became an elemental unit of narration (plot-hole?) in videogames: wherever you can't make the narration, a teleporter comes in handy[5].

If videogames fell short in their original promise for interlocking with nerves of their players by becoming corrupted with narration and plot, they developed a new medium and space of interaction instead, which is imbued with the logic of holes and emergence. Only through submission to the banality of storytelling, videogames could invent an original genre mainly working with poromechanics of holes. The promised science fictional vigor of initial videogames has been internalized within their architecture. Xeno-spaces and alien structures are now presented by the architecture of videogames themselves not the science fictional stories they narrate. Such an architecture – mobilized by dynamics of holes – certainly can be used as a model of planetary emergence. This is why, videogames are perfect Lovecraftian artifacts. They are too saturated with mechanisms of emergence and dynamics of porous media to be mere cultural products or digital innovations in the realm of ludicosm. For this reason, videogames are more suitable to be models or sophisticated simulations of new modes of warfare within military domains or anomalies and new formations in politics. In fact, nowhere the vermicular architecture of ()hole complex can be better diagramed as in videogames and wars associated with insurgents, guerillas, rogue states and stealth constabularies. Not only techniques of digging and archeology are increasingly becoming the fields of interest for avant-garde military theorists and planners but also the science of dwelling and fusing with holey entities (becoming with one with holes) on every level has developed a peculiar military and political field of itself. The contemporary world propagates itself through holes.

The aforementioned asymmetry between ground's consistency and the consistency of poromechanical entities or porous earth has long been formulated by military and political practitioners as an archeological law – *for every inconsistency on the surface, there is a subterranean consistency*. The law of subterranean cause in archaeology bears a striking resemblance to Freud's suggestion that for every psychosomatic breakdown, there is a Complex (an anomalous convolution and knottedness) beneath consciousness. The reason for this similarity lies in the fact that according to both archeology and Freudian psychoanalysis, the line

5 The part on teleportation ('portable hole'), holes and ludicosm as well as sections on 'imperialism of holes' (C. Miéville) could have never been developed without provocative conversations with China Miéville.

of emergence (the nemat-function) travels according to the resistivity against emergence, the dynamism of emergence and degree of porosity. The course of emergence in any medium is identical to the formation of that medium; the more agitated the line of emergence becomes, the more convoluted and complex the host medium will be. In terms of poromechanics and ()hole complex, the superficial orientation of both archaeology and Freudian psychoanalysis are too complex – immersed in multiplex dynamics of surfaces and their interactions with emergence – to be fathomed. The myths of obtuse flatness or totalitarianism attributed to Freudian psychoanalysis by postmodernist rivals are in most cases the symptoms of misunderstanding the problem of surfaces and emergence. The superficial (as related to visible, circumferential and grounded surfaces) entities of Freudian theories only come into existence as products of unbound activities in emergence, or more accurately, the convoluted and porous formations through which emergence takes place. In the domain of emergence, every surface – whether of constraining ground or porosities – belongs to and is mobilized by the poromechanics of ()hole complex. And in ()hole complex, depth exists as the ambiguity or the gradient between inner and outer, solid and void, one and zero; or in other words, as a third scale or a dynamically balancing, intermediary agency which operates against the unitary or binary logics of inner and outer, vigor and silence, inclusion and exclusion. Holes definitely develop a ternary logic. It is through the ambiguous logic of depth that Lovecraft's nether realms or abysmal geometries come forth or sink within the earth. There is only one line of inquiry, one line of movement for traversing depth that is the dynamic inertia for all Lovecraftian protagonists – to descend. Every movement in and for depth is reinvented as a descent – *katabasis*. More we move, further we descend; this the general law of dynamism for hollowness and lacunae of existence. In the wake of the ternary logic of holes – depth that is – what is a deep thought and what is the depth of an analysis?

For both archaeology and Freudian psychoanalysis, the process of emergence and its immediate connection with formation and dynamism of surfaces, namely, ()hole complex inevitably coincides with paranoia. For every inconsistency on the surface, there is a subterranean consistency; here is an overlap between two consistencies. One is the consistency according to the dynamic surfaces of holey space or simply cavities, and the other is the consistency between cavities surfaces (holes) and the circumferential surface of the solid (ground or visible surface). For every cause with a vertical distribution, there is a cause with a horizontal or slanted distribution, or vice versa. The effect is simultaneously produced by two causes with two different logics. For being registered on the circumferential surface or the ground, the schizoid structure or consistency of ()hole complex should be transmitted to the solid body where it has to be consolidated. Anomalies on the ground-surface are imminent to the two planes of schizophrenia and paranoia. According to the archeological law of contemporary military doctrines and Freudian psychoanalysis, for every inconsistency or anomaly on the ground, there is a schizoid consistency; to reach the schizoid consistency, a paranoid consistency or plane of paranoia must be traversed. This is why paranoid cultures and their apparatuses always leave security leaks; they breed more holes and more solids than everyone.

Diagram 2. Archeology, psychoanalysis and military theories: subterranean consistency and the two planes of schizophrenia and paranoia.

The militarization of the contemporary world both in its politics and concrete approaches is architecturally, visually and psychologically paradoxical (too paranoid to be schizoid and too schizoid to be paranoid); since its agencies – as of in War on Terror – are shifting from the logic of grounded earth to the poromechanical earth and the logic of hole agencies. Although making examples restricts the vastness of militarization in respect to the poromechanics of war and archeology as the science of military innovation in the twenty-first century, but enumerating one or two cases might increase lucidity.

1. In countries with detailed homeland security protocols or relatively high level of alertness, where ground or aerial operations as of hostile, subversive or stealth activities cannot be conducted, the emergence of intricate poromechanical entities is escalated and cannot be avoided. In such countries, the distribution of illegal immigrants or smuggled products such as drugs and weapons around the border regions follows not patterns of activities on the surface but the formation and the architecture of nested holeyness beneath the ground. Activities or lines of movement (tactics) are not separate from the architecture of such ()hole complexes. According to military experts or urban planners with military educations, criminal and hostile activities can no longer be explained, analyzed or traced on land, aerial and water levels. These activities only conform to (paranoically that is) structures of vast underground nemat-spaces and their constantly displacing and vermiculating lines of emergence (schizoid formations of surfaces). The distribution, escalation and diffusion of complicities is identical to different aspects of hole trafficking. For military experts, the terror market is nothing but that of porosities of earth. Cross-border wormholes under the US-Mexico border, tunnels under Gaza-Egypt and all other examples of hole trafficking confound the polarities of surface globalization and its politico-military facets. Economic and power formations for clandestine Guerilla-states,

anti-State movements and ambiguously Imperialist states configure themselves on poromechanics of war.

2. The Battle of Tora Bora in Afghanistan mainly escalated by coalition forces (especially US forces to the point of using BLU-82 bombs and a potential nuclear bunker buster strike) based on the collected information about vast underground facilities and terror networks in Tora Bora mountains. US and British forces initiated a surgical strike comprised of sophisticated tactics, innovative command and control and inventive use of military implements and weapons. Tactics and the entire logic of military progression in Tora Bora were formulated precisely in order to match the mountains, and give an appropriate military response to the holey architecture of terror compounds. In short, the military formation of the entire battle was determined based on the supposed tortuousness of the holey complex within the mountains, and then techniques and solutions for neutralizing and clearing them. The complexity of movements or formative dynamics belonging to US and British forces was compatible and in counter-geographical correspondence to the nested complexity of holes, tunnels and underground chambers. The Battle of Tora Bora was actualized based on the complexity of Tora Bora sub-surface facilities but in the absence of actual holes and vermiculate complexities. Bound to the paranoid logical line in holey complexes (from the ground to the cavity) and unbound by a nonexisting schizoid architecture of nested holes, coalition forces led by United States developed the first full-fledged example of Cappadocian Complex. Adhering to the logic that wherever hostile activities and threats are inconsistent and asymmetrical, there is an underground cause of nested holeyness; and consequently one must formulate formations to counteract these convoluted and subterranean architectures is the heart of Cappadocian Complex. Where in Tora Bora, there was no sub-surface nexus or complex, in Cappadocia beneath every surface and in every mountain or hill there is a multiplex of holes, lairs and passageways.

Poromechanics is simultaneously construed by the vector of schizophrenia and the vector of paranoia. Lovecraft's fiction, his 'obsessional racism' (Houllebecq), fanged realism and unbound schizophrenia should be examined in the light of poromechanics of his writing, horror and world.

Tactics of Digging

Every mine is a line of flight that is in communication with smooth spaces – there are parallels today in the problems with oil.
(Deleuze and Guattari, *A Thousand Plateaus*)

The schizophrenic skin of the Earth has more to do with fluxes of Oil and Gas than the holey space of mines and metallurgic probe-heads. The Blob (Irvin Yeaworth), the Ancient Enemy (Dean Koontz) or Devil's Excrement (Pérez Alfonso) are full-fledged Lovecraftian entities of ()hole complex. The distribution of porosity through the Earth does not follow a rhizomatic structure but

random clusters with variable densities similar to dispersion of suspended dust and moisture in fog, the same fog and cloud complexity can be seen in the GIS cartography of the Internet. The mutual contamination of solid and void in holey space is increasingly intensifying with no sign of stoppage since it is the internal impetus of solid to be active, to re-modify itself, to knit itself through economic networks which maintain and guarantee its survival and growth, aiding it to be grounded. All activities through the solid part are reinvented as convoluting lines of perforation at deeper levels of the composition; this is one of the most genuine discoveries that lies at the base of Lovecraft's fiction in regard to all human endeavors for survival. Whenever solid messes with void to keep itself dynamic and solidly constructive or consolidated, void becomes more contaminative, its worm-functions become more furious, excited to the point of frenzy; they begin to rise from compositional depths to engineer an intricate traffic zone – the vermicular space of emergence. This way solid levels all obstacles in its path to damnation by each activity that it deliberately undertakes. ()hole complex is never low on infidelity and perfidiousness, it is the source of clandestine manipulation of solidus and double treachery to both solid and void.

In the past, the holey space of mines incited peasant revolutions and barbarian invasions, but now they are oil fields which make technocapitalist terror-drones and desert-militarism of Islamic Apocalypticism cross each other, forming militarization programs and complicities for revolutionizing the planetary surface. It is not a question of politico-economic evolution if oil has undergone a process of weaponization on the Islamic front of War on Terror and has turned into a fuel for technocapitalist warmachines. In Arabia, Sudan, Libya, Syria and even Arabic clusters under the Persian Gulf, the Islamic state must cross deserts to feed on oil fields because of the exclusive location of oil fields in these countries. But the desert is the space of nomad-burrowers, desert-nomads and their warmachines with minimum climatologic regulation. Of all nomads traversing the Earth, the most radical nomads in terms of forging warmachines under the minimum influence of climatologic factors and strategic participations with the Earth are the desert-nomads. This is why both the renomadization of the Wahhabistic state of Saudi Arabia through desert-militarism (belonging to desert-nomads) and semi-sedentarization of nomads (by the State) and their metamorphosis to *naphtanese* (clandestine petro-nomads who roam between oil fields instead of oases) were inevitable. Bound to purely nomadic ways of living, and remaining relatively distant from environmental factors of climatological dependence such as water, moderate climate or diverse pastoralism (they are mostly just camel-keeping pastoralists), the nomads of Arabia retained truly nomadic traits until the mid-twenith century and were introduced to the State's sedentarization programs very late. This pre-mature but late sedentarization of desert nomads by the oil seeking State was in fact the main factor in contamination of desert nomads of Arabia with petropolitics and pestilential vitalization of Wahhabi religion with nomadic tactics, ways of life and logic of the desert. The contemporary religio-political traits of Wahhabism (the Wahhabistic agencies supposedly targeted by the War on Terror) are undoubtedly diverse mutations resulting from the attraction of the occultural and alien elements of desert nomadism through oil. Both the State and desert-nomads were introduced and slid to each other through the poromechanics of oil and the holey space shaped by the logic of oil extraction in the desert. The petropolitics of world – earth as narrated

by oil but the other way around – in regard to the Middle East and War on Terror has emerged out of these mutual contaminations between States and desert nomads, facilitated by the holey space of petroleum.

Other than forging outlets from the exclusive characteristics of both desert-nomads and the State, oil fields draw nemat-spaces for manipulation of the State by furious desert-nomadism and reconfiguration of desert-militarism according to the political trends concentrating around the oil fields as the consequence of the State's policies to control and monopolize oil. This corresponds with the ambiguity between solid and void in the ()hole complex which traffics and smuggles the itinerant lines of its own out of the polemics of solid and void. The problem of oil fields and the ()hole complex between the State and desert-nomads is indeed far more sophisticated than the problem of mines and their ambulant dwellers (miners). First there is no equivalent of miner for oil fields since the connection of naphtanese (former desert-nomads) with oil is not an intimacy based on consumption, production or even transportation (what connected especially old miners to mines as their temporary niches). Second, oil as an ubiquitous earth-crawling entity – the Tellurian Lube – spreads the warmachines and politics of *naphtanese* or desert-nomads as totally pervasive (diffusing-escalating) entities. Finally, even in the absence of desert-nomadism, oil turns Time to apocalyptic blasphemies. A patch of oil is enough to stir the apocalypse out of Time. If oil does not benefit the middle class (an economical boom initially moderating economy but consequently giving rise to economic fissions) and if it does not lead to the outbreak of cannibalistic economies as in the case of Mexico, Venezuela, Sudan and possibly Mauritania, it will certainly charge clandestine-military pipelines with apocalyptic modes of divergence as in the case of Islamic countries. In either case, oil with its poromechanical zones of emergence in economy, geopolitics and culture cheats on the Divine's chronological Time with the utmost irony and obscenity.

The nemat-spaces of both mines and oil fields attract nomads and different types of martial entities around themselves, assembling them as mercenaries, treason-armies bound to privatization of military forces which in most cases belong to foreign or multi-national mega-corporations around oil fields and not the State. Although these corporations are symbiotic entities within the nucleus of the State and synchronized to its politics (also linked to techno-economic or military failure and poverty of the State or the criticality of mines or oil fields) but their functions are external to the economy and environmental stability of the State as non-native forces; they are potential dangers of *coup d'état*, class insurgencies, ethno-national crises and even invasions of the foreign countries from the inside. As a matter of fact, ()hole complex suggests that hole agencies are essentially (but not actively) double-dealing and treacherous; they are counter-hegemonic and hegemonic. Ambulant hole was originally utilized in a full-fledged form (unlike the complex in Meimand region of Iran) by the State. The underground cities of the Hittites in Hattian Empire were mainly burrowed out for employing the formidable power of a military dwelling entity in Anatolia. These underground cities were settlement-fort-factories with immense impacts on the geopolitical formation of Mesopotamia (Babel, Assyria and Ugaritic civilizations), that is to say, the most hegemonic States of the time. The hegemonic States (and the emergence of despotic States in the region) were dynamically influenced – if not moulded – by

the metalistic staging of these hole agencies or underground cities in the service of the State. The
role of iron production from these underground cities (Kaymakli and Avanos in Cappadocia for
example) was more than just supporting the formative and geographic boundaries of the States
(Iron weapons over copper) but also molarizing the populations of the region through
stratocracies connected to these hole agencies. Assyrians cleared the last underground cities of
their human dwellers by releasing and sending vermin (diseased rats, polluted water, rotten
bodies and snakes) down to the complex because as the most advanced militant state of that time,
they knew that these are not the vectors of decay and disease which solve the problem of 'hole
people' but the worm-dynamics of the complex which gives the flux a militant hydraulic edge and
autonomous tacticality. This is in opposition to the Wittfogelian fluid dynamics that drives its
power out of the irresistible hyper-activity and turbulence of the flux. However, ()hole complex's
double-dealing field of activity is radically (although subterranean and from the standpoint of
strategic divergence) autonomous in becoming pilotless or acephalous in a long run.

Oil fields and mines usually come with corporations and their privatized armies, one as
the owner and the other as the extractor, and mercenaries as outsiders who protect the temporal
bonds between the extractor and the owner on the one hand and the oil fields and true
beneficiaries on the other hand. Although these corporations and mercenaries which have already
sucked into the ()hole complex of mines or oil fields induce repressions and poverty (through
policies germinating on militarized secrecy even obscure to the State's macropolitics), they play
significant roles in double-insurgencies, violent internal fissions of the State, civil wars and
unrests. Anywhere that a nemat-space emerges, propulsive waves of insurgencies and politico-
economic insomnia rise imminently. To this extent, where is the realism of Lovecraft's
poromechanics of horror as refined and manifest as in Middle Eastern politics and the hadean
ethics of living on oil?

One of the characteristics of ()hole complex is inspiring new forms of utilization or
sparking off innovative usability – previously unknown abuses – in its consumers, or what can be
identified as aggravating instrumentalization of the Whole, the system's directorship and its
afforded environment. In this regard, ()hole complex carries out a putsch to exhaustively
degenerate the Whole in its functional restrictions. Attributing unprotected accessibility to
utilization, or in other words, insistent multi-purpose utilitarianism with a pervasive edge is a trait
of holes as ambiguous entities which can be reductively deduced from the machinery of ()hole
complex.

Holes prostitute themselves, they are at the same time pimps and prostitutes. This is in
contrast to the ecological stability between whole and its environment. The holistic political,
religious and military readings sacrifice the autonomy of their object in favor of their
environments or their global wholes. Holistic readings, in general, are in accordance with events
bound to the ground and the dynamics of circumferential peripheries such as surface
globalization, consolidated economic progressions, conventional military fields, etc. Such
readings impose logics of systems which are either theoretically reductive or pragmatically
disconnected in regard to their objects. For this reason, lines of emergence associated to the
porous earth, hole agencies and terminally political and insurgent formations – as of the Middle

East – or what Lovecraft suggests as cosmic dread necessitate new reading methodologies. Hidden Writing is one of these investigating methodologies which itself corresponds to the dynamics of emergence, degenerate architecture of ()hole complex; it can grasp all of them together without reducing them to a whole or separating them from each other. For reading both the Lovecraft's fiction and world, Hidden Writing is the ultimate tool of extraction, digging and participation, that is to say, reading in both scrutiny and realization.

Hidden Writing whether as *apocrypha scripta* or *steganographia* integrates the utilitarian frenzy of the ()hole complex as its functioning principle which cannot be separated from its convoluted structure. In Hidden Writing both the structure and function are the same as in the dynamism of emergence and formation in porous earth. Hidden Writing can be described as utilizing every plot hole, problematics, suspicious obscurity or repulsive wrongness as a new plot with a tentacled and autonomous mobility. The aftermath of this utilization manifests as an act of writing whose effect is deteriorating the primary unified plot or remobilizing the so-called central theme and its authority as merely a structure or a primary substance for holding things together. Reinventing the central or main plot is solely for hosting, transporting and nurturing other plots stealthily. In Hidden Writing, a main plot is constructed to camouflage other plots (which can register themselves as plot holes) by overlapping them with the surface (superficially dynamic plot) or the grounded theme. In the wake of this writing, the main plot is the map or the concentration blueprint of plot holes (the other plots). However, the propagation of plot holes in hidden writing is not merely the evidence of actual independent plots – with radically different contents and themes – beneath and through the visible surface or the so-called main story (books within a book). It is also the indication of the active inauthenticity and anti-Book distortions that Hidden Writings carry. In addition to being the manifest symptoms of other ongoing plots, plot holes originate from pseudonymity, anonymity and deliberate distortions linked to authorship issues usually tied to Hidden Writings. Shifting voices, veering authorial perspectives, inconsistent punctuations and rhetorical divergences bespeak of a crowd, one author multiplied to many. In fact, mis-authorial problems which are usually associated with Hidden Writings[6] give rise to tendriled plots as new narratives spreading out from the surface plot in all directions; plots capable of seizing the surface story or the textual structure from the dominant authorial space. A text twisted by plot holes is essentially a Lovecraftian read.

6. As in the case of biblical writings appended to the Septuagint and Vulgate versions of the Old Testament.

Diagram 3. Perpetuation of plot holes is imminent to the dynamism of sub-surface plots.

One of the most prominent examples of Hidden Writing is Johannes Trithemius' treatise on black occult and scholastic astrology, *Steganographia*. Trithemius' work lacks a superficial coherent plot and consistency, as if it has been infested by plot holes, content and thematic losses. However, the book is in fact a massive treatise on the science of code and cryptography camouflaged and buried within the surface plot that is constituted of occult and astrology. Instead of layers and levels, Hidden Writing populates subways, sunken colonies, a social commotion teeming underneath. Trithemius' treatise on unorthodox occultization, astral communication and black magic haunted by a restless population of cryptological entities operates on the plane of Hidden Writing. The surface plot is an exoskeleton to provide the living palpitating interior with protection, dynamism and military potencies.

Archeologists are fanatic readers of Hidden Writing who as they claim, concretely contribute to the text. In fact, Hidden Writing as an investigating and analyzing method was introduced to new military theories from archeology. Vast Mesopotamian necropolises virtually always consist of a so-called in-situ site or wonder zone and an in-subsido site or a missing site; the wonder zone or the site in its appropriately mapped place is usually located on a desolate plain or a mound with the ruins of ostentatious architectures erected on it. The wonder zone or the in-situ site is constituted of empty tombs or cenotaphs and caches in the ground; it is a surface faerie with precarious existence and even perfected – in the sense of falsification – by underground regions flaunted by treasures and exotic objects. Treasures have been buried in the ground; chambers have been interred with sham bodies of royal families and heroes as sub-plot digressions on the real underground complex. Beneath the ground and even its sub-surface wonders, within the mound itself there is a dense burrow or warren compound thickly populated by tombs, murals, weapons and afterlife oddments. The surface problematic site and bizarre settings such as empty tombs (*kenotaphion*) and misguiding edifices radiate a massive attraction for looters and vandals to divert them from the subway system or the real necropolis. These holes

and inconsistencies as superficial entities outline a positive fishiness which foreshadows the existence and activities of the Necropolis' urban space in the form of subways or an out-of-place site (ex-situ site). For an archeologist who reads the site through inconsistencies and profound defectiveness of what is available through the surface, cenotaph as an empty tomb is a hole in the story which points to an exact direction: the entrance to the warren compound of the necropolis or the real underground network. In a necropolis' surface-site, everything from empty tombs filled with sham bodies to treasures deliberately buried within the ground suggests that there is something else, a missing site nearby. For the looter, however, it is just 'Wrong' but at the same time satisfactory and lavish. Following the strategic absurdness of the surface and operational plot holes, if there is something as an archeologist's aestheticism, it will emerge along this line of extolment, *there is something deeply wrong with this thing.*

Diagram 4. Mesopotamian necropolises and their sites as models of political archeology.

Tiamaterialistic[7] entities in the Middle East utilize a different field of distribution, infiltration, multiplication and cognition for their progression and activities, which resembles the heavily perforated space of hidden writing.

The peculiar diagram of the Middle East is a near-to-collapse surface, full of inconsistencies and irrelevancies or simply story holes leading to a stretching undercurrent and subway system. This space of nested holes is undercurrent-friendly; it has the obsession of turning any political and religious movement into a burrowing machine. Every activity of this machine

7. In Tiamaterialism, the line of emergence is nothing but becoming one with the vermiculation of the zone of emergence or the nested holeyness. And the porous media, in terms of emergence, is essentially tumultuous i.e. intricately holey.

structurally degrades the wholeness of the field or the ground and ironically makes the problematics or holes more relevant to the perforated space or the zone of their activity and less relevant to the ground or the established surface. The irrelevancy of the Middle East to the rest of the globe is not a symptom of too many politics and histories; it directly comes from its approach to the globe and its undercurrents. It is not new to say that the Middle East picks discarded holes in the world's economics and politics to populate them, turning them into its objects of enlightenment. As for the world, it has not seen anything of Tiamaterialism yet. The world order and its breakthroughs have been grounded on the tortuous ratholes of Middle Eastern Tiamaterialism with its burrowing heads. If the most advanced economic systems are not reliable or do not work properly; it is not their fault. It is because they are the plot holes of Middle East's Tiamaterialism and its ambulant holes and tunnels. Ontologically, wherever there are holes, there are surfaces as superficially dynamic symptoms; for a holey universe as vermiculate as Middle East's Tiamaterialism, the surface or superficial entity that symptomatically emerges will be as stretched as the planetary ground, that is to say, the global skin.

From the stand point of surfascists, Middle East's Tiamaterialism may look as if it impulsively messes around restlessly but the way it works is intricately strategic from the perspective of hidden writing, which is of holes' creative surfaces. Tiamaterialism contributes to the world order not through the so-called main story line or the plot currently moving forward, but works through the plane of hidden writing. The Wahhabi hostility against idolatrous embodiments has escalated to that degree which even mosques and holy tombs belonging to the prophet's family and disciples should be destroyed because they legitimately break the rules of the God's exclusive oneness. So what they are doing is shifting the location of their underground infrastructures to areas near mosques and holy shrines, changing the directions of underground construction projects including subways to these places, concentrating pipelines, water storages, and other transport tunnels under the holiest Islamic sites to gradually surrender them to the forces of nature or destabilizing the sites' foundations. Usually a third party such as the neutral hostility of nature should take care of holy tombs and sites. There is this materialistic personification of monotheistic zealotry on the ground and integrated pipelines creeping beneath, concretely biting at the structure's foundation; interrupting the transfer of loads from the superstructure to the ground or creating fault foundation and sinkholes beneath the sites. This whole cyclorama from the outset is an example of hidden writing. The collective history of Tiamaterialism or Middle East as a sentient entity is a masterpiece of hidden writing.

[...] from crypts where the world thought them safe.
(H.P. Lovecraft, *The Case of Charles Dexter Ward*)

Nemat-space is infected with gate hysteria; its surfaces are always prone to collapse and re-emergence from somewhere else thus restlessly clicking new gates open. It gapes, yawns, bloats, coils and slithers as an endogenic parasite over, through and within the Earth. ()hole complex gives more passages than are needed to the Earth's body, thus rendering it a host of its own ulterior motifs. The heretic Zoroastrian cults, *deavo-Yasns*, *Kaxu?i* and *Yatumants* or *Akht-Jadu*

(*Yatu*) called this indefinable earth which secretly squirms from of the Outside and is fermented upon countless perforations, *Drujaskan*. According to ancient Zoroastrian scriptures, Drujaskan is technically the most messed-up space that is awakened from and by the Earth to unground the Earth's wholeness or manifest divinity. In a nut shell, it is the worst possible planetary entity, laying waste, rotting erect, oozing pores. Similar to the cult of the Old Ones responsible for awakening Cthulhu, these Zoroastrian sects have been associated to the act of reducing the wholeness of the divine sphere or degenerating the Earth's wholesomeness, hence speeding the emergence of Drujaskan and its inextricable holeyness. While in Lovecraft's fiction, the cult raises Cthulhu from the city of R'lyeh, heretic Zoroastrians encourage the porous city of Mother of Abominations or Druj to take the Earth over. Pests teeming forth from *Drujaskan*, from passages which themselves are inseparable from the writhing bodies of the pest-legion. Ungrounded and unreported histories of the Earth are full of passages, vents and soft tunnels mobilized and unlocked through participations with the Earth as a compositional entity. These histories are engineered by openings and what crawl in them; every movement in these passages engineers what makes Earth, Earth. Only as a Nemat-Space, the Earth endures; an opening through its whole, a hollow body drawing its cartographies on surfaces of holes and other superficial entities.

The awakening ritual that the cult of the Old Ones practices to speed the return of the elders, is messing with the solid part; it constitutes advanced re-modifications and operations on the solid part of holey space to strategically assist new vermicular lines or worm-functions be composed and autonomously digging passages for the Old Ones' Return, opening yawning pits as zones of their rebirth. Each activity 'on the solid part' or 'at the side of solid' is a sacred oblation to the Old Ones. To be a devoted architect of solid is to feed solid to the vermicular lines of the void.

They excavate tunnels in earth and lay their eggs within its pores; the larvae burrow through the earth's skin, migrating in the connective tissues, crust and strata, feeding on necrotic solids and surfaces. Burrowing sounds may be heard from within the earth. Once infesting the earth's solid part is finished, the larvae will cut breathing holes and press their headless tails against the surface for air. The larvae will continue to grow while boring out spinal cavities for the earth's body which will never be filled. As the larvae grow, they will enlarge the holes and come out of the ground.

THE SOLAR SNAKE
How the sun sheds its skin

Astronomers have discovered a key fact required to understand the Sun's 11-year cycle of activity. Sunspots and flares on the Sun's surface follow the cycle, but expelled gas clouds do not. It seems that these ejections trail the sunspot peak – they peaked in 2002, two years after sunspots. The expelled gas takes away the Sun's old magnetic skin allowing a new one to emerge to start a new cycle.

The Sun's 11-year cycle of activity – as recognised by the coming and going of sunspots – has been known since 1843, when Heinrich Schwabe, a German astronomer, noticed the pattern. Years later the activity was recognised as being of magnetic origin by George Ellery Hale, the US astronomer, who, in 1908, saw that sunspots were intensely magnetic. Since then many theories have been put forward to explain the solar rhythm.

The accepted theory is that the sunspot cycle is a consequence of rotation and convection inside the Sun. The fact that the Sun's outer layers are bubbling, and that the Sun rotates faster at the equator than the poles, and faster on the inside than on the surface, results in a solar dynamo that, over 11 years, becomes increasingly wound up.

So at some stage during the magnetic cycle the Sun has to somehow shed its old, contorted magnetic skin and allow a newer, less troubled one, to emerge. The Soho (Solar Heliospheric Observatory) satellite may have obtained evidence about how the Sun does it. Eight years of observing gas eruptions – coronal mass ejections (CMEs) – show that they are removing the Sun's old magnetic field bit by bit, first from one pole and the equator, and then the other pole.

"The Sun is like a snake that sheds its skin," says Nat Gopalswamy of Nasa's Goddard Space Flight Center, author of a report in the *Astrophysical Journal*.

"In this case, it's a magnetic skin. The process is long, drawn-out and it's pretty violent. More than 20 thousand coronal mass ejections, each carrying billions of tonnes of gas from the polar regions, are needed to clear the old magnetism away. But when it's all over the Sun's magnetic stripes are running in the opposite direction."

H P LOVECRAFT AND THE LOCH NESS MONSTER

In December, 1933, the *Daily Record* published the first known photograph of an amorphous, cyclopean Loch Ness Monster, taken by Hugh Gray on November 13th of that momentous year. In a letter to Clark Ashton Smith one week before, H.P. Lovecraft had written of "the suppressed manuscript of Dr Fergus MacBain, which spoke of a flickering luminescence in the loch – something which waxed and waned as if in answer to corresponding flashes on the dark part of the moon's disc." Lovecraft seems, instinctively/ creatively, to have been on to something...

 The Clan McBain (or McBean), meaning "Son of Beathan" (*Bain* = ban: white, fair), is part of Clan Chatton, "Cian of the Cats", a confederation of highland clans with the motto: "Touch not the Cat". They are said "to have sprung from the ancient house of Moray". In the 18th century, a Dr Fergus

MacBean lived in Inverness. He was a Gaelic scholar, but a his writings were proscribed after the Battle of Culloden ir 1746 (MacBean's magnum opus was the notorious *Leabha. Mor na h-Oidhche*). During the last nine years of his life MacBean resided at Druidtemple House, near Leys overlooking Inverness, where he is said to have practised accursed conjurations and horrid crafts... contrary to the express Law of God. MacBean died in 1771, and is buried or Tomnahurich Hill, Inverness. One of the good doctor's 20th century descendants, George MacBean (Registrar for the Burgh of Inverness and member of the town's Scientific Society) saw the Loch Ness Monster on June 17th, 1934.

 Lovecraft appears to have oneiromantically linked the name McBain (or MacBean) with shoggothian entities ir Loch Ness. He also wrote of "caverns beneath caverns" in the

loch, and bizarre "pictographs full of diabolic revelations concerning the Earth's pre-human past".

During the late evening of May Eve, 1991, I took part in a surrealchemical Nnidnidist ceremony, around midnight, with a group of naked witches. We invoked Bucca, in the woods of Lower Pelean, Cornwall. The night was cold, dark, and wet. In the pre-dawn hours – with inebriation as insulation – we continued the Beltaine revelry indoors. Finally, I crawled into bed, to sleep, to dream, to wake, to write ...

"I am standing in a cavern, beneath the fort of King Brude mac Maelchon, beneath Castle Urquhart, Loch Ness. The wet surface of this rough dome-like vault is adorned with Pictish carvings, and faintly lit by seemingly random blobs of green luminescence. The only sound is a hollow, continuous drip-drip-drip of water, from stone roof to stone floor. Then I hear the sound of my own breathing and the muffled beating of my heart. And now I hear the breath and heartbeat of another, and another, living creature. I am not alone. Two naked women stand before me. I know them. They are the green witches, Sine and Sileas. Their long green hair is braided, and their glistening green bodies are tattooed with Pictish symbols. On their bellies they wear the sign of Nnidnid. They are beautiful. I shift my shape into that of the goat with three horns, Saraim. The witches raise their arms, throw back their heads, and chant in unison:

'Cuirtear an siol san Earrach. Is gile an ghealach na an ghrian. An staf bhi ag Cthuihu, ba ghreanta an tseoid, ach ... Do gheobhair gan dearmad taisce gach seoid. An te atathuas oltar deoch ach an te ata thios buailtear cos air. Chifid siad. Saraim ... Saraim ... Netsah ... Monstrum!'

I howl an answer:

'Saim! Scaoilim! Ta na hamhrain sin ana-bhinn, is glas iad na seanamhrain naiad. Aivor ... Angarth ... Cruadhioach ... Shub-Niggurath ... Nnidnid!'

The twin witches scream with lunatic laughter. Twin goatish phalli swell and rise, extending, snaking towards the women. And I – Saraim – am laughing, as I lovingly enter and serve them with black frothing wine.

A caphcornish copulation. Our unholy trinity united as a monstrous ONE ... writhing, thrusting, sighing, yelping, slithering, on the wet cavern floor. Our mad love twists and turns us into a tentacled, luminous star-thing with a savage eye. We have become IT!"

That was a mixture of remembered dream and automatism; techniques with which we can peel away the surface skin of quotidian "reality" to reveal the authentic surreality of our psychic levels. Lovecraft used similar methods (automatic writing while in a semi-hypnopompic state), and revealed the nightmares of his unconscious. As a "rational" materialist, Lovecraft rejected the possibility of any paranormal elements in such activity.

He was, as we know, mistaken.

There is, undeniably, something "Lovecraftian" about Elephanteuthis Nnidnidii, the great worm of Loch Ness. My concept of the thing was influenced by ancient petroglyphs of a grotesque "Pictish Beast". I am sure that such carvings exist beneath Castle Uruquhart, and they bring to mind Lovecraft's "pictographs full of diabolic revelations" on the walls of caverns beneath caverns" at Loch Ness. In 1970, a high-definition, side-scan sonar established the fact that there are underwater caverns in the loch; and in 1976, curious stone circles were discovered at Lochend. There was – and still is – a stone circle on MacBean's estate at Druidtemple (as its name implies).

Lovecraft probably believed that he had invented "Dr Fergus McBain" as just another of the many literary jokes, surrounding the Cthuihu mythos, which he regularly exchanged with Clark Ashton Smith ("Klarkash-Ton") and others; but his unconscious mind had, somehow, made contact with the real 18th century MacBean of Inverness. H.P.L. was obsessed with the 18th century, and felt that he truly belonged to that period. It is entirely possible that this obsession enhanced his powers of mediumship.

In 1937, H. P. Lovecraft died, and Leonora Carrington, the surrealist sorceress, wrote her first published story, "The House of Fear", in which a shamanic birdman, Loplop, freed the heroine from Fear. Loplop was/is the totem creature of Max Ernst, the surrealist seer, who (also in 1937) painted a demonic, beaked "Angel of the House". Carrington and Ernst visited Cornwall, that same year, and took part in surrealchemical ceremonies. It is quite possible that they involved a sea-serpent and a birdman.

The surrealchemical "Great Game" continues.

–Frater Monstrum